How to Create a
SUCCESSFUL
PHOTOGRAPHY BUSINESS

Allworth Press books may be purchased in bulk at special discounts for sales promotion, corporate gifts, fund-raising, or educational purposes. Special editions can also be created to specifications. For details, contact the Special Sales Department, Allworth Press, 307 West 36th Street, 11th Floor, New York, NY 10018 or info@skyhorsepublishing.com.

15 14 13 12 11 5 4 3 2 1

Published by Allworth Press, an imprint of Skyhorse Publishing, Inc.
307 West 36th Street, 11th Floor, New York, NY 10018.

Allworth Press® is a registered trademark of Skyhorse Publishing, Inc.®, a Delaware corporation.

www.allworth.com

Cover design by Elizabeth Etienne
Interior design by Kristina Kritchlow

Library of Congress Cataloging-in-Publication Data

Etienne, Elizabeth.
 How to create a successful photography business / by Elizabeth Etienne.
 pages cm
 Includes bibliographical references and index.
 ISBN 978-1-58115-886-1 (pbk. : alk. paper)
 1. Photography—Business methods. I. Title.
 TR581.E85 2012
 770.68--dc23
 2011048163
ISBN: 978-1-58115-886-1

Printed in the United States of America

How to Create a
SUCCESSFUL
PHOTOGRAPHY BUSINESS
Elizabeth Etienne

ALLWORTH PRESS
NEW YORK

Dedication

I WANT TO DEDICATE THIS BOOK TO MY FAMILY:

To my mom, who raised three children alone after my father died when she was only thirty-two years old. She became the most passionate, fearless, dedicated entrepreneur I've ever known. I was only ten years old when she encouraged me to open my first checking account with birthday money from my grandparents, and then she even showed me how to balance it! At the age of seventy, she is still working nonstop, managing numerous business ventures and creative projects, and probably will continue to do so until the day she dies. An interior designer, home builder, antique collector, and artististic entrepreneur herself, she is the inspiration behind everything I have ever learned about the business side of my profession.

To my beloved dad, who rose out of bed every day, went to work, and never complained, despite a painful and fatal illness that eventually took his life at the young age of thirty-four.

To my stepdad, Tom, who took on the world when he stepped through our crazy family's door! Thank you deeply for your patience, love, and support all of these years.

To my brother and sister, Scott and Renee, and to my nephew and niece, Luke and Chloe Etienne. May this book serve not only as a means of learning more about the life of your sister and aunt Elizabeth, but also as a reminder of the entrepreneurial spirit that's forever part of our family's DNA.

Table of Contents

Dedication v

Acknowledgments ix

1. **Making a Plan** 1
 The blueprint for your photography business

2. **Establishing Your Legal Business** 11
 Entities, DBAs, permits, licenses, and more

3. **Start-Up Expenses** 17
 Common expenses associated with starting a photography business

4. **Ongoing Monthly Expenses** 33
 Common expenses associated with keeping your business going

5. **Funding and Managing Your Business** 41
 Working with investors, banks, and credit cards

6. **Invoices, Contracts, Estimates, and Releases** 55
 The essential docs you'll need to look like a pro

7. **Individual Job Expenses** 75
 The essential expenses for each job

8. **Assistants, Labs, and Agents** 85
 How to find and keep your success-team players

9. **The Ten Commandments of a Successful Photography Business** 95
 For repeat clients and increased revenue

10. **Dialing In to the Success Frequency** 107
How to get it and keep it!

11. **Pricing Your Services for Profits** 117
An easy estimating formula for any job

12. **The Art of Handling Your Clients** 129
Turn a $200 headshot into a $2,000 job

13. **Preparing for Your Photo Shoot** 143
Wardrobe, location, gear, assistants, and lighting

14. **Directing and Shooting People, Places, and Things** 157
Portraits, engagements, weddings, food, and interiors

15. **Creating a Recognizable Brand** 171
Images, logos, and packaging

16. **Promoting Your Business** 179
Create a buzzzzzzz about your bizzzz . . .

17. **Diversify and Unify** 201
The keys to survival

18. **Recycling Your Images** 211
Giving your images a second life

Resources 222

Index 225

Acknowledgments
The Roots of My "Success Tree"

SITTING BACK REFLECTING ON MY CAREER AND THE BLESSINGS I'VE been granted over the past few years, I started to ask myself, "Where did it all come from? Where did it all begin?" Clearing the cobwebs of my memory, I went backward, down the branch of my tree to the roots of the seeds. I then recalled all of the people who were so instrumental to the success of my career.

I want to give a very special thanks to my former intern/assistant Elizabeth Bassle, for it is *she* who is the very root of my success tree. I humbly admit that I think I've gained more from my assistants over the years than I could ever manage to give back. It was Elizabeth, upon searching for ideas to build a new website, who led me to photo-craft master Barbara Smith. I melted when I saw the amazing craft projects Barbara created with her images and the books, workshops, and products she sells to teach others how to create them!

Barbara and I became fast friends, and in turn she introduced me to photography industry legend Skip Cohen, former publisher for *Rangefinder Magazine*/WPPI and "godfather" to the photo industry. Sharing a love of shaggy dogs—and a sense of humor that made our faces hurt from laughing—Skip and I also became fast friends. In the spirit of organic friendship, Skip casually introduced me to Nancy Carr, Kodak's worldwide media relations manager. Nancy fell in love with my work and persuaded Kodak's pro photographer relations director, Audrey Jonck-

heer, to take a peek at it. Audrey was ecstatic and immediately invited me to become a member of Kodak's prestigious advisory board (alongside legendary *National Geographic* photographer Steve McCurry!). Three degrees of separation later, both Nancy and Skip introduced me to Nikon's senior product manager, Michael Corrado. Mike also became an instant fan of my photography and was impressed by my passion for mentoring and all things "Nikon." A short time thereafter, he invited me to become a member of the prestigious Nikon Pro Services and speak at Nikon's pro photographers platform at the Wedding and Portrait Photographers International (WPPI) convention. Wow . . . what an amazing journey it's been!

All of these people are very important parts of my "success tree." They are the sweet fruit at the end of the branches and it is *they* who inspired me to write this book and to remember the seeds of my humble beginning.

I want to thank all of these people, not only for exhaling long enough in their insanely busy careers to take a look at me and my work, but for leading me through doorways I never knew existed. I am forever blessed.

Elizabeth Etienne

How to Create a
SUCCESSFUL
PHOTOGRAPHY BUSINESS

1

Making a Plan
The blueprint for your photography business

BEFORE YOU BEGIN THINKING ABOUT STARTING YOUR OWN PHOTOG-
raphy business, ask yourself a few questions: Do you have the spirit to
run your own business? Do you want to do this part-time to supplement
your existing income, or do you want to do it full-time, giving up your
salaried day job? Lastly, what kinds of things are you willing and prepared
to shoot? This chapter should help you answer these questions by defining
your skill level and the amount of time you want to dedicate to your
business.

WHAT KIND OF ENTREPRENEUR ARE YOU?

Do you have the *entrepreneurial* spirit? The "Type A" entrepreneur has
a lot of self-discipline, enjoys being his or her own boss, and dislikes
working for others. A Type A entrepreneur is always thinking of inven-
tive, new ideas and feels ready to take on his or her own destiny. These
kinds of people usually get an adrenaline rush from carving their own
path through the forest, making their own decisions, setting their own
schedules, and taking more risks in the hopes of controlling their own
financial futures.

The "Type B" entrepreneur feels safer with a regular paycheck but still
wants to dabble his or her feet in a side business to fulfill a creative need.

Whatever your entrepreneurial type, you may still feel lost, anxious,
and confused when considering how to market yourself, create a job

1

estimate, and ask for payment from your clients. No worries; this book should provide you with all the tools you'll need through an easy, step-by-step process.

DEFINING QUICK "MONEY MAKERS" TO PAY THE RENT NOW!

Set your ego aside, folks. It's important to ask yourself, "What am I willing to shoot to pay my rent right now?" Consider it a luxury to have the opportunity to practice your craft and get paid to do it. (Yes, a luxury. What's the alternative? Waiting tables or working a 9–5 desk job? Not for me, thanks.) Being photographers gives us a chance to communicate—to speak another language on another level, and this is a true gift and a real privilege. I can't tell you how often I hear the same baffled response when I tell someone I'm a photographer: "So what else do you do? What do you REALLY do for a living? You don't really pay the bills with your photography, do you?" Yes, I do.

When I graduated from photography school in 1989, I had this vision that I would go straight to New York City, carry myself down Fifth Avenue, and in no time I would be shooting celebrities and fashion shows and attending cool parties with rock stars, models, and movie stars! I was quickly humbled and learned that it wasn't going to be that easy. Even if you have a unique talent, an eye for capturing image compositions, and a knack for adjusting the right settings on your cameras, running your own business is an entirely different thing.

The majority of young photographers I meet all seem to want to shoot fashion. For whatever reason, fashion seems to be the ultimate fantasy for almost every young photographer. If this is not you, you're in the minority. While I appreciate and respect the fashion photography industry, earning a living as a fashion photographer is just about as difficult as winning the lottery. Why? Because the industry is flooded with aspiring fashion photographers. Not only that, the majority of fashion images are used for editorial magazine spreads and most magazines do not pay much (unless you are a very well-known or even famous fashion photographer). Why do most magazines pay so little? It's because they can. Magazine editors know the majority of young, hip photographers would kill to have a spread

in *Vogue* because it looks cool and "might" land them lucrative advertising campaigns down the line. True, but again this is a one-in-a-million chance, and this book is about how to start your photography business and start earning income right away.

So, let's take a look at what we enjoy in life and how we can make money at it. Begin by grabbing a notebook and dedicating it to your new photo business.

ASSIGNMENT #1

1) List 5 hobbies or interests you enjoy

These might be anything from fly-fishing to surfing, cooking, reading, nature walks, hiking, socializing, antique cars, gardening, biking, sports, family gatherings, and animals.

2) List a few things you like to shoot

People? Portraits? Products? Sports? Food? Cars? Nature? Still lifes? News? Travel? Wine tastings? Art openings? Boudoir? Journalism? It's a known fact that the more someone likes what they do, the more likely they are to become successful at it—especially if there is a market demand for it and a shortage of professionals specializing in that field. When you like what you do, it becomes effortless and you feel happy. People want to be around happy people! However, while there certainly may be subjects you enjoy shooting, sadly, these subjects might not generate much income. The world is changing, and it's important to look at what subjects are actually generating good revenue if you want to pay the rent with your camera.

How can your hobbies or interests be translated into a money-making photography business?

There are many ways in which images are used everyday. Begin to take note of these things. If you see an image related to your interests in an advertisement or magazine article, tear it out and build an "image idea" folder. There are certain subjects you'll be able to shoot and start earning money with immediately, while others may be more long-term, potential

income-earning topics. Research these markets, speak to other photographers who are shooting what you want to shoot, and ask them about the income-earning potential of this specific market. If it seems to have potential then ask yourself, "Where do I need to live to make this work? How can I define my market and approach it in a VERY *unique* way? What makes *my* images different from what's already out there?"

The next thing you will want to consider is your lifestyle. Are you married with a family, or single and carefree? Some photography topics are not necessarily conducive to the lifestyle you live now or would like to live later. For example, while photojournalism may sound exciting and may even offer a chance to travel worldwide, it can also be dangerous and unpredictable. This lifestyle might make it difficult to maintain a stable relationship and family lifestyle. If you desire a padded bank account, take into consideration that some subject matters can generate more income than others. For example, shooting photojournalism for a local newspaper or magazine may sound appealing, but most editorial publications might only pay $50–$100 per image! To add to this, many newspapers and magazines are closing their doors because more and more readers turn to the Internet, TV, or radio to get their news fix. On the other hand, shooting high-end weddings or a major ad campaign may generate several thousand dollars, but these subjects require more advanced skills and shooting them may be considerably more stressful. To add to this, advertising jobs are harder to obtain because there are fewer of them and the competition is fierce. These are all things to consider when formulating your long-term goals. Do your research. Talk to other photographers in your specific field of interest, or consider assisting one of them to see what it's really like to do what they do. Some photographers will trade their true passion for a bigger paycheck and shoot what they really love during their free time—fine art, for example, or travel—while other photographers simply refuse to settle. If weddings are something you want to shoot, read my book *Profitable Wedding Photography* for step-by-step instructions.

Lastly, you will also want to consider how much time you want to dedicate to your photography business. While most advertising jobs will

likely be shot during the week, a wedding or event photographer must be prepared to work weekends and will usually end up spending weekdays processing, editing, retouching, designing albums, marketing, location-scouting, and meeting with clients. It can be challenging to find time for yourself.

Start by making a 1-year, 3-year, 5-year, and 10-year projected lifestyle plan and take a look at it. See how it fits into your photography business. To do this, you may need to just sit someplace quiet, close your eyes, and stare out into the ocean or some other open, unobstructed space for a few hours. Let your mind go; envision yourself and what you want your life to be like. Where are you living? Do you see yourself married with kids or single and independent? Are you comfortable with an unpredictable income or do you crave stability and routine? These are very important things to consider and they may change from year to year. They also affect your decision about the direction you may want to follow with your photography career. However, it's important to remain flexible, because life is unpredictable and the subject matter and direction of your business may change in the years to come.

Below is a list of subjects divided into three main category listings. You will notice that a majority of the topics involve photographing people. Photographing people can be the fastest cash-producing arena because people always need and want images of themselves or others. This is not to say that you can't land a job shooting products or inanimate objects (cars, jewelry, food, etc.), but such jobs are less common, especially when you're first starting your business. Even if you decide that you prefer to shoot racing boats, you will still have to sharpen your social communication skills because you'll be dealing with people one way or another.

The chart on the following page is a general blueprint of photography subjects. Each photographer's experience may vary, but this will give you a basic understanding of the kinds of subjects you may be able to shoot in relation to your skill level and the amount of income you can expect to generate.

LEVEL #1: $
Advanced beginner photographers: part-time

Easy, fast, pocket-cash-producing subjects.

- ASSISTING • HEADSHOTS • MODEL PORTFOLIOS
- FAMILY PORTRAITS • PREGNANCY • KIDS • PETS
- PERSONAL PROJECTS • BASIC ENGAGEMENT SESSIONS
- BASIC PRODUCTS • LOCAL NEWSPAPER or MAGAZINE ARTICLES • REAL ESTATE PROPERTIES

LEVEL #2: $$
Intermediate photographers: part-time or full-time

Requires more experience and a better portfolio.
Earn more money than level #1.

- PARTIES • BAR and BAT MITZVAHS
- EVENTS • PRODUCTS • STOCK
- DELUXE ENGAGEMENT SESSIONS • SMALL WEDDINGS
- SMALL BROCHURES, SIMPLE ADS, and CATALOGUES
- DELUXE PROPERTIES

LEVEL #3: $$$
Advanced, seasoned photographers: full-time

Requires advanced experience and a very polished portfolio.
Earn the most income.

- LARGE, BIG-BUDGET WEDDINGS
- DELUXE ENGAGEMENT SESSIONS • AD CAMPAIGNS
- CELEBRITY PORTRAITS • FILM STILLS • STOCK
- FINE ART and DÉCOR ART • DELUXE PROPERTIES

You will notice that as each level increases, so does the income-earning potential, the amount of time involved, the demand for more advanced technical, directorial, and production coordination skills. A single dollar sign indicates the lowest income-earning potential, while triple dollar signs signal maximum earning potential. Beware; as competition increases you will need to have a more polished presentation of your images and your business.

Reviewing the items listed in each of the three categories, you will notice that I have small weddings listed at Level #2 and larger weddings at Level #3. Contrary to popular belief, shooting weddings is not for beginners. Time and time again I hear young, inexperienced photographers talking about how they will just "start [their] businesses by shooting a few weddings on the weekends." I almost choke when I hear this, because shooting a wedding is like running an Olympic marathon. I don't know why or how people perceive this as an easy way to earn some quick cash. While shooting weddings can be absolute pure joy, and you can earn a substantially larger amount of money than you can from shooting a headshot, it is by no means an easy task. (As mentioned earlier, my book *Profitable Wedding Photography* can provide you with a step-by-step process for reducing the amount of stress an otherwise ill-prepared, inexperienced wedding photographer might endure.)

You will also notice that I have two levels for weddings, engagement sessions, and property interiors/exteriors. While a small wedding or basic engagement session should still be handled with the same amount of commitment, they require less production time and a lower skill level than a big-budget wedding with 300 guests and a demanding bride or a deluxe engagement shoot. A deluxe engagement shoot usually involves hair, makeup, wardrobe, props, and a stylized location. A big-budget wedding typically involves handling larger groups of people and being capable of creating more dynamic images on a tight time line. You might need another assistant or two in order to do this. Naturally, the income-earning potential will also vary from one to the other. In today's economic climate, engagement shoots are becoming more and more popular as couples opt out of larger, more costly weddings. Shooting an engagement session not only helps you get to know the couple better before the wedding day, it's also an excellent way to develop your production skills, increase your income, and create potential residual income. Creating stylized images might even land you a big-budget ad campaign. To learn how to create dynamic engagement images and see over 200 sample photos, read my book *The Art Of Engagement Photography*, published by Amphoto Books.

Much like engagement shoots, property interiors and exteriors can be shot at any level, but you may not be skilled enough with lighting techniques, props, and staging at Level #1. As your skills increase, so too shall your fees.

Lastly, you will see that I have listed fine art and décor art in the advanced level section. As with stock photography, you can certainly consider these subjects at the beginner and intermediate levels, but they are not necessarily easy, fast, cash-producing photography subjects. To add, the demand for these subjects is steadily declining, resulting in a surplus in supply and increasingly tougher image quality requirements. Fine art, décor art, and stock should be considered supplementary income-earning categories and should not to be relied upon exclusively as a means of supporting yourself. See chapter 18: Recycling Your Images for more information on stock and fine-art photography.

Once you have a general list of the kinds of subject matter you can and are willing to shoot, in accordance with your skill level, you can begin to focus on these subjects more precisely. The following chapters will discuss how to shoot these subjects, price your services, handle clients, create job estimates, and effectively market your business.

Notes

2

Establishing Your Legal Business
Entities, DBAs, permits, licenses, and more

"Hang your shingle" is an old expression that means to hang your business sign and open your shop. To start your business, you're not only going to need office and photo equipment; you'll also want to open a bank account and officially register your business name with the state in which you conduct your business. Every penny you deposit into a checking account needs to be accounted for when you file your taxes, or things can get very confusing and you could be operating and collecting money illegally.

To keep your personal and business funds separate, you will want to open a business checking account dedicated exclusively to your business transactions. This includes money deposited from photography jobs and check withdrawals for photography business-related bills and expenses. However, in order to open a business checking account you must present the bank with all of your official business documents (often referred to as your "Articles of Organization"). All these forms can either be filed on your own for a minimal fee through the Internal Revenue Service (at www.irs.gov) or through the secretary of state's office in your state (via an online service like www.legalzoom.com), or you can have your personal accountant handle it all for you for a slightly larger fee. However, if you plan on doing it yourself to save money, make sure you read everything carefully so that you fully understand the language, definitions, and requirements on each form in order to fill them out correctly. Once the forms have been

filed, it can take anywhere from 6–8 weeks (or sometimes longer) for you to receive all your paperwork back from the state. Be prepared; this is not something that can be done overnight.

FILING YOUR LEGAL BUSINESS DOCUMENTS

• Step 1: Registering your business name

The critical first step in setting up your business is to legally establish your business name. To do this, you will need to file a "Doing Business As" (DBA) form, otherwise known as a "Fictitious Business Statement." Registering your DBA with the state is required by law if you plan to conduct any business transactions using your legal company name. In fact, if you present your business under a name other than your proper legal name without proper notification, it may be considered fraud. Filing a DBA also allows you to legally do business for a very minimal cost (usually around $100 or so) without having to create an entirely new business entity. You can accept payments, advertise, and otherwise present yourself under the particular name you have chosen. For example, if Karen Smith does business under the name ABC Photography, she would need to file a DBA for the company name "ABC Photography." If, on the other hand, Karen Smith is a consultant or independent contractor and does not use a specific company name, then there is no need to file a DBA. Instead, she would only need to obtain a local business license. Fortunately, filing for an assumed name is so easy and inexpensive that there's really not much of an excuse for not filing one. However, a DBA does not protect your personal assets because the business entity is still a sole owner. A sole owner is liable for all civil or financial liability that the business incurs.

Before choosing your company name, however, you may wish to search the existing business names on file at the clerk-recorder's office to be assured that there is no one else operating under the same name, and then request the official forms from them. These public documents are kept on file until they expire or are abandoned.

• Step 2: Determining your business entity

The next step is to determine what kind of entity you would like your company to be. The number of partners and amount of assets that require

protection typically determine which kind of entity you should choose. Business entities include organizations such as corporations, partnerships, charities, and trusts. Business entities, just like individual persons, are subject to taxation and must file a tax return according to the laws of the state or states where they conduct business. Each entity will have different filing fees, tax levels, and tax forms. Most likely, your business entity will be either a sole proprietorship or a Limited Liability Company (LLC).

SOLE PROPRIETORSHIPS

A sole proprietorship is the simplest, most inexpensive way to start a business. Many people who decide to run a business themselves start by forming a sole proprietorship. However, a sole proprietorship does not protect your assets (such as real estate, an expensive car, a boat, or photography equipment), in the event that someone tries to sue you for posting their picture in an ad campaign without their permission, or if someone trips on one of your tripods and breaks their neck. If you lose a lawsuit, these valuable assets could be taken from you to cover the damages. While you may have liability insurance rolled in your photography equipment policy, it may be limited. If you don't have any valuable assets to protect, filing for a sole proprietorship is fine, but if you do that you will want to consider an LLC (see next paragraph).

LIMITED LIABILITY COMPANY (LLC)

If you are one person and you do have a lot of personal assets you want to protect, you will probably want to incorporate or form an LLC. Essentially, an LLC separates and protects you and your personal assets from your business dealings. Choosing an LLC will also allow you to define certain details of the structure of a partnership (should you have one). However, keep in mind that LLC filing fees are paid annually. Each state has its own fees and some states are more expensive than others. These fees are considerably higher than a sole proprietorship or DBA filing fee. A corporation, depending on the state in which you want to incorporate, or LLC may cost anywhere from $100 to as much as $800 (like here in California)! If you file a corporation or an LLC, you don't necessarily need to file a DBA. I suggest you consult your accountant or an online service

like legalzoom to determine which one suits you and your company best. You can change structure or type of entity whenever you want.

Seller's Tax Permits

A seller's permit is also called a reseller's license, wholesale license, retail license, state sales tax ID, or resale certificate (they all mean the same thing). You can apply for your seller's permits through any number of places; try www.legalzoom.com or just do a Google search for "seller's permits." There is also a website called www.Businessnameusa.com that sells them for $79: https://www.businessnameusa.com/forms/dbaform/sellers.aspx

Since photographers sell their digital files, prints, albums, and other merchandise they are required by law to obtain a seller's permit. You need this if you buy items wholesale (such as film and photo paper) and pay no tax, then mark these items up for a profit and sell them to your customers retail. Selling retail requires charging taxes because you most likely didn't pay taxes when you bought the wholesale items. Some photography stores will sell you certain items wholesale if you plan on reselling the item to your customers retail. All you have to do is present the cashier with your resale tax ID number. However, this is usually not applicable to purchasing camera equipment unless you can prove that part of your business is buying and selling cameras. In this case you would have to demonstrate that you do this and make a profit. It is doubtful you'll buy a new camera and then resell it used for more money than it could be purchased for new. However, you may purchase items such as film (or glassine envelopes for your clients' prints) and then include these items in an all-inclusive, taxable package, or sell them separately. These items should be purchased wholesale (no tax) because the law does not require that they be taxed twice (your client is already paying the tax on them).

Note: If your business is located in MI, GA, NV, MD, IL, or NY, you are required to obtain a federal tax ID before you can obtain a seller's permit.

• Step 3: Opening a bank account

When you first decide to start your photo business, you'll want to open a bank account in your business's name. The bank will require two forms of ID (a driver's license, ID card or passport, and credit card and/or utility bill with the address of your business) as well as any and all business filing documents. This will include a Fictitious Business Statement/DBA, tax ID number, resale tax number, and your Articles of Organization. Business bank accounts have stricter regulations than personal bank accounts. For example, while your assistants can easily make deposits, obtaining cash withdrawals and writing checks will be restricted solely to the person(s) whose name(s) is/are attached to the account. Even if you are in a business partnership with someone else, I still recommend that only one person be in charge of the accounting. This makes things less complicated and it reduces the amount of potential misuse of funds.

Once you have established your legal business name, entity, and bank account, you'll feel empowered and ready to take on the world. Congratulations! You're officially "in business." You should feel proud and excited to launch your new adventure. Having all of this in place will get the ball rolling, and as you generate cash flow in and out of this bank account, your credit will begin to develop. Obtaining established credit is particularly useful later when you want to open a PayPal account or merchant account to offer your customers the convenience of paying with a credit card.

3

Start-Up Expenses

Common expenses associated with starting a photography business

THE REAL STEP TO STARTING YOUR BUSINESS IS TO INVEST IN THE necessary photography equipment, office equipment, and supplies. This is the fun part because it means you get to buy things! However, it's critical that you keep track of every receipt for every item you buy that pertains to your photography business. Not only will these receipts be used as deductions on your income taxes, a percentage of the value of these items will be factored into your job estimate formulas (see chapter 11: Pricing Your Services for Profits). If you have already purchased an item and no longer have the receipt, you will have to make an estimate of its current value in order to include it in your expense item list.

Before you begin buying things, you will want to create an expense budget. To do this, start by listing all the "must-have" items—the things you absolutely "need" to start your business (see a sample list of items below). Then you can create a wish list of all the other items you "want" later (when and if your pocketbook allows). It's imperative that you differentiate between "want" and "need." After you've made your expense list, you may find you simply don't have enough money to buy everything you need; in this case you may want to consider getting a loan from your bank, a friend, or a family member. The good news is that you will already have an itemized list, so you'll be one step ahead. For more info on loans and money management see chapter 5: Funding and Managing Your Business.

PHOTOGRAPHY EQUIPMENT

Your photography equipment investment is probably going to be one of your largest but most important purchases. Before you buy your camera system or consider upgrading or changing to another manufacturer, do your research and make sure the camera body, lenses, and flashes (or any other gadgets) are exactly what you want and need. There are numerous websites that offer consumer reviews and ratings alongside product comparisons for price and functionality. I like www.bizrate.com, www.consumerreports.org, www.MyProductAdvisor.com, www.Buzzillions.com, etc. There is also a guy named Ken Rockwell who writes great, unbiased photography equipment reviews. Visit his website at www.kenrockwell.com.

If you have a limited budget, I encourage you to buy a camera that will allow you to grow and advance your skills. If you don't know what a certain function does, read your manual, test it, and call customer support. You just might find a new feature that's really cool and that will enable you to finally get the kind of image you've been hoping for. If you're lost as to which equipment to use, Nikon has a great variety of lenses, cameras, and flashes to choose from. I've been shooting with Nikon products for years because I like the way they feel in my hands, the way they function, and their full range of capabilities. I firmly believe they create superior equipment.

I highly advise having as many backups as possible. This means at least two camera bodies and two flashes for every shoot in case one fails, and plenty of extra fully charged batteries, digital CF cards, and film (if you shoot analogue). Take no chances. It's not a question of *if* but rather *when* something will break down on a shoot. You might consider an older or used model as a backup, but always make sure it works properly. You may also consider keeping similar lenses on hand as backup. It's important to use all your cameras and lenses from time to time to keep the parts lubricated and active so they don't harden and break. Again, these do not need to be identical, but ideally they should have similar focal ranges. I always advise photographers to try to get enough lenses to cover every perspective point, from a wide angle to a detailed close-up. While fixed focal length, prime lenses are ideal because they are slightly sharper and have a different compositional perspective as compared to a zoom lens, these lenses can be

considerably more expensive and offer you only one focal length to play with (I have several, such as my 20mm f/2.8, my 50mm f/1.8, my 85mm f/2.8, and my 105mm f/2.8). In other words, if you can't afford a bunch of different prime lenses, buy a good zoom lens for the time being with as large an aperture opening as possible. There is a visible difference between a portrait shot at f/2.8 and f/5.6. The zoom lens is the most important lens in your bag because it will cover a wide range of focal lengths and allow you to gain a variety of different images from a variety of different positions. Every photographer needs one or two (a 24mm–120mm and a 70–200mm lens are excellent starter lenses). While shooting a portrait with a 200mm lens will require you to be at a considerable distance from your subject (especially if you're shooting headshots), at least you will have a portrait lens to get the shot your client wants if your other lens dies. The same holds true for wide-angle lenses and other equipment you find yourself using frequently. If you can't afford to buy backup gear immediately, then rent or borrow it until you can. Your reputation is at stake and it will cost you more than the rental fees when equipment fails. Be prepared. The goal is to make great images because this is how you will sell your services.

• Flashes

Having at least two flashes will not only give you a backup if one fails, it will enable you to shoot from two cameras simultaneously (allowing one to cool down and recharge in between flashes). It will also allow you to use two different cameras with different lenses and get different perspectives of the same shot quickly. With the new wireless flashes (such as Nikon's SB900), you can use several flashes synched together with a controller (such as Nikon's SU-800 wireless speedlight commander and Nikon's SU-4 wireless slave flash controller), illuminating different areas of a scene with different flashes at the same time. For example, if you're shooting a portrait, you could place one flash behind the person's head for a nice rear rim and hair light and the other flash could be positioned in the front of her head at a 45-degree angle for a beautiful side front light (commonly known as Rembrandt lighting). If you buy a miniature soft box and place it over the flash head, it will diffuse the light and spread it out more evenly. This creates a softer look and reduces the shine reflection on a person's

face otherwise caused by a raw flash. It's an awesome system and I can't imagine working with only one flash.

• Camera bags

A smaller, comfortable camera bag is imperative for your outdoor location shoots, where you want to be discreet, access your gear quickly, and shoot fast (avoiding onlookers) without looking "overly professional" (drawing the attention of local guards or police, who might demand a shoot permit). There are several types of shoulder and waist bags. I would suggest that you try them on before you buy to see what feels most natural to you. Later, after you've accumulated more gear, you may want to buy one of those roller suitcase-like bags for your larger studio or private location/permitted shoots. The roller bags will save you trips to the chiropractor and enable you to swiftly move from one location to another, as one might during a busy wedding shoot. Make sure the bag is padded really well to keep all of your gear separate. Equipment is more fragile now than ever before, so this will help reduce the amount of collision impact (and repair bills!). Companies such as Think Tank and Tamrac make an excellent variety of carrying bags and cases.

• Double the amount of photo perishables

My motto is: better to have it and not need it than to need it and not have it. Always remember to have on hand twice the amount of film, digital cards, and batteries needed for each photo shoot (I prefer smaller 2G, 4G, or 8G cards, depending on the number of images I plan on taking, as opposed to the larger 16G or 32G cards, because they download faster and if one malfunctions I don't lose as many images).

• Portable data storage

In addition to your digital cards, you will want a case to carry all of your CF cards. It should be something that allows you to insert and remove cards quickly but securely. You may also want to purchase a portable hard drive to transfer your images on location as a backup.

Locked Equipment Closet

Most photography insurance policies will require proof that you took every precaution to safeguard your photo and office equipment. It's essential that you have a secure cabinet or closet for your photo equipment. You should have a lock on this cabinet or at the very least a lock on your office door. If you opt to have your office at home, be aware that some homeowners' policies will not cover any equipment related to your home business. Much will depend on the level of use of your equipment and the number of people (clients, assistants, and crew members) entering and leaving your home office. You will most likely need separate photography insurance. There are a few insurance companies to choose from, such as Firemen's Fund, Hill & Usher, Taylor & Taylor, and Tom Pickard & Co. Because I have yet to make a claim with any insurance company, I am reluctant to recommend one company over another. Just make sure you understand all the details of your policy before signing.

Office Equipment

• **Computers**

The kind of computer you buy will most likely be defined by your budget, and as with most things, you get what you pay for. While Dell is known for making very basic, inexpensive PCs, they may not be fast enough or capable of doing what you need. You can also buy a used computer on craigslist or eBay, but again, if you have a choice I would suggest getting the fastest computer on the market. I am biased toward my Apple computers primarily because I love the way they function and interface with my iPhone, my iPad, and various other Apple products and software. They are also entertaining, fun, and creative, and they have a user-friendly operating system, numerous creative software applications, and beautiful, flat cinema display screens that allow you to present your work in a fabulous manner. Plus they're just *cool*—and for artists, who require constant stimulation, these computers make working long hours far more pleasurable. In addition, Apple computer systems are known for transmitting far fewer viruses than PCs. However, Apple computers are more expensive than most PCs, so you will need to consider all your options

and decide for yourself. Keep in mind that until you can hire others to handle every other aspect of your business aside from shooting, you will most likely spend 80 percent of your time in front of your computer and only 20 percent of the time shooting. Time is money, as I always say, and having the fastest computer will enable you to work faster and earn more money.

Get the largest display screen you can afford. This will enable you to work on several images at once and see your images full-screen without the time and hassle of scrolling back and forth to see what you're working on. I also advise you to get a high-speed Internet connection and the latest versions of image editing software programs such as Lightroom, Photoshop, Bridge, and Aperture. The objective is to be able to process, organize, edit, retouch, and deliver your images to your clients as fast as you can so that you can move on to the next customer and keep the cash flow moving. Unfortunately, as technology advances, so do the applications and programs that accompany it. Keep in mind that you will need to upgrade your computer and software every few years (or less), so make sure you factor that into your expense budget spreadsheet.

• Office data storage

The world of digital media is not foolproof. CDs and DVDs are fine for *temporary* storage, but they are *not* long-term storage solutions because they are more susceptible to corruption from a variety of known and unknown factors than hard drives are. Do not write on them or attach stickers, as many people do. The ink or sticker glue can eventually penetrate the CD material itself and corrode the data inside. *Always* store a backup of files on a minimum of two external hard drives. I *highly* advise that you back up all of your images and data. Do not risk storing your images on your computer's internal hard drive. This not only fills up your computer storage, it also slows down your computer's functionality. Moreover, it could be *very* dangerous when your computer crashes (again, it's not *if* it will crash, but *when)*. Yes, it has happened to me and yes, I lost a lot of images! I was sick about it for months afterwards. Light-weight, portable, external hard drives are ideal in the event of a natural

disaster. You can simply grab them and run. I make a habit of copying files to numerous hard drives each time I save them. You can purchase a raid system that creates and stores copies of your data simultaneously on numerous hard drives. To conserve storage space, you can save your black and white images as grayscale (not sepia toned). The file size of a noncolor image is considerably smaller than a color image because it contains a fraction of the data information. I have even gone so far as to store an entire full hard drive of my "greatest hits" offsite at my parents' house in another state, just in case there is a natural disaster at my office (after all, I do live in California, where we are prone to earthquakes and wildfires). *Be prepared*! Again, do your research on these hard drives. You may even want to consider purchasing two different brands. Like computers, these can fail, and because external hard drives also get "tired" over time, data is at risk of becoming corrupted or lost, or the drives can simply stop functioning altogether (yikes!). It is highly advisable to turn off or shut down your hard drives from time to time to let them rest and cool down. Make sure to properly eject them before doing so, to protect against data and device malfunctions. You may also want to consider transferring your data to a new drive entirely every few years, just in case.

- **Office supplies**

There are a lot of smaller office supplies that we may overlook on our start-up expense list. These are not ongoing perishables such as paper clips, stamps, and envelopes, but rather items like a calculator, pens, markers, notebooks, a bulletin board, push pins, three-ring binders, a stapler, a return address stamp, stickers, a label maker, and your time/expense job log book (see chapter 11: Pricing Your Services for Profits for more info).

- **Printers**

There are some fairly inexpensive printers on the market designed for simple printing. I have two Epson printers. One of my printers is a great, very inexpensive, multipurpose inkjet printer that has a fax, scanner, photocopier, and printer all in one. I use this for my everyday printing of documents or reference prints. While the print quality is good, the printer

only prints up to 8.5" x 11" and the prints are not long lasting, since they use inkjet. The other printer I own is a large Epson fine-art, archival-pigment dye printer. It can produce large, magnificent, fine-art, archival prints (for my client gifts or fine-art photography galleries) that will last one hundred years or more without fading. However, the ink cartridges and paper for this large printer are considerably more expensive, so I'm very selective about what I choose to print from it. I have been known to make several test prints adjusting color, contrast, and exposure. It's part of my creative process and I get a huge thrill out of seeing the magic shoot out of my very own machine! I do, however, use my local custom photo lab for my clients' standard job prints, simply because it's faster and far more cost effective, and my lab really does a fabulous job!

• **Telephone** (cell or landline)

If you don't have clear enough cell reception, you should invest in a landline and a good-quality cordless phone with the largest reception range available. There is a reason that some phones are less expensive than others. Do your research. Many phone and cable companies are now offering super-low rates for basic telephone service, so it's a minimal expense that may be well worth it. It's imperative that your client conversations are clean and clear. Lousy reception can kill a deal. Remember, again, they're giving you a *big* deposit and they need to trust that you're not a scammer who is going to run off with their money, never to be found again.

• **Fax machine**

As a professional means of reserving your services and confirming job details, a signed photography contract is one of the most important documents that will pass through your hands. You don't need to meet with your client in person to exchange contracts; they can sign and fax it to you. While a deposit and email exchange stating the details of the job can also serve as a legal form of intent for smaller jobs, I always suggest a signed contract as security, especially for larger jobs. There are various options for sending and receiving signed documents. To save yourself the cost of purchasing a separate fax machine and fax telephone line, you

can either just use your all-in-one printer/fax/copier/scanner machine (to print, sign, scan, and email important documents) or simply plug your telephone line into it whenever you are expecting to receive a faxed document. Another option is to use an online service like I do. I receive my faxes through my email. It's really easy. I purchased a very inexpensive 800 number through a company called Ring Central for about $125 a year. I use the 800 number for both my photography workshop company and my incoming faxes. Their service detects whether the call is a fax or a phone call. If it's a phone call, it rings in my office, and if it's a fax it arrives as an attachment in my email inbox. If I'm away from the office, I can also download the faxes online by logging into my account on the Ring Central website. It's a really user-intuitive system. I just love it, and I don't need to pay for an additional fax line.

• Office furniture

The most important pieces of furniture in your office will be your desk, the chair you sit in, a secure storage cabinet or closet (to lock up your expensive photo gear), and a table or couch for client meetings. You don't have to spend a fortune on office furniture at some fancy showroom. You can do what I did and buy your furniture at Ikea, or even consider looking for used furniture on craigslist. The important thing is that it doesn't look like cheap, scattered, odd bits and pieces you found in the trash. Again, your office is a direct reflection of who you are and how you operate your life and your business. Ideally, your pieces of furniture should match each other, so I would suggest a furniture set or coordinated collection over individual random pieces.

Having a sturdy, professional, uncluttered desk for your photography business is extremely important. Your desk is not only the place you will be sitting most of your day but also probably the first thing your clients will see upon stepping into your office. It should not contain anything unrelated to your photography business; you need to be able to keep your mind focused. Equally as important is a chair with good back support. This should be something you'll feel very comfortable sitting in for hours on end when you're editing and organizing your images. As your business grows you will probably have assistants working with you. Keeping

this in mind, you may want to get a larger desk that could accommodate another computer screen and office chair when the time comes. Having dual computer screens side by side makes it easier for you to oversee and approve the work that's being done.

A couch or conference table and chairs for client meetings is also important. Making others feel comfortable is the first step toward getting them to relax and trust you. Once they trust you they are far more likely to sign the contracts and give you a big deposit for the next photo job. You need to have adequate space to spread out your portfolios, contracts, and deposit slips. This is the setting for deal making and money collecting.

The next articles of furniture you may want to consider are cabinets. I like to keep my office neat and tidy, so I use cabinets to hide most of my messy reference materials. I keep my very valuable equipment in a locked storage cabinet. It's important to store your equipment in a dry, humidity-resistant place to reduce the amount of potential mold and moisture that can corrode and rust the metal and electric compartments of your devices.

Shelving is an excellent way to organize additional office equipment such as printers, stereo speakers, framed prints, and maybe even an antique camera or two. However, because your shelves are highly visible, you should put some thought into what you place on them and how you arrange these items. Keeping your office clean and tidy is a major factor in keeping your mind clean and tidy. Your environment has a large impact on your mental state.

Last but not least is a clock. If your computer doesn't have an easily visible clock for you and your clients to glance at from time to time during your client meetings, then you should have a separate one somewhere in your office. Remember: Time is money, and you don't want to lose track of time.

• Paint

Like everything else in your office, the colors of the walls will directly affect you and your clients' emotions. Research indicates that certain colors stimulate certain emotions. For example, while most people would

think that white walls would bring to mind a clean and sterile environment, statistics now reveal that four white walls can actually make people feel anxious. The color white can remind them of hospitals, mental institutions, and prisons. White can also reflect a lot of light, creating an odd glare on computer screens and glass picture frames. Soothing colors work best. While blues can be relaxing, they can also make people feel cold. Yellows, reds, and greens work well, but should all be muted down to a deeper, more relaxing shade. The last thing you want yourself, your assistants, and clients to feel is overstimulated. This creates stress. I chose a light sage green for two of my four walls and a deeper version of the same color for the other two walls. It's very nice. Having different tonal values gives the illusion of more space. Four solid and similarly colored walls make people feel trapped and closed in.

• Office lighting

While it's a known fact that a lack of sunlight can cause depression, the *wrong* kind of light can affect people's emotions just as much. Green fluorescent lighting can actually make people feel ill. When I notice fluorescent lights in someone's kitchen or a cheap restaurant, I immediately become uncomfortable. I'm fully in favor of energy-saving "green" lightbulbs; just make sure you get the warm-colored ones. Either way, the lighting should be bright enough to illuminate your portfolios and framed artwork on the walls and diffused enough to make everyone feel relaxed. Track lighting or hanging picture frame lights are best for creating a warm and inviting gallery ambiance.

• Signage

While most businesses that conduct their services on-site must be zoned for commercial business, photographers can sidestep this requirement. While we may "meet" with our clients at our home offices, we normally don't perform our "services" (shooting) there (unless you have a home studio). However, because our offices fall into a sort of gray area between commercial and noncommercial spaces and most of us have a lot of expensive photographic equipment, we don't necessarily want to

post a large sign stating ELIZABETH ETIENNE PHOTOGRAPHY in front of our homes. This could alert potential thieves or the local Better Business Bureau. Not only could you risk getting robbed and give your insurance an excuse to reject a claim, you might also find your business license revoked for operating in a noncommercial business location. Play it safe; be tactful about your signage. You might want to post a very small sign with just your name on your front door and/or office door (or none at all). Keep it professional but be discreet.

- **Business attire**

You'll need at least *one* business outfit to help you close the deal and to wear at formal shoot occasions such as a wedding or celebrity event. Many venues and coordinators will have strict dress codes, so always have at least one pair of pressed dress slacks, a pressed white shirt, polished shoes, a tie for men, and some classic but simple jewelry for women. I stress the word "pressed" because photographers are notoriously poor dressers. I had an assistant arrive the day of a wedding shoot in a shirt and slacks that looked like they had been crunched in a ball in the trunk of his car. I couldn't believe it; I had to drag out my old ironing board and make him press his clothes before the shoot! Keep in mind that what you wear says everything about how much you respect yourself, your business, and your clients. It could be one of the key factors that determines whether or not you get hired for the job or asked back to shoot another one.

MARKETING MATERIALS

There are numerous ways in which you will be able to advertise and show off your work while simultaneously promoting your other photography-related products. Why not use your office as a mini showroom by having a few samples of these items on display? It's subliminal advertising, and it might be well worth adding these items to your start-up expense list.

- **Websites**

You can hire a web designer to create a customized website for you, or simply use a ready-made site gallery template like the those offered by companies such as Photobiz, like I do. After numerous frustrating

years of feeling like a prisoner to my web programmers, I finally decided I wanted an attractive, professional-looking website that I could easily manage myself on the fly, 24 hours a day, from anywhere in the world. I don't know anything about html coding or web programming—nor do I care to learn. I just wanted something that made it as easy to add and delete images and text as it is on Facebook. I also wanted a shopping cart so that my clients could pay me immediately and purchase a range of products and services (instead of waiting for the check to arrive in the mail). Lastly, I wanted to be able to have a fast and easy way for my clients and their friends and family to view their images (password-protected if they so choose), order prints, and approve album page layouts. Photobiz offers all of these features plus about a hundred different customizable templates (both flash and html) and the most amazing tech support I have ever encountered. You get all of this for only a few hundred bucks plus a nominal monthly fee. "Incredible" is all I can say. When you do open a PhotoBiz account, make sure you include my name in the "referred by" section when signing up. For more details on websites, see chapter 16: Promoting Your Business.

• Framed image gallery

The first things your customers should see when they walk into your office are your beautiful images on the walls. After all, you are a photographer, and you certainly want to take advantage of the valuable real estate your wall space provides. A framed gallery of selected photographs is not only an attractive and impressive way to furnish your office, but an opportunity to show off your work and sell your services as well. This also plants the seed in your clients' minds for their own home gallery, and you could greatly increase your income with additional print sales this way. Since you will need to update the prints in these frames from time to time to show only your best work, the prints themselves should be listed in your ongoing monthly expenses.

• Portfolio books, business cards, envelopes, and letterheads

While some items such as your portfolio books, business cards, and letterhead may seem like they should be a part of your start-up expenses,

they will need to be updated from time to time as well. For this reason, these items should be listed in your ongoing monthly expenses instead, even if you only update them once a year; simply divide the annual cost into 12 months.

• Security doors, safes, and alarm systems

After spending all of that money to start your photography business, it would be a shame if all of that were stolen or damaged. As an added precaution—and to display to your insurance company that you are doing all that you can to protect your expensive photography gear, computer equipment, and data—you should consider investing in an alarm system, a safe, and strong deadbolt locks. If your car doesn't have an alarm system, get one, and do your best to camouflage your gear when it's inside. The alarm system expense may be both a start-up expenses as well as a monthly expense (depending on the system you install and how you make your payments), so be sure to add this expense to the necessary expense lists.

• Auto

Lastly, if you purchased or leased a specific vehicle for your business— an SUV, for example—but you also use this same car for personal use, you will need to determine what percentage of its use is related to your business and add this to your start-up expense list if the car is purchased. If on the other hand the car is leased, you will want to add this to your ongoing monthly expense list.

Notes

4

Ongoing Monthly Expenses
Common expenses associated with keeping your business going

EACH MONTH YOU WILL HAVE TO COVER REPEAT EXPENSES TO KEEP your business running. If you pay certain bills quarterly or even annually, just divide the total annual fees by 12. If you run your business from your home, you will need to determine what portion of your ongoing monthly expenses are exclusively dedicated to your photography business. Below is a list of the most common expenses you might incur. Once you have a list of your own monthly expenses you will be able to factor this percentage into your job-estimating formula (see chapter 11: Pricing Your Services for Profits). Using programs like Quicken or Microsoft Excel will help you keep track of your expenses in an organized fashion.

RENT

Whether you opt to work from your own home or rent a designated office space somewhere, you will want to include this in your list of ongoing monthly expenses. If you work from home, you will want to determine what percentage of your home is used for work and treat that percentage of your rent or mortgage as a business-related monthly expense. If you own your home outright or have free office space, you will not need to include this in your expense column.

• Employees

As your business grows, you may find that you simply can't handle it all and would like to employ others to do specific tasks on a regular, salaried basis. These employees might include a daily assistant (to handle your bill paying, errand running, minor client relations, and other miscellaneous tasks), an accountant, a digital image technician (to process, edit, and retouch each job), and an album book designer. However, unless these people are regular employees, they should be considered freelance, independent contractors, and therefore should not be included with your ongoing monthly expenses. Instead, they would be listed as part of a specific job expense.

• Utilities

Your utility expenses might include: water, electric, gas, cable, telephone, cell phone, etc. Again, if you work from home, you will need to determine what percentage of certain bills should be considered business expenses. In other words, if you live in a 2,000-square-foot home and the amount of space you use for your office is 500 square feet, then you would treat 25 percent of any expenses that go into making your home livable such as gas, electric, and cable as business expenses. If you use your cell phone for both work and personal calls, you will need to determine which percentage is for what. However, there may be some expenses that are 100 percent business-related, such as your photography insurance. You will need to look at these items closely.

• Photography insurance

Some insurance companies are reluctant to offer you a homeowner's or a renter's insurance policy if you run your business out of your home and clients and assistants frequently come and go. However, there are several companies that specialize in photographer's insurance (see the reference index at the back of this book for a list of these insurance companies). These specialty companies offer policies that can cover everything from your camera equipment, computers, hard drives, and image library (data) to liability and illness. Make sure you fully understand every detail of your policy and don't be shy to ask the most seemingly obvious questions. If

you don't understand something, ask to have it revised in layman's terms so that there is no confusion later. Some insurance companies intentionally make their policies vague so the interpretation is to their benefit later when it comes to settling a claim. Make sure your policy covers traveling in and out of the country and things of this nature. You want to make sure you and your equipment are covered while you're shooting in the jungles of South America, traveling to and from a location, and while the equipment is locked in your car.

Liability coverage is also advised. This will cover any liability claims should someone trip over your tripod or fall down a flight of stairs while you are positioning them for a photo. Many commercially owned properties (such as hotels, conference centers, night clubs, restaurants, etc.) require that a photographer present proof of liability coverage insurance to indemnify them against any injuries caused by you while working on their premises. It's imperative that you clarify any vague terms in your policy, such as "policy holder must take all precautions to protect his or her equipment." What exactly do they consider "precautions to protect [your] equipment"? Ask them to define it specifically. The insurance company may ask you about the security of your office or wherever your equipment is stored. You may be required to have deadbolt locks and an alarm system to be considered to be "protecting your gear." If the insurance agent has to explain it verbally, make sure you have this very specific explanation detailed in your insurance policy so that, again, there are no misinterpretations later.

You can check insurance company ratings and reviews by just doing a search on the Internet under that subject matter. Ask other photographers you know or check the numerous support groups for referrals before signing any contracts with any company. Make sure there are no pending lawsuits against the company and that they are 100 percent reputable.

• Office supplies
DVDs, paperclips, staples, paper, ink cartridges, file folders, Sharpies, rubber bands, and anything else expendable and perishable should be considered an expense. While these expenses may vary from month to month depending on usage, after a few months you will begin to see a

pattern and you'll be able to make a rough estimate. It'll probably be between $20 and $50 a month. When estimating variable expenses, I aim for a higher amount rather than a lower amount just to be on the safe side.

• Business forms

There are numerous forms you should have in place in order to run your business in an organized and legal fashion. These include estimates, contracts, invoices, model release forms, property release forms, and pet release forms (if your contract doesn't include certain image use parameters). Whenever you use one of these forms you will want to keep the original for yourself and give a copy to your clients. To do this, you can either make a photocopy on your all-in-one copy machine or have carbonated copies preprinted at Staples or Kinko's FedEx. For samples of these documents, see chapter 6: Invoices, Contracts, Estimates, and Releases.

• Business cards, letterhead, thank-you note cards, and envelopes

Do not try to make your own business cards. Have them printed professionally. There is nothing that screams, "I'm poor because no one hires me because my work isn't good" more than a self-printed business card. *Ugh!* I see this all the time with struggling entrepreneurs, and it simply tells the world they're not really ready or committed to taking themselves or their profession seriously. Please don't do it! Borrow the money if you have to, but this is one minor investment you must not overlook. If you elect to use one of those online companies, make sure to see their ratings first. From my experience, you usually get what you pay for. I had to return two print orders from a major online printer because the quality was absolutely garbage. While they were ethical enough to refund my money, I lost precious time uploading my files and making trips to the post office to return the orders. As I always say, time is money, and these cheap printers actually ended up costing me money in the end. I did find one online printer whose quality was very good, and I found a very reasonable local printer in my area that did a fabulous job as well (and I didn't even have to leave home to place my order). I simply sent them the print files and

then they sent me back the cards (see my resources page for recommended printers and photo labs). I suggest that you order the smallest quantity of cards when you place your first print order. This will allow you not only to inspect the print quality but also to change any contact information and design/layout issues without losing much money.

• UPS mailbox

For added security, I would suggest that you not post your physical home address anywhere. I don't. The only people that know where I live are select friends, family, prescreened assistants, and prescreened clients. Why? Because we photographers have a lot of expensive equipment and we don't want to give potential thieves or stalkers our home addresses. If you get a mailbox at a UPS center, your mailing address will simply be the address of the UPS center along with a box or suite number. This is different than a post office box where your address is P.O. Box 134556, or what have you. Not only does having a standard street address make you look more professional to your clients, the UPS center will pick up all your FedEx and box deliveries for you (FedEx won't deliver boxes to a P.O. address). No more worrying about making sure you're at home to sign for your packages or having your valuable boxes left outside your door to be rained on or stolen. Having a separate address is also a great way to avoid anonymous, unscheduled drop-ins from unexpected admirers on a Sunday when you're lounging around in your pajamas watching TV. A separate mailing center offers great privacy and security.

• Advertising

Website hosting and maintenance, Facebook banner ads, promo mailers, and anything else you use to promote your business is considered a business expense and should be included in your monthly expense list. While some items such as your portfolio books, business cards, letterhead, and gallery prints may seem like they should be a part of your startup expenses, they will need to be updated from time to time as well. Therefore, they should be listed as ongoing monthly expenses, even if you only update them once a year (simply divide the annual cost by 12). This is a

crucial part of keeping you and your business fresh. For more information and ideas for advertising, see chapter 16: Promoting Your Business.

• Automobile

You will need to determine what percentage of your gas, mileage, parking, valet, car washes, repairs, licenses, registration, insurance, and car payments are dedicated to your business. Typically, if you find yourself using your car approximately 50 percent of the time for business-related activities (location scouting, driving to and from labs, camera stores, or prop shops, etc.), then you should factor 50 percent of your total monthly auto expenses into this category.

• Cleaning and office maintenance

A clean office space is a clean mind. A clean mind enables you to multi-task, stay focused, and accomplish more things. Accomplishing more things means booking more jobs and making more money—the keys to a successful photography business. I just work better and feel better when my office is clean. I am referring not only to keeping it tidy and organized but also to keeping it dirt-free by vacuuming and dusting. Controlling the level of dust reduces the amount of buildup on my printers, photo equipment, and computer fans. This means fewer repairs, replacements, and hassles. I like to have my office professionally cleaned once a week. My cleaning lady comes on Saturdays, when I'm usually away shooting on location. This way I get to start the week off on Monday with a clean office, and this makes me feel good.

• Photography and office equipment repairs and upgrades

It seems every few months I have to repair, replace, or upgrade my photography equipment, office equipment, or computer software programs. These can be anything from some inexpensive items like a flash soft box, lens cap, or computer program to larger items like a camera, printer, or hard drive. I have now calculated that I must dedicate approximately 10 percent of my annual income to these items. You will be able to determine what percentage you will need as well, but I would suggest starting at 5 percent and dividing that dollar amount by 12 months.

Your ongoing monthly expenses may vary from month to month and will need to be reviewed from time to time, but you will at least gain an understanding of the percentage of the amount of expenses you will need to factor into your estimating formula to create your job bids. Knowing your expenses will give you a blueprint of your potential profit margins and enable you to see how and where you might need to adjust the amount of money you spend on certain items in order to increase your annual income. This is the core foundation of a profitable photography business.

5

Funding and Managing Your Business
Working with investors, banks, and credit cards

When you get serious about starting your photography business, you're going to need some investment cash to buy the basic essentials if you don't already have them. If you don't have a savings account, some secret stash, or a trust fund, you'll need to find another way to finance your start-up expense costs. This might involve charging them to your credit cards or getting a loan from a family member, a friend, or your bank.

The most effective way to convince a bank or a personal lender to give you a business loan is to confirm that you are a low-risk investment. To do this, you may need to convince them that you have a sound business idea and good credit, and in some cases provide some material collateral (such as the title to your car, your boat, or your home) in the event that you default on your loan. There are pros and cons to borrowing money from either of these sources, so consider all of them before making your decisions.

Personal Lenders

Borrowing from a friend, family member, or acquaintance might seem ideal because they might offer you some flexibility in your pay schedule, payment amount, and interest rates. You might even be able to negotiate a lengthy grace period and pay no interest at all! A grace period is a time during which you do not have to make payments, so you can gain financial momentum while your business is getting off the ground. The biggest

advantage of borrowing from a personal contact might be that you both get to witness and perhaps even participate in your success!

However, getting a loan from a friend can place pressure on the relationship should you not be able to adhere to the agreed arrangement and default on your payments. Your personal relationship could be damaged forever and you may never again be able to lean on this person in your time of need, should a bank or credit card turn you down, for example. If you have to choose between paying off your credit cards or your personal business loans, choose the personal business loans. One cannot put a price on these personal relationships. They are worth more than the 20 credit cards you have in your wallet. These are all things to consider when deciding which avenue to take to fund your business. There is simply nothing more insulting to a wealthy person than someone treating their loan like a grant or gift and "assuming" the money they "loaned" you is petty cash in comparison to the billions they have in their bank accounts. The assumption that a wealthy investor will likely forget about the loan and turn a blind eye to any payback is every wealthy person's greatest fear. It's not the money they need, but rather the respect that you show them by honoring their grand gesture of kindness and faith. After all they showed you deep respect by believing in your dream. You owe it to them to do the same in return. If you honor this agreement, making consistent payments every month as agreed (without him or her ever asking you first), your investor will feel more appreciated and may even decide to become a partner in your business and forfeit the remaining balance owed as their investment in your company! Either way, he or she may be someone you might be able to approach again for a second loan to expand your business down the road. It's all about creating a mutually trusting and respectful relationship.

When approaching a personal contact for a loan, it is crucial that you put yourself in the other person's shoes and think about what you would want from someone if they were approaching *you* for a loan. Present your idea in the most professional manner possible. Most people assume asking a personal contact for a loan can be casual since you already have an established relationship with this person. This is anything but true. Treating a

personal lender with any less professionalism than you would the president of your bank is a sign of disrespect and arrogance. Anyone willing to take your business idea seriously is doing so because they care about you and want to be a part of the thrill of your success. They also want you to respect them as much as you respect the money they are lending you. There is no better feeling in the world than the ability to help someone rise to their full potential and knowing you were the one that made it possible.

When you present your personal lender with your business plan, let him or her know first how honored you are that he or she would even consider investing in you and your idea and how much you value your relationship. This is imperative. Do not take the gesture for granted, even if it's your billionaire uncle or parents who have footed the bill a thousand times for a variety of your life's expenses. Schedule a professional meeting, dress like a businessperson, and present him or her with a professional business proposal. Not only will your grandfather be super impressed with your professional presentation (and find it endearing), creating this proposal will be one of the most powerful things you can do to get yourself mentally and physically prepared for your big venture. It should help you define what you will need and create a financial forecast for your future. Should the family member or friend you're approaching turn you down for whatever reason, you will be ready to present to the next potential investor. You'll be sending the message out to the universe that you're "expecting" to receive the money, and the "expecting" space is a powerful space to be in. (See chapter 10: Dialing Into the Success Frequency.)

ASK for more money than you think you need. This may sound crazy, but it gives you a cushion and a space for negotiation. I say ask for twice as much. The lender may offer to give you half and say, "Let's see what you can do with that first." If this is the case at least you will have enough to get started. However, if you're lucky and get twice what you think you need, you will undoubtedly use all of it—no, not on nights out binge drinking at the bar, but rather on other unexpected expenses that will most likely pop up. To do this, cushion each category with a bit more expense than you think you need and don't forget to create a miscellaneous category.

CREDIT CARDS

Another option is to use your existing credit cards, if you don't have to finance that much money and can foresee being able to pay off each month without paying hefty finance charges. See if you can find a credit card with a low interest rate. If you already have some credit card debt, try to find a 0 percent interest balance transfer offer and transfer your higher interest balances to this card to buy you more time. These special offers usually give you 3–12 months to pay them off with no interest. However, read the fine print in the contract. If you're late or fail to pay it off completely during this time period, your balance might be subject to hefty fines or very high percentage rates. Just follow the rules and you'll be OK. The goal is to pay the least amount of interest to finance your new business. If you don't have a credit card yet, it's imperative that you get one. I know many people who fear credit cards. They don't trust themselves and are scared they will just end up spending money they don't have and get themselves further and further into debt. This is certainly a legitimate and healthy fear, but having a credit card is about more than borrowing money; it's also a critical means of establishing your credit, which is imperative should you want to buy or lease a car, home, apartment, or anything that requires proof of your credit. The better your credit is, the lower the risk you appear to lenders, and this usually translates into lower interest rates on loans and credit cards. It all makes sense.

The easiest way to get your first credit card is usually through your own bank. Once you've opened a bank account (even a personal one) at a particular bank, you will begin establishing your credit. This will happen over time as a result of your depositing checks and cash and withdrawing funds to pay bills and such each month. Within a short period of time, the bank will see that you are a trusted customer and that you are capable of managing your own money. They may then offer you a credit card from their bank, but it will most likely have a very small spending limit such as $500 and very high interest rates (can be as high as 29 percent!). This spending limit will increase over time as they come to trust you more, and eventually you may have a limit as high as $20,000 or more! The way you gain your bank's trust is by spending on the credit card they gave you and then making payments on that account (ideally in full) each month

when your bills are due. Credit cards and banks make a lot of money on credit cards because if you don't pay them off entirely each month they will charge you interest charges. If you're late in making a payment, they will charge you a penalty fee on top of the interest charges.

If you cannot get a credit card from your bank—or if you don't even have a bank account yet—your last option is to get your parents, a partner, a lover, or a friend to allow you to be a second cardholder on *their* account. Commit to only using the card for small charges once a month and then paying them back immediately. Charging to the card that has your name on it will slowly get your name in the system, and from there it will start to reach the credit bureaus. This will start the process of slowly developing your own credit history. It's sort of like piggybacking on someone else's account. If he or she pays his or her bills on time and in full, this will help expedite your own credit even faster. It's a great system.

A person's credit score determines whether he or she has "good credit" or "bad credit." A credit score is a numerical expression based on a statistical analysis of a person's credit files, to represent the creditworthiness of that person. A credit score is primarily based on credit report information typically sourced from credit bureaus. These bureaus accumulate this information over time through the history of your financial activities. The higher the credit score number, the better credit you have and the lower risk you are to anyone lending you money or allowing you to finance or lease something. Raising your credit score takes time. To do this you need to prove that you can charge on your credit card and then pay it back either in full or within a short period of time. This is why it's so important to have a credit card, make some charges, and pay it off. If you're a bit nervous about charging and don't have good money management skills, as was my case when I got my first credit card, then follow this system a while until you get the hang of it: Only use your credit card for business-related purchases that you simply must make in order to turn out a saleable product and sell your services. It's the easiest form of self-discipline. When you are about to pay for your purchase, let's say a new camera, a lens, or a photo application, get out your checkbook ledger and see whether you have enough money in your bank account for this purchase. If so, be prepared to write a check. However, instead of writing

it to the store where you will purchase the new equipment, you will write the check to your credit card company for the same amount and give the cashier your credit card. Keep a stash of stamped envelopes addressed to your credit card company on hand (you can store them in you car's glove box, your purse, backpack, or any other convenient and accessible place). When you leave the store, find the nearest post office box and drop the envelope into the mail. It's that easy. Not only will you be paying off your credit cards in full and ahead of time, you will begin to establish "credit"—*good* credit. Following this system over time will show your lenders you're very reliable, and they will then increase your credit limit as a result. They assume that, as your limits expand, you will want to charge more and more so that eventually you won't always be able to make your payments in full; then they will be able to charge you interest and finally make money off of you. Get it? It's kind of like a game. The goal is not to let them win and to keep making your payments in full and on time. Never skip a payment or be late on a payment because this will cause your credit score to plummet to the ground, and when it hits rock bottom your lending companies will yank the plug and eventually cut off your credit cards. If you're having a difficult month and can't pay off the card in full, whatever you do, at the very least, make the minimum payment. If this means borrowing the money from your neighbor, do so. This is critical to maintaining your credit.

BANKS

Bank loans are usually the most costly and sometimes the most difficult to obtain. Interest rates have soared and even people with the best credit, a solid job, and collateral behind them are being rejected for loans. However, if you cannot obtain a loan from a personal lender and you do not want to finance everything using your credit cards because the interest rates are still too high and you need a considerable amount of money, a bank loan may be your last option. You should approach your own bank first. If you have established a relationship with them, they may be more willing to offer you a loan. Be prepared when you approach them. As with all business meetings, you want to dress the part and have all of your

paperwork organized and ready to be presented. Most banks will require a copy of your tax returns from the last few years (to see how much money you earn) and a list of any assets they could use as collateral. They may ask for a copy of the title to your car, boat, or home. You will then be asked to fill out an application, and they will discuss the rates and terms with you. Most often, the interest rates are set and there is little or no negotiation; however, you may ask for revisions for the payback time (3 years, 5 years, etc.), but this will most likely mean higher interest rates and monthly payments. Should you default on your bank loan payments, the bank will then have the right to seize your assets and take ownership of them in order to recoup their losses. Yikes! All things to think about.

PREPARING A PROFESSIONAL BUSINESS PLAN

Regardless of whom you choose to borrow money from, you should prepare an extensive business plan before approaching anyone for a loan. When doing this you need to think from the lender's position, not the borrower's position. Below is an example of a business plan. You may use this as a template to revise and create your own. Having a business plan in place may give you even more ideas you hadn't previously considered and set the tone for expansion down the road.

There should be three parts to your business proposal. The first is the sales pitch for your amazing idea, and the second part is the list of how and where the loan money will be spent. Part 1 will include four categories: a business description, market analysis, revenue-generating products and services, and your profits forecast. Part 2 should include two categories: start-up expenses and ongoing expenses. Part 3 will be your contract.

There are two ways you can prepare your business plan. One can be a simple version that includes just your start-up and ongoing expenses and a brief general advertising plan. The other version can be more detailed and might include detailed market analysis, statistics, fees, financial-earning-potential profits, and so forth. This will most likely depend on the amount of money you will be asking for and the extent to which you will want to develop and expand your business. Either way you will want to keep your business plan organized and precise. It's important for you to consider the

5 W's: the Who, What, Where, When, and Why that make your business plan a good one.

WHO is your target audience, client, or customer?

WHAT are you selling them specifically? List all the types of photographic products and services you might offer your customers.

WHY is your particular service or product better than anyone else's? (I.e., what makes you unique?)

WHERE will you market your service or product, and how?

WHEN would you like to open your business?

PART 1

• Business Description

This should be a brief, enticing paragraph describing your business, how it will operate, the region you will service, and any features that make your company unique from others offering the same or similar services.

• Market Analysis

Researching the current market for your product or service is critical. You might want to show the supply versus demand of your particular business (including statistics, consumer surveys, and success stories) in your particular town or region. Including the sources in which you found this credible information is also helpful; this way, the lender doesn't assume it's fabricated.

• Revenue-Generating Products and Services

Become a one-stop shop. There are endless product applications for your images, from album books, coffee mugs, and calendars to online slideshows, greeting cards, and gift items. Create a list of à la carte products and services you could offer—especially during your off season—that might increase your income. Think outside the box.

• Profits Forecast

How much do you predict your business will earn in the first, and third years? How about a long-term goal prospectus? While this may seem

difficult to assess at first, I suggest you aim toward the lower side—so that you're not setting unrealistic goals for yourself and creating more pressure to pay back the loan faster—but not so low that your investor loses faith in your business idea. To estimate your earning potential, you need to look at how much you're earning now from your photo business and the number of potential marketing contacts and platforms you have and formulate a hypothesis. You might also try to predict the direction your industry might go based on current data. Do your research.

PART 2

• Start-Up Expenses

This section should detail the main items you will need to start your business and their current costs. These may include everything from your camera gear to your computers and office furniture. I suggest you include options for first choice and second choice items (such as the dream camera you want to have one day and the camera you're willing to work with right now to get the job done and start generating some cash flow). The same might be said of computers, office furniture, and any other expense that has variable cost ranges. This will give some cushion to your loan so that, as mentioned previously, you will still be able to start your business and make some compromises if your lender doesn't want to give you the full amount you're asking to borrow (which should cover the cost of your first-choice items). For more info and details on start-up items, you may refer to chapter 3: Start-Up Expenses.

• Ongoing Expenses

This section should detail your monthly expenses. Advertising and marketing will most likely absorb at least 25 percent of your total monthly expenditure, so you will want to go into detail as to where and how you plan on advertising. While Facebook, YouTube, Twitter, and other social networking sites are excellent places to promote your business for free, you may want to take it up a notch and consider paid advertising after researching the best and most reputable outlets. Many social media platforms now offer paid ads for added exposure. For more info and details on

start-up items, you may refer to chapter 4: Ongoing Monthly Expenses. For more information on marketing, you may refer to chapter 16: Promoting Your Business.

Part 3

• Loan Contract

The loan contract should include the date you receive the money, the grace period (if you have this option, this is the time duration you are permitted to get your business up and running before you have to start making loan payments), the monthly loan schedule, and the loan dollar amount (including interest). If possible, I suggest requesting a 1-year grace period from the date you receive funding. It's the perfect time allotment; it will take the heat off and allow you to focus primarily on creating revenue and profits. These kinds of terms may only be available to you from a personal lender. Lending institutions will probably have their own rules that you must adhere to.

Money Management

Once you receive your loan money, how you manage it is critical. Resist the temptation to spend the money on anything other than your business expenses and the salary you pay yourself. I hate to state the obvious: Spend the money conservatively and wisely. Buy only what you *need*, not what you want (yes, there is a difference—sorry!). This will take some self-discipline, but it can be done. Following my credit card charging system explained above, should you for some reason not be able to pay back your credit cards in full, there are two things you can do. The first thing to do is to call your credit card company and inquire about the possibility of getting a lower interest rate. The goal is to get the interest rate down as low as they are willing to go. I have one card with 1.9 percent, another with 3.9 percent, and another with 11.9 percent. I typically do not use the one with the highest interest rate, for obvious reasons. Some credit cards companies will pick up on this if they don't see any activity on your account and then contact you and offer to lower it. They want your business badly, and they

know that they have competition. They want you to charge on their card until you eventually default on a payment, because this means they will make money from you at some point. However, if you happen to have debt on this high-interest card, you need to call them and request a reduction of your interest rate immediately! Most people are unaware of the fact that *interest rates are negotiable*! I always ask to speak to a supervisor and let them know that I really want to pay off the balance and continue using the card, but if they don't lower the interest rate, I will take my business elsewhere by simply using one of my other lower-interest cards. Sometimes this is an incentive for them because they want to keep you as their customer (so that they can make money on the interest from you), other times they won't budge. If they refuse to budge, then threaten to cancel the card (and do) and cut it in half. This *doesn't* mean you *don't* have to pay off the remaining balance, it just means that you will no longer charge on this card and they have therefore lost you as their customer. If they are still unwilling to lower the interest rate, you can even call their bluff and let them know that you may have to file bankruptcy because you're in so much debt that their high rate is pushing you over the edge. Stress the fact that if you file bankruptcy they won't see a penny, and they know it. This usually gets them motivated because they would rather have *some* money from you than no money at all. Suddenly the customer service rep will put you on hold, talk to a supervisor, and then come back with a better offer. It's a nice thing. When I discovered that the interest for one of my business credit cards, unbeknownst to me, had soared from 7.9 percent to 24.9 percent, I was beyond furious! It's one of the sneaky things that credit card companies do without notifying you. I phoned them immediately and threatened not only to cut the card in half and close my account, but to let everyone else know about this credit card company through my business books and workshops. They immediately lowered my interest to 5.5 percent! I told them I also wanted this to apply to any outstanding balance I currently had on my account. I was so proud of myself for taking action, I felt like going on a spending spree! (Just kidding . . . wink, wink.)

The second, equally if not more effective option for managing your money is to do a no-interest balance transfer. The goal is to stop paying the hefty interest fees every month and buy yourself some time to exhale

while you're growing your business. It simply involves transferring the big balances from one higher-interest card to a lower-interest or zero-interest card. This might be a card you currently hold in your wallet, or it might require that you open a new credit card altogether. I admit to having done this numerous times in my 25-year business career, and it's been a lifesaver. It's sort of a money management game one plays, but it can save you a lot of money in the long run and help prevent you from drowning in the debt whirlpool. Most companies will give you a 6-month, no-interest offer, and if you're lucky you will find a 12-month offer! (Those are really awesome.) However, a cautionary word of warning: Keep in mind that the companies that offer these special arrangements are once again hoping to make money from you at some point when you default on your payments or use their credit card for purchases (at a much higher interest rate, of course). The default penalties can be very high because they are taking a huge risk financing your money for a lengthy period of time. They are betting against the odds that you will not pay off the balance and they will penalize you strongly for this and make a nice profit from you. Each company will have their own rules and regulations and some of them are kind of tricky. Read the fine print and ask questions. If the deal is too good to be true, there's probably a reason. As part of the deal, their contract may include certain conditions, like the condition that if you default on one payment the deal is off and your interest rate on the remaining balance will revert instantly to 29.9 percent! Another condition might be that if you fail to pay off the entire balance in full by the due date, your entire balance transfer amount (not just the remaining balance) may be subject to the 29.9 percent interest! Yikes . . . checkmate! Now they've got you cornered and you're in more debt than before you transferred your balance to them. While not every company may include these conditions in your contract, it's imperative that you clarify the conditions of your arrangement. There are some fair offers out there if you do some research.

The best way to find a no-interest transfer offer is to first inquire with your existing credit card companies. It sounds crazy, but sometimes the best offers will come from your same 11.9 percent interest credit card company, especially if you haven't had any activity on your account in some time. They want you to start thinking about their company again

and using their credit card. The same company may require that you open a brand new account with a different credit card. Now you are their customer not once, but twice!

The best way to win the balance transfer game and make sure you pay little or no interest is to cut the new credit card in half and throw it away as soon as you receive it in the mail. You do not want to accidentally start charging on this card and mix up the balance-transfer interest rate with the new-balance interest rate (these rates could be substantially different). Having too many credit cards to worry about can create stress and confusion. I recommend simply having one credit card for charging and another account for your balance transfers, if needed. The only reason to have more than one credit card in your wallet is for emergency purposes, in the event that your first credit card is declined, for whatever reason, and you need access to another line of credit.

Lastly, to be on the safe side, take the entire balance transfer amount and divide it into 11 months (if you have 12 months to pay it off) or 5 months (if you only have 6 months to pay it off). Know the amount you must pay each month and then pay it off in full one month before the offer is due to expire. For example, if you transferred $5,500 to a 12-month balance-transfer credit card, then you need to pay at least $500 a month for the following 11 months. If you can pay a bit more one month, do so; the important thing is that you know what you must pay in order to avoid any interest and penalties. If you can't pay it all off in time, hopefully you will only have to pay interest on the remaining balance, and—hopefully—that won't be much. This is the money game. It's just about moving money around from one place to another. Millionaires and billionaires do it all the time, and you can too if you have to.

ETIENNE
PHOTOGRAPHY
578 Washington blvd #372
Marina del rey, CA 90292
310.578.6440/800.971.3042
www.eephoto.com
Email: info@eephoto.com

INVOICE

CLIENT: Colin Cowie Lifestyle
566 Broadway, Suite 705
New York, NY 10012

DATE: 8/28/11

JOB DESCRIPTION: Location stills and guest arrivals. Approx 2-3 hour's time.
Boulevard3
6523 W Sunset Blvd
Los Angeles, CA. 90028-7201
Event starts at 9:00PM

PHOTOGRAPHER'S FEE: $750

ASSISTANTS FEES:

DIGITAL FILE PROCESSING FEE:

RETOUCHING FEES:

PRINTS:

ADD'L RENTAL EQUIPT:

ADD'L PREPARATION:

TRANSPORTATION COSTS:

(agreed) _____
Client signature

(agreed) _____
Photographer's signature

A 50% NON-REFUNDABLE DEPOSIT IS
BALANCE IS DUE ON SCHEDULED SH
CLIENT WILL RECEIVE ALL RECEIPTS

Elizabeth Etienne Photography
578 Washington blvd. #372 Marina del Rey, CA 90292
tel: 310.578.6440 fax: 800-971-3042

Wedding, Event & Session Contract

Bride/Client's name: _____ SHOOT DATE _____
Tel: H) _____ W) _____ cell) _____ E-mail: _____
Groom's/Clients name: _____
Tel: H) _____ W) _____ cell) _____ E-mail: _____
Mailing Address: _____ City: _____ Zip: _____
Coordinator's name: _____ Tel: W) _____ cell) _____
Ceremony or Event address & directions: _____
Reception address & directions: _____
Price Package: _____
Add'l Services or Substitutions: _____
Total w/8.795 tax _____ 50% Retainer Deposit _____ Balance: _____

Retainer Deposit
A 50% retainer fee is due upon agreement of this contract. Retainer deposit is non-refundable, guarantees availability of photographer on the date and time specified and covers damages for lost wages for the remaining balance should the wedding be postponed or cancelled. Event cancellation notification is due no later than 30 days prior to scheduled event date and balance is due no later than 2 weeks before event date. A polite reminder notice will be sent out a few weeks before the wedding date. Balance checks may be mailed to the address above.

Print & Album Delivery
Prints & digital files will be ready for pick-up/delivery 10-14 days after event date depending on the quantity of custom retouched images. Allow 4-6 weeks after reprint order has been placed for final albums and enlargements. Client is responsible for choosing and ordering all package print & album orders within 3 months after receiving original proof prints.

30 min. Guest Meal Intermission
Photographer & assistant(s) will be entitled a 30 min. intermission period in which they will be granted "guest" meals.

Overtime & Additional film
Photographer will alert client prior to any potential overtime or add'l film costs.

Disclaimer
Photographer will be supplied with a detailed time line, (similar to "Sample Time line" on eephoto web site), directions & maps to and from all locations as well as all necessary contact telephone numbers. Photographer's arrival short time is agreed upon and should be strictly adhered to by both parties. Photographer cannot be held responsible for quality of service due to a delay in this schedule by bridal party's negligence or absence of a professional event production coordinator. Photographer will do the best to ensure...
film/digital file is handled with the utmost care and profes...
her control for theft, loss, accidents, negligence, damage, or...
Elizabeth Etienne is unable to perform her duties on your w...
qualified Etienne Associate Photographer will shoot your wed...
will be refunded back to you.

Client: Name & Signature

Photographer: Name & Signature

Elizabeth Etienne Photography
578 Washington blvd. #372 Marina del Rey, CA 90292
tel: 310.578.6440 fax: 800.971.3042

JOB ESTIMATE/CONTRACT

Client: Rebecca Smith Interior Design Date: 6-22-07

Project reference: Karen Larose residence

Photographer's Fee: $_____ per day x 3 days + = $
Includes: lighting & camera equipment, any add'l travel, two photo assistants, and post production editing & digital file preparation, processing, color adjusting, retouching, and file making for print portfolios and website use. Client will receive all images will be burned to a DVD.

Project Description & Details:
Note: SOUTH SIDE ROOMS should be shot early morning.
NORTH SIDE ROOMS should be shot Late afternoon

MAIN FLOOR: SOUTH rooms: morning
1 - GUEST BEDROOM - 1 photo (futon w/wood Tibetan style bed).
3 - SMALL SITTING ROOM - 3 photos (one wide, two close ups: left, right side)

MAIN FLOOR: morning OR afternoon
2 - DINING ROOM: 2 photos: one vertical, (to show light fixture; say), one horizontal to show other main elements
4 - FOYER: 2 photos, different angles (shoot up staircase, shooting down) feature elaborate light fixture!

MAIN FLOOR: NORTH rooms: afternoon
5 - LIVING ROOM: 2 photos: one wide, one close up detail. Needs props! plants, flowers, books??? (see Pottery barn catalogue?)
6 - KITCHEN: 2 photos: close up ceramic pieces, full kitchen image?)

UPSTAIRS: NORTH rooms: afternoon
7 - MASTER BEDROOM: 2 photos: (one showing bed, one detail: showing feature artwork on wall w/ light picture)
8 - MASTER BEDROOM SITING AREA: 1-2 photos: showing furniture details
9 - MASTER BATH??? 1 shot, prepped with: wine glass and jacuzzi tub full with bubbles???

UPSTAIRS SOUTH WEST/EAST ROOMS: morning
11 - GUEST BEDROOM: (white, blue, green), 1 photo

UPSTAIRS: WEST rooms: morning OR afternoon
12 - guest bedroom#2: (mustard, burgundy), 1 photo

EXTERIOR: 2 photos: inc. courtyard, rear patio (w/ fountain)

Client: Name & Signature

Photographer: Name & Signature

A 50%, non-refundable deposit is required to reserve
commencement of photo session.

ELIZABETH ETIENNE PHOTOGRAPHY Date: _____ Ref: _____
578 Washington blvd #372 Marina del Rey, CA 90292
www.etiennephoto.com/www.eephoto.com
tel: 310.578.6440 fax: 310.578.6788

MODEL RELEASE

Model's Name: _____
Address: _____
Model's Phone: _____
Model's Email: _____ Age: _____ Ethnicity: _____

Shoot Date: _____ Shoot reference: _____
Shoot description: _____

MODEL'S PERMISSION AND RIGHTS GRANTED:

For good and valuable Consideration of Elizabeth Etienne, herein acknowledged as received, and by signing this release I hereby give the Artist and Assigns my permission to license the Images and to use the Images in any Media for any purpose (except pornographic or defamatory,) which may include, among others, advertising, promotion, marketing and packaging for any product or service. I agree that the Images may be combined with other images, text and graphics, and cropped, altered or modified. I acknowledge and agree that I have consented to publication of my ethnicity(ies) as indicated below, but understand that other ethnicities may be associated with Images of me by the Artist and/or Assigns for descriptive purposes.

I agree that I have no legal copyright rights to the Images, and all the rights to the images belong to the Artist and Assigns. Photographer, Elizabeth Etienne agrees to share 50/50 in any profits she will potentially earn from the licensing sale of this image. I acknowledge and agree that I have no further right to additional Consideration or accounting from stock agency(ies), and that I will make no further additional claim for any reason to Artist and/or Assigns. I acknowledge and agree that this release is binding upon my heirs and assigns I agree that this release is irrevocable, worldwide and perpetual, and will be governed by the laws of the state excluding the law of conflicts.
Definitions:
"MODEL" means me and includes my appearance, likeness and form.
"MEDIA" means all media including digital, electronic, print, television, film and other media now known or to be invented.
"ARTIST" means photographer, illustrator, filmmaker, or cinematographer, or any other person or entity photographing or recording me.
"ASSIGNS" means a person or any company to whom Artist has assigned or licensed rights under this release as well as the licensees of any such person or company.
"IMAGES" means all photographs, film or recording taken of me as part of the Shoot.
"CONSIDERATION" means something of value I have received in exchange for rights granted by me in release.
"SHOOT" means the photographic or film session described in this form.

I represent & warrant that I am at least 18 yrs of age and have the full legal capacity to execute this release.

To be completed By Model:

Model's Signature: _____

6

Invoices, Contracts, Estimates, and Releases
The essential docs you'll need to look like a pro

WHENEVER I RECEIVE A JOB INQUIRY, I HAVE A PAPER TRAIL OF DOCU-ments I use for my clients (for both my nonadvertising clients and my advertising clients). I treat each client with the same level of professionalism, whether they are a major global ad agency or a family friend. Everyone receives the same paperwork. These documents serve not only as legal proof of the service details and fees owed, but also as receipts I can use for my tax paperwork.

While the paperwork is more extensive for my advertising jobs than for my informal, nonadvertising or small advertising clients, it's still imperative to require a signed estimate contract and a 50 percent retainer deposit before proceeding with *any* job, advertising or nonadvertising. Don't even click a single frame without it. It doesn't matter if the person is your next-door neighbor, your mother, or your best friend! Business is business and friendship is friendship. The two are separate. Those who respect you will know you are practicing good business skills. The paperwork shows your clients that you are professional and committed to their job. The more professional you act, the more professional you will become, and the more money you should be able to command. This is just the law of the universe. A deposit also reserves your services for a specified date. My deposits are *nonrefundable*. This is clearly stated in my contract. Why? Because if another person calls to reserve my services for the same date that I have been hired to work (especially with big wedding jobs), I would

have to turn them away and lose all of the money I could potentially earn because my services are already reserved for someone else. A deposit also encourages your clients to commit and not flake out on the day of the shoot (especially for smaller jobs like headshots). There is nothing worse than prepping for a shoot, getting your gear, assistants, props, and location organized and then hearing from the client that they want to reschedule for another day (or worse, they don't show up at all!). Your whole day is wasted, you've lost the income you could have earned for that day and have to pay your assistants' fees, and now you have to prep all over again? That's not fair. This is what the deposit is for. Many busy photographers (such as myself) will book up far in advance (for wedding jobs this can sometimes mean up to a year or more!). It is standard practice in the wedding industry to require a deposit. If a wedding gets canceled, you may have empathy for the bride and groom, but again, this does not mean you are required to refund them the amount of the deposit, for reasons stated previously. You may want to be compassionate and permit them to "apply" this credit toward another photo shoot (or wedding!) within the next 2 years with a 25 percent rebooking fee (in lieu of keeping the entire deposit). When I'm shooting smaller jobs (such as a headshot), if the client gives me enough advance notice (3–7 days, for example) and it's not a major inconvenience, I will simply reschedule the shoot for another day. While you don't want to lose money for the reserve date you already had on your calendar, you also don't want to seem too inflexible at the same time. After all, they might hire you for a bigger job in the future. It's all about building relationships.

It's important that any time money is exchanged, your clients receive an invoice, and you keep a copy for yourself. I urge you to set up an e-commerce system that allows you to accept credit card payments on your website. While you do have to pay a small percentage in transaction fees, the easier you can make it for your clients to pay you, the more likely they are to book you for the job. If you don't already have a credit card system in place, see if you can at least set up a basic PayPal account in the meantime. Either system will automate an invoice by email for you and your client. It's an easy way to keep track of your jobs. If you have neither system in place, you can of course always accept cash or checks. In

this case, you could either have preprinted, carbon-tiered invoices (FedEx Kinko's can make these for you) and simply handwrite in the information pertaining to that job, or you can print out an invoice on your computer using a computer invoicing program. Providing a receipt or invoice each time money is exchanged allows you to keep a record of what is agreed upon, protects both of you, and makes the whole taboo subject of dealing with the money issue an easier process for everyone. This will work wonders when handling jobs for friends and family as well. It eases the awkwardness, it looks professional, and it gives you both an invoice to refer to when doing your taxes.

NONADVERTISING CLIENTS

By "nonadvertising" images I am referring to images that will not be used by clients for anything beyond personal use (weddings, engagements, events, portraits, etc.). For most of my nonadvertising photography services, I already have all-inclusive packages ready-made. In these cases, I simply present my pricing sheets to those clients and, when needed, I customize them accordingly. For my weddings I have several packages that include a variety of different products and services in each. Usually, my wedding clients simply select a price package, give me a 50 percent deposit, and sign a contract, and I give them a receipt for their deposit. In these cases, there is no estimate or job bid. As for my smaller portrait clients (headshots, stylized portraits, pregnancy, boudoir, family portraits, etc.), they simply pay me the deposit, and I give them a receipt that includes their chosen session package name and total price, the 50 percent deposit amount they are paying at that time, and the scheduled shoot date. There is no need for any elaborate contract for these small jobs. The deposit money serves as intent to hire.

The paper trail for nonadvertising clients looks something like this:

1. Price package (in lieu of estimate form)
2. Contract/terms and conditions/request for 50 percent deposit (engagements, weddings, events)

3. Invoice for deposit

4. Invoice for balance (weddings/events: due no later than 2 weeks before date of event)

Below is a copy of my basic contract and basic invoice. I get these printed on two-tier carbon paper at FedEx Kinko's or Staples.

BALANCE INVOICE

For nonadvertising clients, the balance invoice is simply a duplicate of the deposit invoice and shows the remaining 50 percent balance plus any additional expenses or services. These might include services agreed upon during the shoot or those you are giving them at no charge. Each invoice should only display the amount of money you are receiving at that time (including sales tax). In other words, if the total cost of a job is $1,000, each invoice would say $500 (subtotal) + $41 (tax) = $541. I require the balance to be paid on the day of the shoot prior to the commencement of production (with the exception of weddings and events, for which I require that the balance be paid no later than 2 weeks before the shoot date). This is clearly stated in the original-estimate contract. This means that you do not shoot anything without being paid the balance first. Yes, what I am saying is that you should get paid 100 percent before you click the shutter! Think of it this way: When you're shopping online, you pay for products 100 percent up front. It's done a million times a day. Your photography work should be sold in the same manner. You do not get paid the balance upon delivering the prints to nonadvertising clients. If your clients question this business practice, just politely explain to them, "This is standard business practice in our industry because we have expenses including our assistants' salaries and lab fees and we can't front these costs. Our service is customized to you. In other words, I cannot sell your prints to someone else. This is why most professional photographers get paid 100 percent upfront."

If they don't have confidence in your work and your abilities, then they should not have hired you in the first place. Anything artistic and creative will always have variations. This is what makes it unique and this is why it's called "art." There's always going to be an inherent risk for the buyer when hiring a photographer to interpret the client's vision. Do not

let them try to convince you that they will pay you next week or that the check is in the mail. This is especially important when it comes to overseas or out-of-town clients. These could be anyone from a private individual to a top magazine. I have been stiffed on a number of occasions after shooting for out-of-state or foreign magazines whose employees explained that their accounting departments paid their bills every 30–60 days (my phone calls were never returned, and I never saw a paycheck no matter how many times they told me the check was in the mail). If you need to give these kinds of companies an incentive to break their accounting rules, then offer them a 10–20 percent discount for paying 100 percent in advance. If you have a credit card payment system (as I strongly suggest in chapter 16: Promoting Your Business), then there is no excuse for them not to pay you in advance. Because my presentation is very professional and my work speaks for itself, I am rarely questioned about this working requirement. For my wedding and event clients, I usually send or email a polite reminder postcard one month before the due date. One of the reasons that I require the balance payment before the wedding day is that I do not want to bother the clients by asking them to give me a check the day of the event. That is the last thing they need be concerned with.

For all other nonadvertising shoots, I simply hand the invoice to the client on the day of production before the shooting begins, while my assistants are busying themselves with the gear and such. This is a polite reminder that the client should pay you before shooting begins. I've also reminded them the night before the shoot: "I'll give you an invoice for the balance tomorrow and you can just write me a check or pay with a credit card before we start shooting." Once I had a client tell me that they forgot their checkbook. How did I handle this? I simply said, "Oh, no worries, we have about an hour to set up our lights anyhow. You're welcome to pay with a credit card if you don't want to run home to get your checkbook." Because I accept credit cards through my website as well as my PayPal account, they can make payments wherever they can access the Internet with their laptops or cell phone. Thanks to recent developments in mobile software and hardware, you can now accept secure credit card payments by swiping it on your iPhone! It's so cool. All you need is the free card reader (a device that plugs into the headphone or charger jack on an iPhone) and

the free app, and then you simply pay a transaction fee. There are dozens of companies that now offer this service at competitive rates. All you have to do is sign up with them. I also found a few apps that eliminate the swipe and enable transactions with just a credit card number, expiration date, and touch-screen signature. With all these payment options, your clients have absolutely no excuse not to pay you immediately. Yes, I could have waited until after the shoot (and I have made exceptions from time to time), but I do not like to make a habit of finishing a shoot and leaving without getting paid in full. It is not our job to "front" any costs for the client, so get in the habit of getting all of your money upfront. Of course, you will occasionally have to make exceptions, but *never* give your prints or digital files or even *show* them to the client without getting paid first! I know this may sound harsh, but once you practice it a few times you'll feel so much better, and you will never feel taken advantage of again. Your clients will also gain more respect for your ethical business practices and your work.

Small Advertising Clients: Nonagency

When I'm shooting an advertising job for a smaller, nonagency client (such as a small business owner), I will sometimes combine the estimate and contract if the job is not too detailed. Other times, I provide an estimate that contains a detailed shot list and then a separate contract. Each of these contracts is unique and customized to the individual needs of each particular job. However, these estimates and contracts are not as elaborate as those I would prepare for a major advertising agency, but then neither is the job production or client's budget. The goal is to keep contracts comprehensive but at the same time condensed and simple. While ad agency executives are accustomed to lengthy, detailed contracts because they usually work with large, global name brands and must protect themselves and cover every detail, the average small business owner would feel intimidated by such a contract. It's best to keep it simple with these people so you don't risk losing a client.

For those clients who may not be accustomed to working with pro photographers, it's important to gracefully educate them as to the

complete value of your work. Keep in mind that unlike an advertising agency, most of these people have little or no experience as to what is involved in preparing, shooting, and creating professional images. With this in mind, tactfully include the "behind the scenes" services that are a part of creating the images when you create your estimates and invoices. These services might include consulting, research, location scouting, art direction, prop preparation, digital file processing, editing, adjusting, and *minor* retouching. You should also include a list of any à la carte services or products you have available (such as custom retouching, album book designing, print and binding, etc.). You don't want to get carried away and list your entire menu, but list anything you think they may want that directly pertains to the job you just finished. You might write something like: Ask about our custom retouching, album books, and other unique à la carte products and services. Listing these items educates the client as to the time and skill involved in producing a photo shoot.

While it's important to adhere closely to the original-estimate budget parameters during the shoot production, if the client makes a change that will require more labor or expenses, it is the *photographer's* job (not the client's) to tactfully and professionally make it clear that there is an extra charge for this. Just let him or her know that you are happy to do it and will simply add it to the final invoice. Often we develop a friendly rapport with our clients (especially if they are our friends), so it may feel awkward for some of us to address the taboo money issue. Don't worry; with practice, it gets easier.

Occasionally, if I have a repeat client and the additional labor or expense is not significant, I will include it. I'll smile and let my client know that I gave this added service or product to them as my gift to them. Then I might nudge them in a friendly way and ask that they refer me to anyone else they know who might need my services. However, it's important when you do this to always list these "gifts" on your final invoice (just simply write "no charge" next to the item). If you don't, they will never remember it, never appreciate it, and even expect it as part of the deal next time. This then reduces the value of your services.

The paper trail for small advertising (nonagency) clients looks something like this:

1. Estimate/contract/request for 50 percent deposit

2. Contract (if not combined with estimate sheet)

2. Invoice for deposit (optional)

3. Invoice for balance (balance due day of photo shoot, *not* upon delivery of images)

On pages 69–72 are samples of small advertising job estimates/contracts. The first is a combined estimate/contract and the others that follow are separated. Because these estimates clearly separate the photographer's fees from the expenses, the only items that are taxed in the final invoice are the expenses.

Before any images are taken, it's imperative that the appropriate release forms be signed by any models who will be recognizable in your images, or in the case of minors, pets, and properties, by a parent, pet owner, or property owner. These forms serve as a contract agreement and specify what and how the images will be used and any monetary compensation they will receive. While this isn't always necessary (although it is advisable) for nonadvertising jobs, it is very important for images that will be used for any advertising purposes. For copies of standard stock-model release forms for adults, minors, pet owners, and property owners, see chapter 18: Recycling Your Images. I would suggest you revise these forms as necessary per the parameters of each job you shoot.

ADVERTISING AGENCY CLIENTS

When I'm approached by an advertising agency for a job proposal, I prepare myself for a bit of paperwork. Because advertising shoots are more extensive and require more skill on numerous levels, the production costs for these shoots tend to be substantially higher. A few years ago I had an agent who handled most of this for me. She would simply review and confirm the details with me and then send me copies of each of the documents in the paper trail for my records. Now I either do my own production estimates (with the help of software programs such as Blinkbid and

fotoQuote), or for larger jobs, I'll hire a production manager to do it for me. There is also another program called HindSight. These programs offer pricing guides for stock and assignment photography to estimate, bid, and invoice jobs. They are easy to use and include the standard language expected in our industry. I simply plug in all the details (like those mentioned in the previous sentence) and it spits out an estimate for me. It's pretty neat. It can also be customized somewhat for specific jobs.

Unlike the other estimate types presented above, an advertising agency estimate will separate the photographer's creative fee and then detail every single expense separately. Your expenses might include your extensive crew of assistants (hair, makeup, wardrobe stylist, prop director, stylists, photo assistants, etc.), talent (your paid models if any), and physical expenses (such as meals, film or digital file processing, props, location fees, rental equipment, transportation, retouching, insurance, etc.). For more information refer to chapter 7: Individual Job Expenses.

Several things define my creative fees: the economy, the average day rate for photographers of my skill level, and the client's budget. If the client isn't going to give me a dollar amount for their budget, then I take a look at their product or service and where and how they plan on using the images. This usually gives me a rough idea of their budget (even if they're trying to be discreet about it).

The next thing I do before determining my creative fee and creating an estimate is to try to get a feel for the agency or client's interest: have they chosen just me for the job or are they getting multiple estimates from other photographers? I can usually tell this by their tone of voice. If they are expressing how enamored they are by my work and how it's simply perfect for this job, this most likely means that my competition is slim and that they are looking at only a few photographers. This gives me the confidence to keep my day rate at my high end. However, if they are short and curt with me and give me only minimal compliments, this usually indicates that they are collecting numerous estimates and the competition will be fierce. Either way, don't make the assumption that they will necessarily choose the lowest estimate. In fact, a photographer who bids a job too low gives the message that he or she doesn't have the confidence to

charge what he or she is worth, and no one wants to hire a person without confidence. It also gives the message that perhaps the photographer is cutting corners someplace, and this isn't necessarily a good thing either. In any event, be prepared; sometimes estimates may be revised several times before the client agrees and signs the contract.

Don't forget your preproduction labor. If the job is extensive, you may have to spend a day or more prepping. This could include location scouting, set building, casting, and so forth. There should be a separate prep fee in cases like these. A reasonable prep fee is usually 25–50 percent of the photographer's creative fee. In other words, if you're charging $7,500 for your creative fees, your prep fees might be approximately $2,000–$3,500, depending on the amount of technical work involved. However, you do not need to detail what's involved in your prep fees on these kinds of estimates because this leaves too much room for haggling.

In addition to creative fees and expenses, there may be licensing fees to consider. These are fees based on the media permissions, meaning how, where, and for what duration the images will be used. These media permissions will be described as: the media (web, editorial print, billboard, P.O.P, etc.), distribution, placement, size, versions, quantity, duration, region, language, and exclusivity level. The license usage fees are usually based on a percentage of the photographer's creative fees and then compounded based on the level of use the client wants. For example, if you're shooting an ad campaign for a major product and they want to use the images for 5 years for everything from the company website to billboards and print ads around the world, the fees will be considerably higher than they would be for a smaller, lesser known company that only needs the images for its website. Sometimes the clients may request for what's referred to as "unlimited use." This means that they do not need to define where or how the images may be used to advertise their product or service. Or they may request for a total or a "buy out," permitting them to use the images for as long as they want, where and whenever they want. In these cases, your licensing fees will be at their highest. However, all this being said, you may end up including your licensing fees as a means of negotiation to close the deal, if necessary. Unfortunately, with today's economic climate

and an increase in photographers in the marketplace, some agencies are now requesting that these fees be waived if the photographer wants the job badly enough. However, do not give them full "copyright" to your images. A photographer *always* owns the right to his or her images completely. They are works of art, commissioned or not, and the photographer is the creator of this art.

The paper trail for agency advertising clients looks something like this:

1. Assignment-estimate/bid
2. Assignment-confirmation/terms and conditions
3. Advance request
4. Change order form
5. Delivery memo
6. Invoice for balance

Take note: You are the director and the producer of the shoot and your crewmembers work for *you*, not the client. This means you are the one paying *them*, at the *end* of the job, when you get paid the balance by the client. They usually do not get a 50 percent advance as you do (unless they have specifically requested it to purchase props or set-building materials). This is standard in the advertising and editorial industries. Unfortunately, with your advertising clients you will not always have the luxury of getting paid the balance before the shoot (or even on the shoot day). Usually the ad agency is working for the client and everything has to go through its corporate accounting offices (*yes, welcome to the corporate world!*). It can sometimes be 30–60 days before you get paid the balance. I know of a magazine that takes 90 days to pay! Just make certain that you are working with a reputable ad agency. No need to worry too much, however; your contract strictly states that no licensing grants will be applied until the balance is paid in full, so they cannot legally use your images until then. If they do they will be in breach of copyright, and there is a very hefty fine

for this. This usually motivates them to pay you as quickly as possible. To encourage the expedition of the payment process, you can also agree to negotiate your rates down just slightly (or include unlimited licensing rights) if they can pay you the balance upon delivery of the digital files.

There are a number of sample advertising documents, estimates, and other forms (mentioned in the paper trail list in the previous paragraph) available through American Society of Media Photographers at www.asmp.org. You will notice duplicate or redundant information is contained from one document to the next in your paper trail lineage. This is standard and is important in maintaining the consistency of the parameters of the job.

Sales Tax

Yes, you need to charge sales tax. The law states that photographers must charge and pay sales tax because, although we provide a service, this service renders a product (sometimes referred to as "goods") and *products must be taxed*. The amount of sales tax you need to charge will depend on the state in which you reside and pay your taxes and the portion of goods you are taxing. For example, in California, where I live, I do not need to charge sales tax if I am delivering my digital files electronically through either an FTP, email, or electronic file sharing software like YouSendIt. I also do not need to charge or pay sales tax for any out-of-state clients (with the exception of the state of Texas), my stock photo agency, or any wholesaler, like an art gallery (since they will be paying their own sales tax). In addition, my private photo coaching sessions, workshops, and guest speaking appearances are tax exempt because they are services only and these services do not include products. I do, however, need to charge and pay sales tax for all of my other retail customers. This is the core of my client base. The amount of sales tax I pay is based on *how* my goods and services are sold. For example, if a client purchased one of my all-inclusive wedding or portrait packages, I am obligated to charge tax on the *entire package*. This is because I am *not* separating my services from products (the digital files and/or prints they will receive). Sales tax in California is currently 9.25 percent. This means if I charge $10,000 for a California

wedding, the client must pay $925 in sales tax! (Yikes . . . I know!) This money must go to the state; it is not mine to keep. However, when I am doing an advertising campaign and I create a detailed estimate that separates my creative fees from every detailed physical expense, I only charge tax on the expenses (not my creative fee). Each state has different tax rates and regulations, so it's best to consult your tax accountant or the state treasurer's office.

I pay my sales tax quarterly. You may opt to pay it once annually, but I prefer paying it a little at a time rather than all at the end of the year. I either file it online or have my accountant do it. Either way it's fairly easy. No, it's not fun, but the law requires it.

3. MODEL, PROPERTY, AND PET RELEASE FORMS

When and if possible, it's always advisable to get a release form from as many clients as you can (even your nonadvertising clients) just as an extra precaution. As mentioned previously in this chapter, if you intend to use an image for advertising or promotional purposes, it's crucial that you get a release signed by or on behalf of any person, property, or pet that is visibly recognizable in your image (even if they have verbally agreed). Sadly, in our lawsuit-friendly society, even pets now need to have their owners sign releases on their behalf. By law, photographers are permitted to present samples of their work in their portfolios and on their websites provided that the images display the person or persons shown in a neutral or positive manner. This does not include nudes or seminudes or anything in that gray area. If a person specifically requests not to have their image presented on your website, don't fight them. Adhere to their request.

There are different versions of release forms and you may need to modify yours to meet your client's needs. I have one that allows me full use of the images for anything I desire without any further compensation to the client. Because the majority of my images present people in a positive light (and I stress in the release form that their images will not be used in any derogatory or negative manner), most of my clients trust me 100 percent and have no issues signing. However, now and then I will get

clients who are resistant to the idea of waiving their claim to any and all profit from the image. They feel that if I am going to make some money off of their faces, why shouldn't they as well? I totally understand, so to encourage them I'll revise the release form by adding an extra clause that indicates that I agree to share 50 percent of any proceeds I would gain from the sale of an image of them. Lastly, if a client insists that their images not be used for anything other than the photographer's self-promotion, I always revise the agreement accordingly and respect their decision. After all, you don't want to lose a client over an issue like this.

Elizabeth Etienne Photography

578 Washington blvd. #372 Marina del Rey. CA 90292
tel: 310.578.6440 fax: 800-971-3042

Wedding, Event & Session Contract

Bride/Client's name: _____*SHOOT DATE*_____

Tel: H) _____*W)* _____ *cell)* _____ *E-mail:* _____

Groom's/Clients name: _____

*Tel: H)*_____*W)* _____ *cell)* _____ *E-mail:* _____

Mailing Address: _____ *City:* _____ *Zip:*_____

Coordinator's name: _____ *Tel: W)*_____ *cell)* _____

Ceremony or Event address & directions: _____

Reception address & directions: _____

Price Package: _____

Add'l Services or Substitutions: _____

Total w/9.75%tax _____ **50% Retainer Deposit** _____ **Balance:** _____

Retainer Deposit
*A 50% retainer fee is due upon agreement of this contract. Retainer deposit is non-refundable, guarantees availability of photographer on the date and time specified and covers damages for lost wages for the remaining balance should the wedding be postponed or cancelled. Event cancellation notification is due no later than **30 days prior** to scheduled event date and balance is due no later than **2 weeks before** event date. A polite reminder notice will be sent out a few weeks before the wedding date. Balance checks may be mailed to the address above.*

Print & Album Delivery
Prints & digital files will be ready for pick-up/delivery 10-14 days after event date depending on the quantity of custom retouched images. Allow 4-6 weeks after reprint order has been placed for final albums and enlargements. Client is responsible for choosing and ordering all package print & album orders within 3 months after receiving original proof prints.

30 min. Guest Meal Intermission
Photographer & assistant(s) will be entitled a 30 min. intermission period in which they will be granted "guest" meals.

Overtime & Additional film
Photographer will alert client prior to any potential overtime or add'l film costs.

Disclaimer
Photographer will be supplied with a detailed time line, (similar to "Sample Time line" on eephoto web site), directions & maps to and from all locations as well as all necessary contact telephone numbers. Photographer's arrival shoot time is agreed upon and should be strictly adhered to by both parties. Photographer cannot be held responsible for quality of service due to a delay in this schedule by bridal party's negligence or absence of a professional event production coordinator. Photographer will do the best to see that all measures will be taken to ensure that each roll of film/digital file is handled with the utmost care and professionalism. The photographer makes no guarantees outside her control for theft, loss, accidents, negligence, damage, or acts of God. In the unfortunate event photographer Elizabeth Etienne is unable to perform her duties on your wedding day emergency compensation is available. A qualified Etienne Associate Photographer will shoot your wedding and a 50% reimbursement of your total package cost will be refunded back to you.

_____ _____
Client: Name & Signature *Date*

_____ _____
Photographer: Name & Signature *Date*

Elizabeth Etienne Photography

578 Washington blvd. #372 Marina del Rey. CA 90292
tel: 310.578.6440 fax: 310.578.6788

JOB INVOICE

CLIENT: DATE:

ADDRESS:

TEL / E-MAIL:
JOB DESCRIPTION:

PHOTOGRAPHER'S FEE:

ASSISTANTS FEES:

DIGITAL FILE PROCESSING FEE:

RETOUCHING FEES:

FILM PROCESSING FEES:

PRINTS:

ADD'L RENTAL EQUIPT:

ADD'L PREPARATION, (CD'S, mats, frames etc),

TRANSPORTATION COSTS:

(agreed) _____ SUB TOTAL:
 client signature
 TAX:

(agreed) _____
 photographer's signature TOTAL:

A 50% NON-REFUNABLE DEPOSIT IS REQUIRED TO RESERVE PHOTOGRAPHER'S SHOOT DATE:
BALANCE IS DUE ON SCHEDULED SHOOT DATE PRIOR TO COMMENCEMENT OF SESSION.
CLIENT WILL RECEIVE ALL RECEIPTS.

Elizabeth Etienne Photography

www.eephoto.com www.etiennephoto.com
578 Washington blvd. Suite#372 Marina del Rey, CA 90292
tel: 310.578.6440 fax: 800-972-3042

PROJECT ESTIMATE

Client: Kennith Martin 555.655.1212 **Production Shoot date:** 5-1-10

Project reference: Sunrise Restaurant

Project Description/usage/License Agreement: Unlimited self-promotional purposes to include: editorial magazines, presentation portfolios, marketing materials, e-mail newsletters, website, press kits, etc....

Photographer's Fee: $

Photo assistants: $

Post Production Processing: $
Includes: file processing, color adjusting, retouching, file resizing for website use & print portfolios.

TOTAL: _____ $_____

SHOT LIST DETAILS: 13 shoot set-ups:

FOOD PLATES: 6 shots **TIME:** late morning
Close up details of selected food entrees, each positioned on wine cask (as table setting), candles lit on tables in background. Move wine bottles to corner, add glasses on left side, remove frame from wall.

CHEFS PORTRAIT: 2 shots: **TIME:** mid day
• Chef to wear uniform, standing in kitchen w/skillet. Show foreground w/cutting board and vegetables.

• Overview /wide angle of kitchen to show background with busy staff (out of focus)

LOCATION EXTERIOR: 2 shots: **TIME:** late afternoon
Remove heat lamps, add more tables and chairs, small flowers on patio tables, exterior lights, photographer to supply additional lights under trees and plants.

• Close-up of fountain (showing dinning table?) (horizontal & vertical)

• Overview /wide angle from east side/ back yard showing seating area & fireplace (horizontal & vertical)

LOCATION INTERIOR: 3 shots: **TIME:** early morning
• Overview /wide angle of room from staircase w/ fountain in background (horizontal)

• Overview /wide angle from east side/ back yard showing patio seating area & fire pit (horizontal)

• Close-up of restaurant sign

Elizabeth Etienne Photography

www.eephoto.com www.etiennephoto.com
578 Washington blvd. Suite#372 Marina del Rey, CA 90292
tel: 310.578.6440 fax: 800-972-3042

PROJECT CONTRACT

Client: Kennith Martin 555.655.1212 **Production Shoot date:** 5-1-10

Project reference: Sunrise restaurant

Project Description/usage/License Agreement: Unlimited self-promotional purposes to include: Residential interiors/exterior design images to be used for editorial magazines, presentation portfolios, marketing materials, e-mail newsletters, website, press kits, home office gallery displays etc....

JOB DESCRIPTION: 13 shoot set-ups: see estimate sheet for more details

PHOTOGRAPHER'S DAY RATE FEE: $
Includes: lighting & camera equipment, any add'l rental.

PHOTO ASSISTANTS FEES: $

POST PRODUCTION DIGITAL FILE PROCESSING FEE: $
Includes: file processing, color adjusting, basic retouching, file resizing for website use & print portfolio

CUSTOM RETOUCHING FEES: optional

ADD'L RENTAL EQUIPT: **included in fee**

ADD'L PREPARATION: includes CD of both high res and low res files, photo booklet **included in f**

TRANSPORTATION COSTS: included in fee

PROPS: supplied by client N/A

Total w/tax: $ **50% Retainer Deposit: $** **Balance: $**

Note: *A 50% retainer fee is due upon agreement of this contract. Tax is charged on any service that renders a product. Estimate is honored up to 30-days from estimate date. Retainer deposit is non-refundable; guarantees availability of photographer on the date & time specified. If photographer is unable to perform her duties on scheduled shot day due to an emergency retainer-deposit can be refunded or transferred to next scheduled shoot date. Balance is due on or before the scheduled shoot date. Add'l images not included on this estimate will be charged add'l fees to be estimated upon client's request. Photographer will supply detailed shoot description. Photographer's arrival shoot time is agreed upon and should be strictly adhered to by both parties. Photographer cannot be held responsible for quality of service due to a delay in this schedule by client's negligence. Photographer will do the best to see ensure that each digital file is handled wutmost care and professionalism. Photographer makes no guarantees outside her control for theft, loss, accidents, negligence, damage, or acts of God.*

Client: *Name & Signature* *Date*

Photographer: *Name & Signature* *Date*

Notes

7

Individual Job Expenses
The essential expenses for each job

BIG OR SMALL, EACH JOB WILL COME WITH SOME EXPENSES. THESE will vary from one photo shoot to the next depending on your production level. If you are shooting a family portrait in your backyard the expenses may be minimal, but if you're shooting an ad campaign in Paris your job expenses could be extravagant. Either way, don't overlook all the costs involved in completing a job and include these in your expense logs and job estimates. Below is a sample list of some of the expenses you might expect to incur.

• Photo assistants

As stressed in chapter 8: Assistants, Labs, and Agents, you should have at least one photo assistant for every shoot. Don't cut corners. It's not worth it. It's better to lose a bit of your profits if you must in order to present yourself in a more professional manner, have a more effortless photo shoot, and produce better images. Better images will give your business more credibility, and this should enable you to gain more customers and increase your rates. An assistant will help you get there. However, if you still can't afford to pay an assistant, borrow your husband, wife, boyfriend, or best friend or trade assisting with another photographer (or anyone else that loves photography and wants to learn something from you). Most people with the free time love to be around photo shoots, especially when you're a good photographer! They want to be a part of the magic behind the scenes.

Professional photo assistants' fees will vary from one economic demographic to the next, but you can expect to pay between $100 (for a basic photo shoot) and $500 (for a very experienced digital tech). If you're doing a simple noncommercial portrait shoot, you can either include your assistant's fees in your job description (for example, "Photo shoot includes photo assistant(s), location scouting, and art direction"). However, if you're performing a large advertising job, your photo assistant's fees should be listed separately under your list of crewmembers. For more information see chapter 6: Estimates, Contracts, Invoices, and Releases.

• Additional crewmembers

For your larger photography productions (such as advertising, engagements, or even big-budget weddings), you may also want to hire additional crewmembers. These might include a production manager, hair stylist, make-up designer, wardrobe consultant, prop stylist, and set designer/builder. Even if you're shooting products, interiors, or food you may still want to have these people around. Be prepared; in addition to their shoot-production day fee, some of your crew may charge you preproduction and postproduction day fees. They may need extra time to scout for the right materials before the shoot, build the set and then tear it down, and return things. It's not uncommon for photographers to charge a standard day-rate fee for the shoot day and a lower rate for the prep and wrap/return days; so too can the crew members. It all depends on the person, the production level, and the budget.

• Props and wardrobe

Your props and wardrobe will vary from shoot to shoot. For example, when I'm shooting home interiors or food, some clients don't have the time, the desire, or the eye to pick out the right props. These might include fresh flowers, framed artwork, or the right towels for a bathroom shot. In these cases, I will hire a prop stylist or offer this service myself for an additional fee. As searching for the right items will require a lot of additional labor time, do not include this service as a "deal closure" unless the job is enormous and you have a ton of cushion in your profits. Either way, the

cost to rent or buy the right props should always be listed in your expense log and estimates.

For most of my smaller, nonadvertising portrait shoots I encourage my clients to handle the wardrobe themselves. Props are usually not a concern. While they will certainly consult me on which clothing items to bring (and may even purchase something specific for the shoot), these items are not listed on their estimate sheet. However, when I am shooting an advertising campaign, props and wardrobe will definitely be an expense. As with a prop stylist, if the budget permits, you may want to hire a dedicated wardrobe stylist (or find a prop person who handles both). While some items can and should be purchased or rented and then returned (such as bed sheets, wine glasses, clothing, and accessories, provided the items aren't damaged), other things are perishable (such as flowers and food). Regardless, all items should be listed on the estimate sheet at 100 percent of their full purchase cost even if they can be returned and credited back after the shoot with your final invoice. You do not want to be responsible for fronting any expense costs. Because you don't always know how much these expenses will cost, you will have to create a rough estimate (you may want to separate perishable from nonperishable or returnable items). While some crewmembers will cover the cost for these items themselves (and bill you later), others will require petty cash advances (especially if they are extravagant expenses). Just make sure that they give you all of their receipts.

• **Extra equipment rental**

While most photographers own most of their photo equipment, there may be a particular job that requires additional special photo or grip equipment. This might involve extensive strobe lighting, a smoke machine, or maybe even scaffolding to raise you up above a set. You will certainly want to discuss these additional items with your client beforehand so that they are aware of what equipment is included in your fee and what isn't. These items should certainly not be overlooked in your job expense log.

• **Meals (craft services)**

Whether you're working on a large or a small shoot, it's important to always feed your crew if you'll be working more than just a few hours.

A well-fed crew will have the energy to put in those extra hours you may need on long shoot days. For smaller nonadvertising shoots, you might just grab a quick ready-made sandwich or fast food and eat it in the car en route to the shoot. In these cases, you do not need to list this small expense on your estimate sheet. Just factor it into the miscellaneous expenses absorbed into the shoot costs. However, for advertising shoots that may include a larger crew, an art director, the client, and models, you will definitely want to include this as an expense item in your estimate sheet. To make things easier, you may want to have carry-out delivered directly to the set for everyone (as opposed to going out for lunch someplace, which can be a hassle and take up precious time). This is usually the job of the production manager or one of the assistants. This is commonly referred to as "craft services." Either way, you should always have an extra stash of protein bars and bottled water on hand to keep everyone happy.

• Accommodations

If you travel for a job you may incur accommodation costs. For smaller, tighter budget jobs I always try to keep this fee as low as possible for my client. This might mean staying at a simple Motel 6 and sharing a room with my assistant. I don't want my client to be discouraged by the cost of transportation for my crew and me and decide that it isn't worth the added expense and hire a local photographer instead. I want to do everything I can to try to "accommodate" their budget needs. For larger shoots there may be more room in the budget for you to stay with your crew in separate rooms in more luxurious accommodations. It's best to request this in advance, and if your client is hesitant, you can either opt to hire local crewmembers (instead of bringing in your own) or stay in a less expensive hotel.

• Transportation

Gas, mileage, tolls, parking, valet, airfare, train tickets, taxi fare, bus tickets, and any other expense involved in your transportation to and from the job should be noted. Make sure to save every receipt if you're paying cash. As with everything else, for smaller jobs this expense may not need

to be listed and instead simply factored into the miscellaneous expense costs for the job, but for advertising jobs requiring extensive travel, you can calculate approximately 50 cents per mile for mileage if you use your own car. Charging per mile is important because it covers the cost of your regular oil changes, tires, and other repairs and maintenance.

• **Equipment carnets**

An equipment carnet is an official, itemized list of all of your equipment and their serial numbers. It's legal proof that the items you are carrying with you are yours and were purchased in the United States. If you're traveling abroad, you will want this as you depart your foreign destination so you don't risk having to pay duties and tariffs on your own equipment (or even worse, having the equipment held up) in the country you're visiting. This is obviously the worst-case scenario, but it's important to know that it's a possibility.

There are a number of companies that can prepare an official equipment carnet for you for a fee. The fee is based on the total value of your equipment. The United States Council for International Business, or USCIB (www.uscib.org), has been designated by the US Customs Service as the United States' issuing and guaranteeing organization. There are a few other companies that can assist you as well, such as ATA Carnet (www.atacarnet.com) and Carnet (www.shoots.com/carnet.html). Bring a list of all of your equipment, their serial numbers, and any receipts and insurance policies you have to their office, fill out their form, get it signed and stamped, and make copies to stash someplace hidden in your suitcase. An ATA carnet is valid for one year from the date of its issuance. Merchandise listed on an ATA carnet can be imported to and exported from any of the member countries as many times as needed during the one-year life of the carnet.

There are pros and cons of having an official equipment carnet, and there is much discussion as to whether or not it's even necessary. The downside of having an official carnet is that you may instantly look like a "professional" or photojournalist, and as a result you may not necessarily be welcomed in some countries. The trick is *not* to look like a pro, say you're a pro, or act like a pro. Act like a tourist (most of them carry more

equipment than we do anyhow) and you'll probably be left alone. My belief is that if you're not carrying a lot of equipment, you probably don't need to bother with the hassles and expense of obtaining an equipment carnet. Although I have personally never been stopped or questioned about my gear (most likely I would be asked where and when it was purchased), I always carry copies of my insurance policy (along with the serial numbers of my various lenses, cameras, flashes, and such) just in case.

However, if you *do* carry enough equipment to invite speculation about your profession, I wouldn't take any chances. I know of one photographer who was billed for several thousand dollars three months after a trip! Thankfully, he was able to prove he left with all the necessary signatures because he had the copies from the US customs office. In some countries, when you arrive at the airport at early or late hours, the required officials are not available. Then you have a real dilemma: either leave without their official signature of approval (big mistake) or cancel your flight. I heard another story about a photographer who had a strange experience with his equipment upon his return to the United States from abroad. A new customs officer, eager to prove his credentials, argued that the film and CF memory cards had increased in value since their latent images would be processed and used commercially. Therefore, he surmised that the value had to be calculated on each roll and CF card based on the future income it would produce. Insane! Fortunately, an older customs manager stepped into the heated discussion and eventually allowed the photographer to pass through.

• DVDs, prints, and album books

If you are including prints, CDs, and album books in your all-inclusive packages, don't neglect to factor those costs into your expense logs. Likewise, if you create customized CD jackets for special clients, don't neglect your ink and paper costs. While some of your costs may seem so small that they aren't worth considering, it all adds up in the end. The importance is to understand all the things that go into funding your photography business so you can know where, when, and how you can reduce certain expenses to increase profits.

• Presentation and packaging materials

As detailed in chapter 15: Creating a Recognizable Brand, don't forget to create a dynamic presentation when delivering your CDs, prints, album books, or any other additional photo-related products you may offer. While your expenses may be as minimal as a $4 padded envelope, you might also want to splurge on a $50 antique box for a theme-oriented engagement shoot. What about the padding inside your packages? This might include fake moss, dried leaves, or anything else theme-oriented to cushion the valuable prints and create a polished finish to your presentation. Lastly, don't forget to include the cost of the additional shipping boxes themselves and any packing materials (like bubble wrap, packing tape, and popcorn). While you do not need to list the details of these expenses on an estimate sheet for your client, they should certainly be included in your own personal job expense log so that you can factor these costs into your estimating formula.

• Messengers and postage

The final expense in delivering your precious jewels will be your shipping or messenger-service fees. I always advise using UPS or FedEx for all shipping needs and getting a tracking number, insurance, and signature confirmation. Sending your packages this way tells your customers that you are proud of your work, you want to protect it, and you respect the money your clients spent to create it. Do not send your images, album books, or anything else important by standard mail. You don't want the delivery person to leave the packages out in the rain at your client's door. (Yes, this happened to me once, and $500 worth of prints were destroyed! Needless to say, I really learned my lesson.) In a perfect world I would have my packages hand-delivered by a gorgeous guy wearing white gloves and a royal uniform, but unfortunately this is not an option!

• Miscellaneous

I usually add approximately 5 percent of the total job cost for odd, miscellaneous expenses. These include random items I often forget about (such as AA batteries, canned air, rubber bands, or maybe a surprise

parking ticket). Having a miscellaneous category gives me a cushion for the unexpected expenses as well, like equipment repairs or upgrades. It seems that for almost every shoot something needs to be repaired, replenished, or purchased.

Once you have a list of your individual job expenses, you will gain a better understanding of the cost involved in producing a similar shoot. Then you can begin to price your services more effectively to maximize your profits.

Notes

8

Assistants, Labs, and Agents
How to find and keep your success-team players

You can't build your empire alone. Behind every powerful, successful leader is a team of supporters that push the leader up one rung higher on the ladder. Be a leader and lead your people. I can't imagine ever shooting anything without at least one assistant; I almost always use two and I sometime use three! I see photographers scrambling with their gear all the time, trying to save a buck by not hiring an assistant. Don't do it—don't even think about it! Even if you make little or no money on a shoot because you had to pay an assistant, it's still worth it. Why? Because you'll look and feel more confident with an extra pair of hands to get you a lens, more batteries for your flash, or move a chair out of the background so you can grab that spontaneous shot of Grandma dancing on the table. It's just not easy alone. Ideally, you'll want an experienced assistant who really knows what he or she is doing, but in a pinch you can always grab a friend and then prep them in advance so that they know what you'll need and how to act.

There are leaders and followers, drivers and passengers. Most of you reading this book are probably leaders like me who dream of having a follower who can also lead from time to time—a passenger who could be your designated driver when you need them, so to speak. You also want a person who can take charge and work as smart as you can, a person with common sense who can think on his or her own (and for you!). These are what I call "leaders in training." In other words, they are followers

(for the time being), but eventually they will want to lead, and they will most likely leave the nest faster than your standard "followers." If you are blessed enough to come across such an individual, do whatever you can to encourage them to stay. These people are "keepers," worth their weight in gold. Don't take these people for granted because they will make your business and your life ten times better. If they cost you a bit more it's worth it, so don't cut corners. I'm committed to surrounding myself with positive, healthy-minded team players. We are working together as a sort of "family," so I feel it is crucial that I select my family members carefully. Some of my assistants have been with me for years. They know my system of shooting and the appropriate way to act around my clients. My photo lab knows exactly how to process and print my images. If it's not done right, they do it over again at no charge. They are eager to please me and I readily express my gratitude. Developing long-term working relationships is one of the keys to a successful business because these are the people you can count on when times are challenging. Finding your team members may seem difficult, but once you know what to look for, you'll most likely make better decisions when it comes to choosing the right people.

Don't Assume People are Who They Say They are

Some people are just good salespeople; they will say just about anything to land the job or just to get the chance to hang out with a pro. Years ago—prior to the implementation of my internship/assistant training program—in a last-minute rush I made the mistake of hiring an assistant who *said* he was qualified, when in fact he wasn't. At the time I was not skilled or savvy enough to know what to look for when interviewing assistants, so I simply took his word and trusted that a person would never promote himself as a photographer's assistant unless he really had some degree of experience and interest in the profession. I think he thought he'd just wing it, gain some experience, and go home with some cash in his pocket (how hard can it be to lug a camera bag, after all?). I sent him to the camera store to buy a certain kind of film and asked him to load the cameras. As it turned out, he had bought the wrong film, and when the pictures came back I was devastated. What's more,

he didn't know the difference between a wide-angle lens and a zoom and he kept fumbling around with all of my lenses—it was a nightmare. The next assistant I hired showed up on the shoot wearing high heels, long nails, and dangling earrings. How was she supposed to lug my gear up the hillside and through the brush-filled canyon? She spent half the time on her cell phone arguing with her boyfriend (I nearly grabbed her phone and threw it off the cliff!). While she was somewhat knowledgeable about gear, having graduated from one of the top photo schools, she knew nothing about proper client/assistant/photographer relations. She was more involved in talking to the client about personal things than listening to my requests for another lens, and her incessant giggling made it hard to coach the model. To make matters even worse, she opened the back of one of the film cameras, exposing all the film. *Then*, instead of tactfully whispering to me what had happened, she shouted it across the field, so my clients could hear that we had just lost the last thirty-six shots! (Are you cringing yet? I was.) Another assistant showed up to the shoot an hour late, hungover, and reeking so strongly of booze from the night before that I could smell the guy from ten feet away—and so could my client! A makeup girl I hired actually challenged my client and me over which clothing would better suit a specific shot! Assistants and crew are *never* to interfere with the client and the photographer. This makeup girl clearly had no "set etiquette" training; she was really overstepping her boundaries, and I was furious! While it's great to have active assistants, you don't want someone who takes charge, runs you over, and makes you look incapable in front of your clients. I really learned my lessons with all these assistants. Now all of my assistants and interns are drilled on everything from my specific gear-prepping system to client relations, dress code, and set etiquette. While I am very open-minded about age, sexual orientation, and cultural identity, I have little or no patience for misleading, unreliable, and disrespectful assistants.

INTERVIEWS

I interview everyone I'm considering connecting to my business—my photo lab, agent, publishers, sponsors, assistants, and unpaid interns.

Why? Because these people will have a direct impact on my my reputation, my energy, my self-esteem, and the success of my entire business. The first thing I do is stress my expectations and listen for their response. If their response sounds formulated, then I know they are not sincere. I like people who also ask *me* questions. This tells me they are engaged in what I am saying and already thinking on their own.

Interviewing interns: While time is money for all of us, my interns trade their time for my time. I explain to them my time is worth $200 an hour. Their time is worth about $15 an hour. If I am going to take the time to train them and explain things to them, I want them to know what that precious time is worth. Contrary to the old notion that interns are paid slaves, *my* interns are anything but. Once they reach the level where they no longer need *me* to devote my time to explaining things to *them*, then the internship is complete, and I will offer them a paid, freelance, second-assistant's position. When they are as skilled as my first assistant (this means knowing as much or more than I do about my gear), then they will be offered a first-assistant's position and wage when these positions are available. It's all common sense. I know what you're asking yourself: So does the first assistant get the boot, then? Nope. They all work freelance, and seniority gets priority when it comes to jobs. To illustrate, my first assistant, who has been with me the longest (about seven years), gets first dibs on jobs. He is known as the senior first assistant. If he isn't available (he shoots his own jobs and assists other photographers as well), then the job goes to the next assistant in line, known as the standby first assistant. If the senior first assistant *is* available, the standby first assistant is offered the next best thing—the second assistant's position—and so on. It always seems to work out.

Interviewing assistants: While most of my assistants now join my team via my internship program, I occasionally interview new assistants just in case one of mine is not available. When interviewing potential photo assistants, I ask them specific questions about my gear, photographers they have worked for, their attire, and set etiquette. I also look at their appearance and see if it conforms to the image I would like to present

to my clients. I cover basic etiquette and make sure they are aware that I tolerate nothing less than the best from them—and that, in turn, they'll get the best out of me. My time is too valuable for subpar collaboration, and if they don't already know this stuff they should apply for my internship program. I am not here to pay an assistant to learn basic photography skills or show them how the equipment works. To add, photo assistants outnumber photographers (and photo jobs) ten to one, so we photographers can afford to be particular about the people we choose to work with.

Interviewing photo labs and bookmakers: Labs and any other vendors you might use are fighting for your business, but good quality service is also hard to find these days. Introduce yourself to the employees and owners with a smile and a handshake if you can meet them in person. If you use an online service for your prints, make a phone call and talk to a manager. Let them know you're a pro and planning on bringing them lots of business if they can achieve the things you're looking for. Also let them know that you're looking to build a long-term working partnership. Ask for test samples, and if you like what you see, offer to refer their business to your friends and fellow photographers (and do!). You should work together to help each other out; it's so much nicer when people genuinely care about one another. My lab and bookmakers and I are on a first-name basis and all their employees know my assistants and me. They go out of their way to make my work look amazing and I always express my deepest gratitude. At Christmastime I always remember to send a gift basket or a bottle of great scotch for the owner.

Interviewing agents: As your career evolves you may want to consider an agent, especially if you pursue a career in advertising photography. However, don't assume that having an agent will automatically make your career blossom. Not all photographers want an agent because they often don't want to share a chunk of their profits with an agent, especially if it turns out that they themselves are doing most of the work securing their jobs. A good agent can help you, but you cannot rely solely on this person. Marketing, press, and advertising are your job; their job is getting your

work seen at agencies and negotiating your fees once you've been positioned to bid on a job.

Before signing any contracts, it's imperative to interview the agent you're considering hiring. While you may be expecting *them* to interview *you*, tactfully and respectfully turning the tables a bit can put you in a position of greater respect. An agent is going to be as much a part of your career development as any other team member. In addition to getting your work seen by the right people, some agents will handle production work (creating detailed production estimates, calling the crew, arranging craft services, etc.), although others won't. It's important to clarify all details during your interview and get it in writing before signing any contracts. While many contracts are negotiable, it is standard in the industry for agents to require a 2- to 5-year exclusivity contract and then take 20–25 percent for every job you acquire. This even includes those jobs that come directly to you without the seeming intervention of your agent. This is because agents believe they invest a lot of hard work into developing your career for you, and contacts and connections may come to you through a variety of sources. My advice is to negotiate a shorter (but renewable) contract term, for example 2 years in lieu of 5. This will allow both of you the freedom to go elsewhere should you feel the partnership is not a successful one.

You will encounter all kinds of agents. You may meet young, eager, and motivated people but discover them to be inexperienced and unknown to ad agencies. This is a hindrance to your career development because they won't know the shortcuts to getting your book seen by the right person at a busy agency. You may also find agents who are very established in the industry but clearly burned out and unmotivated, relying on their established photographers to generate the jobs while they take in the profits. You can be the big fish in the little pond or the little fish in the big pond. On rare occasion, if you're lucky, you may encounter an agent who is someplace in between—experienced, skilled, and still energetic—someone who will keep their promises about shopping your book around to the various agencies on a routine basis and push hard to close the deals for you. If you can persuade such agents to meet with you for ten minutes, go for it. However, be prepared as they may already have enough

established photographers to manage in their stable of talent and may not want to take on new talent at this time. Don't be offended; be respectful, thank them for their time, and always stay in touch with them in the future. There is nothing worse than an arrogant photographer whose feelings are hurt by a seeming rejection. You never know when there will be an opening with this agent should one of their photographers decide to leave for whatever reason. As with marriage, not every photographer–agent relationship is meant to be.

NURTURING YOUR TEAM

Most of my assistants are super gear- and tech-savvy—they know the latest and best gadgets on the market and how they function, so I don't have to train myself much. Once I find a great intern, assistant, photo lab, or other collaborator, I go out of my way to make sure that they know what a great job they're doing and how deeply I value and respect them. A pat on the back goes a long way. I've had a few assistants who have been working with me for a number of years. One of my assistants is always available for a late-night SOS call when I'm in a jam and is so dedicated he's even pulled a few all-nighters with me to complete rush jobs for my clients. What's more, during photo shoots he is very good at thinking on his feet, and after many years of working with me he knows my trademark lighting and composition style. As a result, he is always ten steps ahead of me in preparing for the next shot. The best part is that because he knows my very specific way of composing images, I can trust him to work as a second shooter for me for bigger jobs. He's almost a "mini me." Because of my reputation and very specific shooting style, it was years before I was able to consider a second shooter. Now that I can, I do whatever I can to reward him. This means sushi dinners, Christmas gifts, and even hiring a professional massage for us after a photo shoot. I have another assistant who has worked as both my production manager and as a photo assistant. While she isn't as tech-savvy as my other assistant, she is a true organizer—coordinating travel plans, organizing the crew, planning the meals, handling paperwork and receipts, keeping us on schedule, and just about anything else logistical I need to make the shoot and my life easier. She's a real gem.

Since all of my assistants are great photographers in their own right, I offer my private consulting time reviewing their work or going over business and client relations as a gesture of my sincere gratitude. Nurturing these relationships is like nurturing yourself, so it's absolutely imperative as you and your reputation grow that you keep these relationships devoid of any bad feelings. Gossip and word of mouth are more powerful than all the money you could ever spend on advertising. Be careful during a heated conflict not to say or do something you may regret later. *Always* maintain a calm, professional demeanor, even if you feel like you're exploding inside. The world and our lives are unpredictable; situations and circumstances are changing all the time. You never know when you will cross paths with this person again and when you might need them as your ally. If you have to let a team member go, do it with respect for their dignity. Let this person know how much you have appreciated working with them and that you will consider them again at another point in the future.

Notes

9

The Ten Commandments of a Successful Photography Business

For repeat clients and increased revenue

JUST AS THE PRESIDENT OF THE UNITED STATES TAKES AN OATH OF office when he begins his first term, so too shall you when you begin your photography business. The following list of rules (I call them my "Ten Commandments") will serve not only as the guidelines for structuring your business, but also as a sort of an internal coach that keeps you on track. They will provide a foundation on which you can expand according to the nature of your particular business.

You will notice that I have written the rules as statements. I have done this because I find when I repeat something out loud, with conviction, its impact is far more significant.

Rule #1: *"I will NOT shoot any photo jobs for FREE!"*

The biggest issue my assistants and interns encounter when they start their businesses is that they are constantly being asked to shoot something for free. These insulting requests usually come from a friend or a family member. I don't understand why anyone who cares about someone else would ask them to provide a free service, especially when it's that person's means of earning income. I have found when we do something for free the other person usually doesn't value it even half as much as they would if they had paid for it, so it's a "lose-lose" situation.

I say you can offer to walk a friend's dog, wash her car, babysit her children, or bake her a cake, but do not give your *photography* services away for free. Not only is it harmful to your relationship with this person, but you're doing a great disservice to your entire profession. By agreeing to shoot something for free, you send the message to the world that photographers do not need to get paid for what they do. And guess what? You won't. In fact, I'll go so far as to say that when a friend offers *me their* service for free, I usually decline because I respect their profession, our relationship, and the healthy exchange of money.

The same rule applies for discounts. The more I discount my services, the worse I feel. I instinctively know when I'm not getting paid what I deserve; I'm devaluing my services and in turn it seems the client continues to expect more and more of me as a result. It's an endless, vicious cycle, and it leaves me feeling used, unappreciated, and resentful.

There is a fine line between business, friendship, and family. Keep them separate. You can be friendly, but it is imperative that you maintain the same professional rules with friends and family as you would with your clients. Let them know that this is your business. When a friend calls me to shoot something and they start by saying, *"I just need a few quick shots of . . . "* I say, *"Great, I'd love to . . . This is what I charge."* The minute you hear someone say the words *"just"* or *"a few quick shots,"* be prepared. Don't get angry; just be enthusiastic and assume that they intended to pay you. It takes practice. While you may feel uneasy at first, soon enough people will stop asking you to do your work for free. This will be a huge relief, and your relationships with friends and family will be so much better as a result. I'm simply a firm believer that friends should pay their friends *more* than they charge, not the other way around. The exchange of money is a healthy way to respect and honor that person. It also sends a message to the universe that you are putting money out into the world, and money will then flow back to you.

All this being said, there is only one exception to this rule (I am reluctant to say this, but I will anyhow). This is if you are considering pursuing a specific subject matter (such as car racing, weddings, or sports photography) and have few or no sample images to show potential clients. In this

case, if someone asks you to shoot this subject for free or offers to cover your expenses, then at least you will gain some portfolio samples, which will hopefully help you to land a paid job the next time around.

Trades

When I am asked for a trade, I am reluctant to agree. I usually respond by telling the person that I would rather just trade cash instead. This way we can each place a fair value on our work and simply agree to hire one another. I say this because often others do not know what I charge for my services; they may assume the value of *my* services is equivalent to the value of *theirs*. For example, I have a friend who is a great massage therapist. He charges $125 per hour. He wants to trade a headshot for a massage. My headshots are $395 and my portrait sessions start at $795. This means that he would have to agree to perform a certain number of massages in exchange for my one session, and I would have to trust that he would honor this agreement. This kind of arrangement can put a strain on the relationship and someone usually feels cheated in the end. Isn't it just easier to trade cash for cash?

Rule #2: *"I will always limit meetings to one hour, if possible."*

When scheduling meetings with clients, tell them you have an appointment slot open at a specific time, say 2:30 PM for example. Be specific, like a busy hairdresser or doctor. Do *not* say, *"I'm wide open . . . I have nothing booked . . . I am very flexible . . . anytime is OK. No worries."* This says, *"I'm just sittin' around playin' on the computer because I don't have a lot of clients because no one wants me because I'm no good."* People want what and who is in demand. If you go by a restaurant or nightclub and see a line out the door, while you may not want to wait, it will make you curious as to what everyone else sees in this place that you haven't discovered yet.

Try your best to limit your appointments to one hour or less. You can cover a lot in an hour if you're prepared, limit the chitchat, and keep the conversation focused. Try answering the most frequently asked questions

before the client even asks them. Time is money, and while you don't want to rush your clients out of your office (especially if they're just on the verge of booking you), you don't want to give them the impression that you don't have other clients waiting, either. Always have (or pretend to have) another appointment immediately after theirs, and always be the one to end the meeting first. If you can make it look like you're in demand, you increase your chances of *being* in demand.

Rule #3: "*I will NEVER look, act, or speak in a way that conveys desperation!*"

If you've made the mistake of not collecting payment from your client before the shoot, do *not* ever say, *"Do you think you could pay me for the photo job I did last week? I really need the money to pay rent—otherwise I wouldn't ask you."* Begging others for something that is owed to you without question is pathetic. It devalues you and the product you created and is a surefire way to encourage someone *not* to pay you. People do not respect desperate, overly available people, especially artists. Whether you're feeling rich or poor, your financial situation is none of their business and it should never be mentioned. If you really are desperate, just "fake it till you make it."

Rule #4: "*I will not shoot ANY jobs without a 50 percent deposit, a signed contract, and the remaining balance paid in full.*"

Your contracts should specify the shoot date and include a cancellation policy. As mentioned previously, because we create a custom product and it cannot be sold to anyone else, it is only logical that we be paid in advance before creating this product. Yes, this rule applies even for friends and small jobs like headshots. It tells people that your time is valuable and that if they don't show up, you will keep the money. Most customized products are prepaid. For example, if you purchase business cards, letterheads, or promo postcards, you must pay for them in advance. There are many noncustomized items that we purchase online, sometimes from companies we have never even heard of, and yet we never question paying

for them in advance. Why should our clients question our request for advance payments?

Rule #5: *"I will ALWAYS give a receipt anytime money is exchanged or I give away free products or services."*

Giving your customers a receipt each time money is exchanged is effective for numerous reasons: It makes your business look more legitimate and more professional, it gives your client and you a record of any monies exchanged so there is never any question, it helps you and your tax accountant organize your taxes, and it is a useful marketing tool because your clients will remember you when they come across your receipt later. You can have a stack of preprinted, carbon-copied receipts made inexpensively at any local print shop or simply make a photocopy when the deal is sealed.

It's also important to give a receipt even when you discount your services or include them for free. This might mean including additional time, additional images, or custom retouching. A receipt in these cases serves several purposes as well. Not only does it remind your customers of your kindness and generosity, the discounted or gratuitous services can be used as a tax deduction as well!

Your receipt should include the normal fees you charge for your services as well as any discounted or free products or services. You might strike a line through the normal fees and show the discounted rate, or write something like, "No charge, my gift to you." If I am including something for a wedding client, I might write, *"Congratulations Bill & Mary! This is my wedding gift to you."* Clients love this! I simply insert this final invoice inside the box or envelope with their finished prints or digital file CDs.

Rule #6: *"I will ALWAYS charge for extra labor time and expenses."*

It's critical to charge for additional services like custom retouching, extra shots, and extra time. If you don't, your clients won't appreciate the extras you gave them and will probably even expect you to include them again the next time. Little by little, you'll find yourself giving away more and

receiving less. It's a dangerous cycle. With this in mind, it's important to have different all-inclusive packages: a basic package that does not include retouching, a midrange package that includes basic retouching, and a deluxe package that includes custom retouching. Since most people don't realize the extra time involved after the shoot to process, edit, and retouch the files, this educates them and adds value to your retouching time and service fees. Most photographers would agree that we could easily spend twice or even three times as much time retouching images from a shoot as the time spent actually shooting them. However, this being said, naturally you want to deliver a professional product. This is why I always stress the importance of capturing the best image possible with your camera to save yourself time during postproduction processing. Nevertheless, we are human, and there will be instances when the need for retouching is clearly *our* fault due to a poor composition, poor exposure, or the absence of something that should have been in the scene but wasn't due to our neglect. In these instances, you don't charge your client. It's your obligation to deliver the product you promised. However, if your client has poor skin, acne, lines, wrinkles, or age spots, this is *not* your fault. While you will do everything in your power to hide these things (using the right lighting, camera angles, and filters during the shoot), additional retouching will be required to give a cleaner, more attractive appearance. In these cases, you need to give your client an estimate of the cost for your retouching based on an hourly rate.

Rule #7: *"I will not reshoot ANYTHING unless I (or my lab) am at fault or I am compensated."*

You may come across a situation where your images do not come out exactly how you or your client envisioned. This is why it is imperative that you define as clearly as possible (in writing, in your contract) what the client has in mind. If the resulting issue is a technical one, this *is* your fault, (even if your lab made the error). It is unethical to do anything less than reshoot the job. Your reputation is worth more than the cost of your shoot expenses, so you will have to suck it up and absorb this one yourself. It is imperative that you act in the most apologetic and professional

manner possible. Do not act frustrated or angry about having to reshoot the job. You do not know the impact a negative review can have on your reputation; news travels fast, so it's best to do the right thing. However, if the client decides that they want something other than what was defined in the contract, again, this is *not* your fault. They have simply changed their mind and they now want to see other options. Instead of assuming they will try to guilt you into reshooting at no additional cost, turn it around and assume that this means another shoot and more business for you! Wahoo! In these cases, remain professional, positive, polite, and flexible. You might feel inclined to reduce your rates slightly, rewarding them for being a "repeat client."

Rule #8: *"I will not take conflicts personally. I will always remain calm, professional, and unemotional."*

Unless you're working with an ad agency, most of your clients will know very little about professional photography, and as a result they may have misconceptions as to the amount of time and labor it takes to produce quality work. If they challenge the amount that you charge, don't get angry or defensive and don't take it personally. Instead, briefly and politely educate them in a positive, professional tone. Explain to them why your products and services are priced the way they are, what your services include, and what makes your product unique compared to those of other photographers. You might detail the amount of time and effort you put into each client's job to ensure that the entire production runs smoothly, from idea research, location scouting, and test shooting to directing, custom retouching, and delivery of the final product. Time is money, and most people can relate to this concept.

However, there will be times when you must walk away from an abusive client who is relentlessly pushing you to reduce your rates. These clients can drain you, kill your self-esteem and creative passion, and they don't support a positive energy flow. Save your reputation and your integrity and politely walk away (even if you're totally broke and desperately need the money). The universe will most likely bring you a newer and better client anyhow. Trust me—it happens all the time. Tell them, *"Thank you,*

but I don't think we're meant to work together. I have another client arriving any moment. I must go." No further explanation is necessary. If you haggle back with them and show them you are angry, not only will you find yourself feeling even worse, you'll be wasting valuable time that you could be using to book your next client.

Rule #9: *"I will raise my rates when I know my work is worth it, even if business is slow."*

Don't make the mistake of assuming you're not getting business because your rates are too high. Sometimes people get suspicious when you're rates are too *low.* When I see something great that's priced really low, I automatically ask: What's the catch? What are they doing to cut corners? Sometimes I'll play it safe and choose a more expensive service, subconsciously reassuring myself that they must be better because they are confident enough to charge more. I know a higher price doesn't always mean better quality, of course, but it does make one wonder.

Many years ago, I realized that even though I had plenty of business, after my expenses I wasn't making a profit. I knew I had to raise my rates if I was going to survive. I looked at my price lists for everything from my weddings and portraits to my interiors and advertising. I kept a "Time and Expense" logbook for every job I did (see chapter 11: Pricing Your Services for Profits) and calculated that I was going to have to at least double my rates if I was going to continue to create dynamic imagery and make a profit.

For most of us there is always a little fear when we move to the next pricing level. The voice in our head says, *"Hey you! Who do you think you are, charging THAT much for a photo shoot? What makes you think you're any better than the next struggling photographer out there?"* The voices went around and around in my head, but I knew other photographers of my caliber were charging considerably more in every subject matter I reviewed. I was constantly showered with compliments from clients and admirers and this support gave me the encouragement and confidence to close my eyes and take the plunge. I knew I had to increase my service rates if I was going to stay in business.

To prepare myself, I had to mentally accept these new dollar amounts. This was a real struggle for me. I had read in a self-hypnosis book that if you write down specific affirmations several times and read them out loud, staying completely focused on the words, eventually your subconscious mind accepts them, integrating them into the fabric of your entire thought process and applying them to the universal law of attraction. In turn, you will be able to make your desires a reality. Sounds like "hocus pocus," but it works! At the time, I was charging a very minimal rate for my work; I didn't have the knowledge or confidence to charge more. I knew I had to double my current rates. Keep in mind, this was many years ago, so at the time the dollar amounts seemed very high to me. I took out a piece of paper and wrote the following words several times, over and over:

I, Elizabeth Etienne, am an amazing photographer!

I deserve $3,500 for my wedding photography.

I deserve $7,500 a day for my advertising photography.

My work is outstanding!

I, Elizabeth Etienne, am an amazing photographer!

I deserve $3,500 for my wedding photography.

I deserve $7,500 a day for my advertising photography.

My work is outstanding!

I just kept repeating the same words again and again. At first I felt silly and conceited, but I could feel a shift taking place, and I felt it a little more with each page of writing. I giggled with excitement, slowly starting to feel very comfortable with that number and dollar amount. All we need to do is train our subconscious minds to accept the new value amount and the world will quickly catch on. By the time the phone rang the next day, I had gotten used to saying these dollar amounts. A wedding client asked how I worked and what I charged. I just repeated my affirmations: *"Thirty-five hundred dollars, and I require a 50 percent retainer deposit."* He simply said, *"That's fine. Please send me your contract."* And that was it; I had done

it!!! But I knew I had to "become" that $3,500 wedding photographer. I knew my work was good, but in my mind it had to be outstanding for *that* kind of money! It really pushed me to the next level and over the years I just kept increasing my rates a bit at a time. With each rise in my income came an increase in the quality of my products and services. From my images to my packaging and everything else in between, I was determined to become a 5-star business!

It's a known fact that people often want what they can't afford. They like to test-drive the new BMW, even though they know their budget is better suited to a Ford Escort, and a savvy salesperson will steer them toward the former. Suddenly, they are digging through their savings, taking out loans from their great-uncle, and miraculously figuring out a way to buy the BMW. Confidence speaks volumes. Learn how to be a good salesperson and politely "educate" your clients as to the value of your work. In time you'll be able to increase your rates because the quality of your work will improve until you have a trademark style that is yours alone.

Rule#10: *"I will always include a 'thank-you' note and/or client gift upon the completion of each job."*

Always leave your clients with warm and loving thoughts about you when you finish a job. In our day of emails and text messages, there is nothing more personal than an old-fashioned, handwritten card. If your budget permits, a small gift is a wonderful surprise. This is a thoughtful gesture of gratitude for their patronage and will most likely make them want to hire you again and refer you to all of their friends. Gift ideas might include a small frame or an enlarged print or even a discount coupon for their next session. These small gestures not only show appreciation, but help boost your business as well.

Notes

10

Dialing In to the Success Frequency
How to get it and keep it!

GET OUT OF YOUR PAJAMAS! TAKE A HOT SHOWER. GET A CUP OF coffee. Play your favorite music (*loud!*), open the shutters, and let the sun shine in! Do whatever it takes to get moving and motivated. This business requires your mind and body to be operating at optimal performance for optimal results. If you feel sluggish in the morning, then get out of the house, go for a brisk morning walk, jump in the ocean . . . get some fresh air! Sometimes I even go so far as to dress in my nice business clothes (even if I'm not seeing any clients that day) just to "get in the mood." Find passion in what you're doing and things that raise your positive energy level. Other times, when I get stuck in a deep rut, I just go see a movie or attend an art gallery opening to recoup my energy and creativity.

Dialing in to the success frequency is like fine-tuning a radio to pick up a specific station when you're living out in the middle of nowhere. When I'm tuned in to my success frequency, all sorts of magical things begin to manifest in my life. Sometimes I get the feeling I'm actually aging in reverse!

So how does one dial in to this frequency? By feeling happy, excited, optimistic, or blissfully joyful about life. Positivity is an extremely powerful energy frequency. There is actual physical evidence that shows that a positive thought creates ten times more energy than a negative one (besides, I don't have the luxury of negative thoughts, so I don't even allow them in).

EXERCISE AND NUTRITION

There are a number of things that can contribute to feeling good. Stretching and exercise can really make a difference. I like to ski, surf, go on a hike up the canyon, or a run on the beach—anything that pumps blood through my veins and builds up a warm sweat always makes me feel great! You don't need to be an exercise freak, but as humans we need to move our limbs and muscles to detox, generate new blood cells, and maintain physical strength and mental flexibility. I try to exercise at least thirty to forty minutes a day and stretch each morning. Stretching is really helpful because when I'm shooting, I'm always squatting, bending, and reaching while holding my gear steady to get the shots I want. When I stretch, I remember that I have a body and this reminds me to love and take good care of myself as best I can. I also try to balance out my exercise routine with yoga and surfing, which strengthens my core and mental concentration.

You are what you eat, and this will affect the way you feel and the images you create. Knowing this, I eat as healthily as I can, sticking primarily to organic fruits and vegetables and wild (not farm-raised) fish and supplementing these with vitamins and minerals. Treating yourself to a little sugar, caffeine, alcohol, carbs, or junk food is OK "in controlled moderation"; just keep things in check. Some of us are more sensitive to these stimulants and depressants than others, so be aware of how they affect the way you feel each day.

You don't need to be an adrenaline junkie like me to raise your positivity frequency. Listening to your favorite song, petting a pony, inhaling the smell of an apple-cinnamon pie baking in the oven, traveling to a new and beautiful destination, giving to someone in need, or simply gazing at a great piece of artwork—it all stimulates the body, mind, and heart.

CHOOSE YOUR WORDS WISELY

Watch what you say. Replace any negative words with positive ones. Change your words and you'll change your life. Instead of saying, "the problem is . . ." or "the issue is . . . " try saying, "the *answer* is . . . " or "the

Sample FAMILY AND KIDS images

Sample INTERIOR images

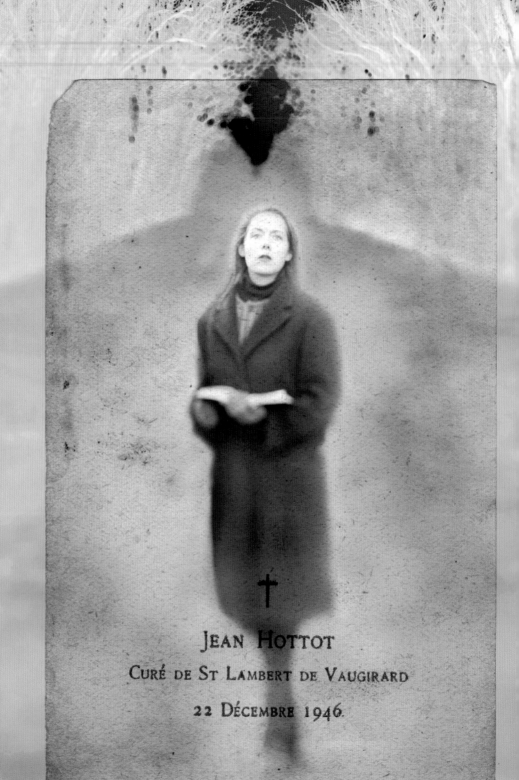

JEAN HOTTOT

CURÉ DE ST LAMBERT DE VAUGIRARD

22 DÉCEMBRE 1946.

Sample FINE-ART images

Sample FOOD AND BEVERAGE images

Sample TRAVEL images

Sample PORTRAITS

Sample HEADSHOTS

Sample STILL LIFE images

Sample ENGAGEMENT images

Sample WEDDING images

Sample ADVERTISING images

Sample PREGNANCY images

Sample FAMILY/STOCK images

Sample CORPORATE PORTRAITS

Sample BOUDOIR images

Sample KIDS images

solution is . . . " Don't tell me what you *can't* do, tell me what you *can* do. Don't tell me what *isn't* possible, tell me what *is* possible! Get it? Turning a negative into a positive brings feelings of hope instead of fear. It opens up a doorway to endless possibilities. In the morning, when I first wake up and get out of bed, or as I'm taking my shower and feeling the warm water rushing over my head, I say to myself, "Great things are happening today!" Before I do a photo shoot, I always say, "I'm going to make some amazing images today!" When you're dialed in to this frequency, it feels like the sun is shining on your face, even on a cloudy day. This will help you to create better images and attract more success into your life.

SURROUND YOURSELF WITH POSITIVE, SUPPORTIVE, AND MOTIVATED PEOPLE

Avoid people with negative attitudes. Naysayers can really destroy one's sense of self-esteem. Isn't it odd how ten compliments can be erased in a second by one insult? As humans, sadly, we are impacted more by painful memories than positive ones, so these are what we usually tend to remember. It's imperative that we shake off those thoughts and stay away from low and dispirited people. Even if a person doesn't insult you directly, the frequency of a negative person's energy can be very detrimental to your fragile soul. We photographers are sensitive people (that's what makes us such great artists), so it's even more important to protect our greatest asset. It's best to focus on the wonderful things people have said about your images, your personality, and your work ethic. I save each and every compliment anyone has ever written to me. Not only do they serve as great testimonials for my website, they remind me how much others appreciate me, and this makes me feel good.

VISUALIZE YOUR DESTINY

I have always been good at miraculously making my visions a reality. I call them "visions" instead of "dreams" because dreams seem just that, dreams, unreal and unobtainable. Once I have a strong desire, it becomes a vision,

and the vision becomes almost an obsession. It's as if I have already lived the vision long before I ever have.

When I was only fourteen, I envisioned myself having a red convertible as my first car. I found an ad in a magazine and used it for an exercise for my high school painting class. I actually painted myself in the red convertible car. Four years later, during my first year at college, coincidentally my boyfriend was selling a car. Guess what car it was? That's right—a shiny, red MGB convertible: the exact same car I had painted myself in back in high school! The same thing happened again with another photograph I had torn out of a magazine. The image was of a beautiful, snow-covered mountain range with a small, red chalet. I just loved it for some reason, so I used it as a template for another painting I did in high school the following year. The year after I bought my red convertible, I spent a semester abroad in the French Alps. I had no idea that the beautiful mountain range I had painted a few years earlier was the *exact* same mountain range where I went to school in Grenoble, France! I realized this when I found the dusty magazine picture posted to my bulletin board in my old bedroom; the caption beneath it said, "Grenoble, France." I just couldn't believe the odd coincidences. It was as if I had painted my visions of my future.

Here in Southern California where I live, a few years back, I used to walk on the beach every day, and I would say to myself, "What a dream it would be to live right on the beachfront." As the months passed by, I decided to change my words: "One day I just *have* to live on the beach." I could just *feel* my soul aching for it; it hurt so badly I wanted to cry. Finally, one day I suddenly said, "I'm going to make it happen! I'm going to live on the beach!" I could actually feel my soul racing toward the vision, and within a few minutes, right in front of me, was a "for rent" sign for a house right on the beach! My heart was racing, moving me forward, like an Olympic athlete crossing the finish line. I couldn't dial the telephone number fast enough. The price seemed above what I thought I could afford, but at that moment I remembered something a friend had said to me: "Everything in life is negotiable, Elizabeth." I could actually hear those words encouraging me, pushing me forward, and for the first time in my life I actually "negotiated" something for

myself. I told the realtor what I was willing to pay and we negotiated somewhere in between. It was mine! I had done it! I was living *right on the beach*. I couldn't believe it! This is the power of positive thinking. This is how we can make our visions reality.

THE EXPECTING ZONE

The "expecting zone" is the most powerful space to be in. This is also referred to as the "law of attraction." People are always asking me, "How did you get sponsored?" "How did you get published in magazines?" "How did you get your book deals, workshops, private coaching, and guest speaking events?" Well, there is no easy answer to all of this. Everyone's journey to success is different. One day I will write a book about how it all came together (so be on the look out for it!), but for now I will just tell you that you need to "expect" that you will get invited to "the party." You need to feel you honestly "deserve" it beyond a shadow of a doubt, or the bouncer at the front door won't let you in. Just as a horse senses a frightened rider and always takes advantage, the same can be said of success. Somehow, I just knew instinctively that it would all happen long before it did. Call this confidence, instinct, or whatever you want, but I was just "expecting" it. I was, and always have been, in the "expecting zone."

Where did this confidence come from? Well, it's a combination of things, from the minor achievements of my early childhood to my day-to-day exchanges with clients and other people. However, contrary to popular belief, in the beginning of my career I was actually one of those shy people who couldn't imagine shooting strangers at a party (let alone a famous celebrity). I hid behind my camera most of the time and kept my distance. I simply didn't want to intrude on anyone's personal space. I was living in Paris at the time, and out of the sheer desperation to pay my rent, I took a job for a press magazine shooting celebrity red-carpet events at film festivals around Europe. Sandwiched between the mobs of sweaty male photographers scrambling to get a good shot, I just knew there had to be a better way to get the images I needed. I had a hunch that the best shots would be at the private parties, but my name wasn't on any of the lists. Rather than standing in the long line with all the other press photog-

raphers trying to edge their way in, I just strutted past the crowd with my head held high to the front of the line and "acted" like I was "someone" expecting to get in. The bouncers were so taken aback by my gumption and my confidence that they didn't even ask to check my name on their guest list! They let me right in, and all the celebrities posed for my camera without hesitation. It was awesome and I got the best shots of the night! I'm not suggesting that you act arrogant, but confidence is imperative.

Fake It Till You Make It

For most of us, approaching a stranger at an event for a picture can sometimes feel awkward, even for the most extroverted, outgoing person. The way I learned to get over my natural timidity was to actually tell myself that I had to become *another* person. No, I don't mean someone with multiple personalities; I mean that I had to think of myself as a performer, just like the actors I was going to photograph. I closed my eyes and just visualized myself smiling as I approached them, focusing their faces into my lens, clicking the shutter, and smiling with a gesture of thanks afterward.

Celebrities know the routine. We are both just actors, playing our parts to do our jobs and get paid. These people are as human as you and me. While it's certainly easier to photograph people who are accustomed to it, you may encounter those who are more camera shy than others. It's your job to try to make them feel comfortable (even if *you're* not). Take the initiative to speak loudly and clearly and give them some direction: "*That looks great! Can you turn just a little this way or that way? How about pulling your mother into the photo? Just step a little to the left if you wouldn't mind...*" I pretend that I'm getting paid $10,000 for this great snapshot of these famous people (even if they aren't famous). This is just a mind game I play with myself. Sometimes you just have to fake it till you make it.

Overcome the "Struggling Artist" Syndrome and Heal Your Relationship with Money

Being a struggling, poor artist isn't cool. It's a silly, juvenile, pathetic vision some people have that forever traps them in a position of inferiority and destines them for failure. Many people have a bad relationship

with money, perhaps passed down from their parents' parents. Some of us were raised to believe that nothing comes without sweat, tears, and years of struggle: that if we didn't work hard to get it, it wasn't ours to have. I actually remember as a toddler putting a penny in my mouth and my mother yanking it out aggressively saying, "That money is filthy!" (And it probably was.) I may have somehow interpreted this to mean that money was dirty and I didn't deserve to taste it. Thankfully, I don't think that way now, but it took some time to "deprogram" myself.

Money and success are good and you deserve to have them. You need to truly accept this into the fabric of your soul or you'll never have either. Think about all the good things and people you'll be able to help when you earn enough money. It's awesome! Look at Oprah; think about where she came from and what she has done to help others with her money. She's amazing, and the work she has done is a true testament to the power and the good of money. Personally, my motivation to earn money isn't just to buy a fancy car, take a luxurious vacation, or buy another Prada handbag. It's more about the endless people I could help if I had enough funds to do so. Remember the episode of *Oprah* when she gave a bunch of needy people a lot of money, and then asked them to give it away to other less fortunate people? How about that incredible movie, *Pay It Forward* (starring Kevin Spacey, Helen Hunt, and Haley Joel Osment)? If you haven't seen it, do. It's the story of a young boy who comes up with the idea to help people in the hopes that they too will help other people, and so forth. Both the *Oprah* episode and this movie touched me so deeply that if I ever won the lottery I would probably give away 90 percent of my money (and savor every moment of it!). I envision that I'll be able to do the same for others one day too. That's the power and beauty of money.

CREATING A "SUCCESS ZONE" ENVIRONMENT

While statistics indicate that most of us prefer to work from home over commuting to an office destination, one downside to this is the number of personal distractions, like family, friends, and neighbors. If you do choose to work from your home office, it's imperative that you set personal boundaries and do whatever it takes to protect the sanctuary of your office

space. Because your office will be the main hub of your success zone, it's critical that you create an environment that enables you to be productive and instill trust in your clients. I recommend a separate room with a door that allows you to create some distance between your business and your personal life.

Working from home will require that you define your office hours, your way of doing business, and your personal boundaries with others. You'll also need to set some rules for yourself in order to stay disciplined and focused on your business. This is one of the most important and challenging aspects of running your own business. My rule is: no drop-ins, no social calls, and no personal emails or texting during office hours. I can hear you saying, "What? What if my best friend is having a crisis because her boyfriend just left her?" Sorry—you'll have to take that call after work. You have to pretend you're working for someone else, not yourself, and you would never consider leaving work because your friend was having an emotional crisis. If you have kids running in and out of the house, close your office door and get a babysitter. Let your friends and family know what a challenge it is to be your own boss and that you need their support and cooperation. While they may have a weekly paycheck that guarantees their rent gets paid, you don't. I like to joke and say, *"My boss is VERY angry at me today . . . I'll get fired if I don't get back to work!"* They laugh and get my point. I also define office hours with clients. I had one client knock on my door on a Sunday morning at 9:00 AM to pick up their prints. They assumed that because I work out of my home they could simply "pop in" anytime. I think some people have a mental picture of those of us who work from home sitting around all day in our pajamas, casually doing a little work here and there between soap operas; we're really not doing anything important, so it's all right to drop in anytime. You *must* separate your social life from your work. This is a challenge, I admit. If necessary, have separate email accounts and telephone lines for personal use and turn off your personal phone during work hours. This enables your friends and family to leave you messages whenever they like, knowing they aren't disturbing you. Then you can check these messages during your designated 30-minute lunch break or at the end of the workday.

Feng shui is an ancient Chinese system of aesthetics believed to draw on the laws of both astronomy and geography to help one become healthier, happier, and richer. A fundamental rule of feng shui is that one should never position their back to the door through which clients (and money) arrive. This means that you should not place your desk flat up against a wall if you can help it. Instead, position yourself, your desk, and your computer so that you are always facing either a window to the street or the door clients use to enter your office. The sound of running water—crashing ocean waves, a rushing stream, or even just a man-made miniature fountain—can stimulate prosperity. Live plants symbolize life and growth. It's also important to take into consideration the color of your walls and furniture. Ideally you will want a mix of round and square furnishings, metal and wood. Too much of one thing will keep you from achieving good balance. There are dozens of books on feng shui that can give you more information. See chapter 3: Start-Up Expenses for more information on color and how it affects emotions and moods.

Once a year I'll refresh my office. I'll put up new images, different frames, or a totally different display altogether. I also believe in cleaning (a lot!). This gets rid of old, stale energy and makes new energy, new thoughts, and new possibilities. I'll move my desk to a new spot, clean out the dust behind it, paint a wall a different color, throw out old items, or reconfigure the placement of all my computer devices. This makes me feel like I'm in a new place—an important element for renewing the energy in my success zone. Last year I replaced the old couch with a new one and bought new, better back-supporting office chairs for my office assistants and myself.

In addition to feng shui, I fully believe in the importance of a clean and organized office. A cluttered office can create a cluttered mind. Like a storefront window, the entrance to your office should be a clear and attractive pathway. Kids' toys scattered on the floor, blaring TVs, and other distractions send the wrong message to your clients and give the impression that you don't take your business as seriously as you should. Removing unneeded clutter is incredibly beneficial to all aspects of your life. Remember, you are creating an environment that enables you to work at maximum performance. You are creating your "success zone"!

11

Pricing Your Services for Profits
An easy estimating formula for any job

"WHAT DO YOU CHARGE?" THIS IS THE BIGGEST QUESTION YOU WILL be asked when approached by a potential client. Effectively pricing your photography services is *the* most important factor in running a successful photography business. Pricing your services too low can be just as detrimental as pricing them too high. While most of us would like to think that our amazing images are the key to our success, sadly, this isn't necessarily the case. In fact, there are many variables that contribute to the success or failure of one's business—and pricing is certainly one of them.

For many of us, pricing our photography services is the most challenging aspect of our business. Connecting our self-worth to a dollar amount can bring up a lot of emotions. I used to stutter and say, "Uuuuummmm . . ." every time someone asked me what I charged. I was worried that I might be too expensive and lose the job. Other times, I would undercut my costs and end up angry (and broke!). Most of the time I didn't even know how much of a profit I was making, if any.

There is no magic number assigned to specific photographic services. Rates will vary from one photographer to the next based on the quality and reputation of their work, the time and expense involved in producing a photo shoot, and the current economic climate of the area they work in. Before you create all-inclusive, prepriced packages or prepare a professional job estimate for your clients, do some calculations on your own using the estimating formula illustrated in this chapter. You should take several things into consideration: your time, your hourly rate, your expenses, the

client's budget, your artistic value, and how and where your images will be used by your client.

The Time and Expense Log

I will ask that you create you own time and expense log. This log is just for you; it is not something you will be showing your clients. Its purpose is to help you keep track of the time and expenses involved in the production of a particular kind of job, so that you can factor these amounts into your estimating formula.

Let's begin with the tangible things, like the actual time it takes to produce a job from the initial inquiry to the final delivered product. Next, let's consider every little expense related to the job, from the printed thank-you note card to the gas you'll use driving to and from the shoot location. Don't overlook the small stuff. Create one column for your expenses and one for your time. It's just important to keep track of these things for the first few jobs. This is the only real way of knowing how to effectively estimate a job when one comes along.

Below is an easy estimating formula any artist can apply to any job situation, anywhere, anytime.

$$T \times HR + E + CVM = MY\ FEES$$
Time x Hourly Rate + Expenses + Creative Value Mark-Up = MY FEES

Time

When you calculate your time for a job, you need to consider the total time you will spend in preproduction, production, and postproduction. Preproduction will include your early correspondence with the client (emails, phone calls, text messages, and faxes) to secure the job and preproduction planning (image-idea research, meetings or emails with your crew, location scouting, props, wardrobe and hair, makeup consulting, equipment cleaning, and checking and prepping the gear). Production will include shooting the job (driving to the job location, taking the images, tearing down the equipment, packing it up, driving home, and unloading the gear). Postproduction will include finishing the job (processing, editing, retouching, packaging, follow-up correspondence, and delivering the final

product). Every minute needs to be noted. This is the total time involved in producing the job.

When your client calls about the job, make note of the *time* on the clock and enter it in your logbook. When you hang up the phone, look again and see how long the phone conversation took. How about emails? How many have you exchanged, and how long does it take you to read and write them? How long does it take you to drive to the location to scout it or research images in your idea files or elsewhere to get ideas for the shoot? What about driving to the post office to drop off the package to mail to them? Keep track of every bit of time involved, every step of the way.

HOURLY RATE

The next item in your estimating formula is your hourly rate. You need to ask yourself, "What am I worth an hour?" Most trained "service" professionals will charge $75–$300 per hour. This includes everyone from a massage therapist to a lawyer. These are people who usually have little or no equipment overhead. With a few months of training, a massage table, some oil, and a clean bed sheet, a massage therapist can be earning $50–$100 per hour. I spent over $100,000 on my 4-year photography education over 20 years ago. I own over $75,000 worth of photo and office equipment, and I have a hefty insurance policy that covers my equipment and liability. With assistants, photo repairs, portfolio materials, marketing, and advertising, my overhead each month is pretty high. That being said, I need to earn a certain amount just to keep my business running (not to mention make a profit).

For those of you at a beginner business level, you should consider yourself worth *at the very least* $75 per hour. This is a very low base at which to begin to rate your hourly fees. As you become more and more skilled and come to develop your unique style, reputation, and business production system, you may find that your overhead expenses will increase because your production value costs will increase. You will probably be spending more to present a better product. This will force you to raise your hourly rates a little as you go in order to make a profit.

Traveling to and from a job location can absorb a half or even full day, if not more. It's important to take this into consideration when factoring in the time involved in producing a shoot. In the advertising photography world, most photographers will typically charge 25–50 percent of their day rate (creative fee) for prep time. Ad agencies and high profile clientele are accustomed to these additional day fees, so there is usually no need to explain. However, in the nonadvertising world, this may be one of the things you use as the deal closer, absorbing it into the cost to secure the job.

Expenses

The next item in your estimating formula is expenses. Everything related to the job and running your business is an expense, right down to your company logo sticker on the envelope. Your expense category will include three expense subcategories: fixed start-up expenses, ongoing monthly expenses, and individual job expenses. It may take a few months or even a year for you to determine your expenses, and the number of jobs you secure will certainly vary from month to month, but over time your time and expense log will enable you to begin to see patterns, so at least you will have a rough average. For more details on expenses see chapter 3: Start-Up Expenses, chapter 4: Ongoing Monthly Expenses, and chapter 7: Individual Job Expenses.

We'll begin with your overall business. Let's say your photography business consists mostly of weddings, events, and portraits. I will choose a single portrait session for our sample job estimate below.

The first expenses to consider will be your fixed start-up expenses. Given that your fixed start-up investment cost will be paid back over the course of many years, I suggest that you dedicate 10 percent of your total start-up expenses for your portrait business. For example, if you invested $30,000 in the initial start-up of your business, and 20 percent of this goes to your total portrait business ($6,000), then allocate 10 percent of this $6,000 for your fixed start-up expense rate ($600) and divide it by the number of portraits you think you can shoot per month (let's say 6, for example) and allocate $100 per portrait job for your fixed start-up expenses.

The next expenses to consider will be your ongoing monthly expenses. For example, if you determine that 20 percent of your monthly revenue comes from your "portrait" business, and your total monthly overhead cost is $2,000, then allocate $400 per month to run the portrait side of your photography business. Over time, if you estimate that you can shoot 6 portraits per month, you can divide $400 by 6 and allocate $66 for each individual portrait job as part of your ongoing monthly expenses.

The last item in your estimating formula will be your individual job expenses. These are the costs directly related to a particular job (CDs, DVDs, faxes, phone calls, messengers, paper, ink cartridges, postage, assistants' fees, meals, props, gas, mileage, transportation costs, and lodging if you are traveling out of town. You might also consider film, processing, and prints). If you determine that your job expense costs total $100 for a single portrait session, you can allocate $100 per portrait job as part of your your fixed start-up expenses.

Once you've arrived at a total for each of the three expense categories, factor the totals into the "Expense" column of your estimating formula (shown below).

- $100 (percentage of fixed start-up expenses)
- $66 (percentage of ongoing monthly portrait expenses)
- $100 (total individual job expenses)
- $266 TOTAL EXPENSE cost for portrait jobs

CREATIVE VALUE MARK-UP (CVM) PERCENTAGE

Creative value mark-up is an optional value-added percentage fee for nonadvertising jobs. It can either be added at the end of an estimate or factored into your hourly rate. If you're shooting an advertising job, this will be a part of your day rate (or creative fee) and in these cases you will not give your hourly rate. While you may not need to concern yourself with this initially or apply this fee to smaller, simpler shoots or fixed packages, I want you to understand what it is and when and how you may want to use it.

Typically, when I apply CVM I usually add 25–50 percent to my total fees (depending on the final application of images and the kind of client

I am working with). If my client is a major corporation with millions of dollars and I know my images are going to become a part of a major marketing campaign, a part of the company's branding, which in turn may help them to generate a substantial amount of revenue, then I will mark up my fees 50 percent. If I am working with a smaller, local company, then I may only mark up my fees 15–25 percent. It all depends. I feel it out by asking a lot of questions of the client first before creating an estimate. It's also important to remember that we photographers are performing a service as well as providing a unique, custom, one-of-a-kind product that cannot be duplicated. If you estimate your fees too low people become suspicious that you are not confident enough about your product and service.

Job Estimate Calculation Example

Let's just say you received a call from a guy who happens to be the chef of his own restaurant. He explains that he wants a simple portrait of himself in his chef's uniform with a plate of food sitting in front of him. You ask him a few questions as to who he is and where the images will be used, and he tells you they will be used for his website, some menus, press kits, and maybe some magazine articles later down the line. Because you're a good salesperson you talk him into a few more shots: "Why not shoot some individual product shots—maybe a few plates of food while I'm there as well? You could use those for your menus or your website. And maybe you'd like some images of the restaurant's interior . . . ?" You begin to think about your time and your expenses, but before you conclude anything you ask a few more important questions: "Will people be there to assist us with moving tables and chairs for better interior shots, and can you make sure the food plates are prepared and ready to be photographed within 20 minutes of my arrival?" (This is imperative. Otherwise you'll be sitting around wasting your precious time while the food is being prepared or spend hours moving furniture back into place with only your one assistant). You're about to hang up the phone when you ask one more question: "Is this the only restaurant you have?" To your surprise, you discover that

it isn't; in fact, the chef explains that he is planning on opening a chain of restaurants! *Cha-ching!* Your images will be used in several different places, so you might want to consider adding a CVM. You explain that you'll need a few hours to put together an estimate and that you'll contact him by the end of the afternoon. You hang up the phone and note that the call lasted 30 minutes. You write that in your time log. Why do you need to keep track of your phone calls and email time? Because time is money, and the faster you can do something, the more profit you will make in the end. There is a fine line between giving your clients the attention they want and knowing the art of cutting it short so that you can move on and maximize your productivity.

You begin to think about the time it'll take you to produce the job. You take 45 minutes to organize your thoughts, type up your estimate, and email it to your client. You exchange a few more emails before he finally approves the estimate and makes a deposit payment with his credit card on your website. This takes another 45 minutes. Total preproduction time thus far: 2 hours.

After giving it some careful thought, you estimate that you'll need approximately 30 minutes to prep and pack up your gear with your assistant, another 30 minutes to drive to the restaurant, park, unload the gear, and another 30 minutes to arrange some things for the shot, set up your lights, and begin shooting. You estimate that shooting the portrait will take approximately 30 minutes (capturing a variety of poses and expressions and compositions), the interiors another 30 minutes, and the food plates an hour. Packing up the lights and gear, load up the car, driving home to your office, and unloading the gear will take you another 30 minutes. That's just about 4 hours for preproduction plus production time. Then you need another 2 1/2 hours to download, process, edit, organize, and retouch the files. That's 7 hours total if you can work quickly. The day of the job, you call the client to remind him that he will need to pay the balance before you arrive to shoot. After the job is finished, you email him to let him know that the images turned out great, and that you will send him a few low-resolution versions of your selected favorites and then send him the CD of high-resolution images in the mail. In total,

this adds up to another 30 minutes. Total postproduction time is 2 hours. Here is the calculation:

JOB ESTIMATE CALCULATION:
Time

Preproduction time: 2 hours
Production time: 4 hours
Postproduction time: 2 hours
TOTAL TIME: 8 hours
HOURLY RATE: $75 per hour

Expenses

Gas/mileage/parking: $10
Assistant's fees: $150
CD: $2
Postage, envelope: $4
Total individual job expenses: $265
Total ongoing monthly overhead percentage expense: $66
Total start-up investment percentage expense: $100
TOTAL EXPENSES: $431

$$T \times HR + E + CVM = MY \ FEES$$
$$9 \times \$75 = \$600 + 431 = \$1031 + 25 \ percent(\$257) = \$1,288$$

Once you have determined what you need to charge to earn a fair profit from a job, sit back for a few seconds and let it seep in. You deserve the amount, whatever it is. Your relationship to money will define how you will present this estimate to your client. To some, $1,200 sounds like far too much money for a portrait, a few interiors, and a couple of food images. To others, this fee may seem far too low; after all, you're doing three shoots for the cost of only one, and some would say that a photographer would just be giving away her services at this rate. Your value of money is directly related to the economic climate you're living in. It is important to know, respect, and nurture your self-worth because if you

don't, others won't either. If you are at all hesitant about what you are about to charge, then others will feel hesitant about hiring you. I have said it before, but it bears repeating that people sometimes get suspicious when something is too cheap. I nearly lost a big wedding job by bidding it too low (at $15,000!). When I sent in my estimate, the coordinator's assistant was baffled and asked if this was just my expense fee. I quickly doubled my rate and closed the deal! However, if the chef is baffled about your rate, expecting it to be considerably less, you can create and submit a professional estimate. See sample estimates in chapter 6: Invoices, Contracts, Estimates, and Releases. In your professional estimate forms it is not necessary to include every detail from your time and expense list (this can seem petty), but you can include the basics: preproduction, production and postproduction time, and general expenses. If he still thinks it's too high and you don't want to lose the job, you can offer him a lower rate of $995 (by eliminating your CVM fee of $257). Your profit will be $600—still not a bad wage for a day's work.

As you become more experienced shooting certain kinds of jobs, you may find ways to cut your time and expenses down so that you can still charge the same amount but profit more in the end.

CREATING ALL-INCLUSIVE PACKAGES

Once you've calculated the approximate cost for a particular type of photo shoot, consider creating all-inclusive packages. Having a standard fee for specific services such as portrait sessions, weddings, events, or home interiors makes things so much easier for both you and the buyer. The same goes for products, food, or anything else you like to shoot, so long as you can estimate your time, the number of images, and your expenses. You can promote your packages much like a restaurant promotes the dishes on its menu, presenting brief but informative and enticing descriptions. Your menu should also encourage your buyers to upgrade to the most expensive package by including more products and services in these packages (at a discounted rate than what it would cost if purchased à la carte). This not only provides more options for people with varying budgets, but the upgraded version can also be used as a negotiation tool when you need to

close the deal. You might say something like, *"For only $500 more you'll get $800 worth of services if you choose the next package up."* The main goal is to generate more profits in the end.

Below are examples of a few menu items and their descriptions; I've used random dollar amounts just for reference purposes. You should determine your own rates based on the estimating formula displayed above.

ALL-INCLUSIVE PHOTOGRAPHY PACKAGES:

• **Family Portrait Session:** **$795**

Package includes: 1 photography assistant, 150–200 images with 2 different shoot settings (Marina del Rey, CA area only).

• **Deluxe Family Portrait Session:** **$1,095**

Package includes: 1 photography assistant, 300–375 custom retouched images with up to 5 different shoot settings or option for individual portraits, shot at the location of your choice within a 15-mile radius of Marina del Rey, CA area.

• **Property Interiors:** **$795**

These are simple, clean, illustrative images, ideal for realtors and landlords.

Package includes: natural lighting, 1 photo assistant, up to 3 hours of shooting, and approximately 50–70 finished images.

Each additional shot set up: $100

• **Deluxe Property Interiors:** **$1,500**

These are simple, clean, illustrative images, ideal for realtors and landlords.

Package includes: natural lighting, up to 8 different shoots/set ups, 1 photo assistant, 8 hours of shooting, standard retouching, and approximately 175–200 finished images.

Each additional shot set up: $100

- **<u>Custom Deluxe Property Interiors:</u>** **$2,200**

These are *Architectural Digest* magazine-quality images. Ideal for interior designers, architects, builders, high-end realtors, and magazines.

Package includes: custom artificial and natural lighting, up to 6–8 different shots/setups, 2 photo assistants, location preview, prop recommendations, prop/furniture arrangements, up to 9 hours of shooting, and 225–250 custom retouched images.

Each additional shot set-up: $150

Notice how the all-inclusive photography package descriptions are simple and informative but become more enticing with the deluxe version of each package. Also note how I have structured the pricing of the different packages, encouraging the buyer to upgrade (for example, if a client upgrades from the standard "Property Interiors" package to the next package up, the "Deluxe Property Interiors" package, they get three times as many products and services for less than twice as much money).

For more detailed examples of all-inclusive, prepriced packages, including many à la carte service ideas, see my books *The Art Of Engagement Photography* (Amphoto Books) and *Profitable Wedding Photography* (Allworth Press).

12

The Art of Handling Your Clients

Turn a $200 headshot into a $2,000 job

JUST AS A GIRL LETS A BOY CHASE HER, A PHOTOGRAPHER SHOULD LET the client chase her too. We have something special and we know it. Yes, art is subjective, but we know *our* work is unique, from the way we compose a shot to our abilities to see and capture the light at just the right moment. This is what makes us true artists.

Because photographers are considered artists, some people may see us as carefree, unreliable hippies who snap pictures "just for fun!" What's more, I have heard a lot of hobbyists call themselves "photographers." This can further confuse our potential paying customers. After all, a hobby might be something you love to do so much that you probably wouldn't mind doing it for free, right? (Remember when I mentioned people asking me what my *real* job was? See the "Defining Quick Money Makers to Pay the Rent NOW!" section in chapter one.) As I have said before, you might have to politely reeducate the world as to what a pro photographer is all about. Yes, it can be a challenge to be both a freethinking artist and a structured businessperson, but you will learn!

Establishing trust with your clients is imperative, especially in our business, because we are asking that our buyer prepay for a customized product, and that product can vary. The end result is never guaranteed, even if we are shooting food, products, or interiors. Your customers don't want to waste hours of their precious time to find out you didn't even show up for the shoot because you were too hungover from the night before,

129

or discover that you aren't experienced enough to take good pictures. You must look and be professional, confident, trustworthy, and above all ethical with your clients at all times. The goal of every client interaction is to land the job, receive a deposit and balance payment, shoot amazing images that exceed their expectations, and have them refer your services to all of their friends and family. You must prepare yourself for your client interactions by acting, dressing, and speaking like a businessperson. *This* is how you will create a successful photography business.

Scheduling Meetings

As mentioned in chapter 9: The Ten Commandments of a Successful Photography Business, when you schedule a meeting with a client, you should let him or her know that appointments usually take about an hour, and schedule them as you would in a doctor's office. Give your potential clients a few days and time choices, or you may say, "I had a cancelation and have an opening this afternoon at 3:00 or tomorrow at 2:00." Firmly set a specific time. This sets a more serious and confident tone for your business. You might also say, "If you think you are interested in booking my services, you can pay the 50 percent reservation deposit then. I accept checks, cash, or credit cards. We can sign contracts then as well." While you don't want to sound pushy, you also want to politely and tactfully hint that there may be others waiting to book you for that date. Ask them to please call if they get lost or are running late. If they do call because they are late, try to be pleasant and accommodating and let them know you'll do your best to push back your next appointment.

Dress the Part

Show the world you mean "business" by dressing like a businessperson. When I prepare for client meetings, whether in person or on the telephone, I typically dress in classic, conservative attire—a freshly pressed button-down shirt or cashmere sweater, small pearl earrings, black slacks, and my hair pulled neatly back into a bun. If I'm meeting with them in person, this gives them a visual of how I might be dressed at the wedding

(if this is what they are hiring me for), and if we're having a phone meeting it puts *me* in the right mood. Even if you shoot rock band photos, I still suggest that you dress a bit on the conservative side. Remember, you want them to trust that you take their job (and their deposit money) seriously. To this end, I suggest that you ditch the nose piercings, hide the tattoos, and tone down the tie-dyed, blue dreadlocks you think are so cool—and yes, your clients will notice your dirty fingernails when you hand them a contract. I would also recommend that you avoid a lot of perfume or cologne, as some people are allergic or immediately find a certain scent offensive (even if *you* love it). Your appearance says everything about how you feel about yourself, your clients, and the world around you. I know I'm going to anger those "artists" out there who want to stand out from the crowd with their funky appearances. I understand. Just keep in mind that you don't have to give up this unique side of your personality *forever*—just until you close the deal and become rich and famous! Not only will a clean, well-groomed appearance make up for the lack of an extensive client list or reputation, you will also just start to *feel* more successful.

ACT THE PART

If you work from home and the phone rings at 8:00 AM and you're half asleep, *don't answer it!* Let it go to your voice mail. If it's later than 9:00 AM, your excuse can be that you were in another meeting with a client. This goes for late-night calls as well. There is nothing worse than stumbling to the phone with a foggy head and a raspy voice. You also don't want your clients to think you're at their disposal 24–7. You have office hours. My hours are 10:00 AM–6:30 PM. If the phone rings before or after these hours, again, I'll let it go to voicemail. This is simply more professional. You could make an exception in particular situations, such as the night before a big, early-morning shoot when the client knows you are working late prepping gear with your assistants. If you're one of those people who loves to add music to their voice mail by placing the telephone up to their stereo speaker and playing a riff by Led Zeppelin . . . skip it. This is never clearly audible, nor is it professional; it sounds muffled and juvenile. Keep your message

clear, concise, and informative: *"You've reached Bill Smith Photography. We are currently out of the office shooting on location or with another client, but we appreciate your call. Please leave a brief message and we'll return your call shortly. For more information, visit our website at www.billsmithphoto.com."* If you want the convenience of an 800 number that can also function as voice mail, forwarding service, and fax number all wrapped up in one, then try a company called Ring Central. You can have this service for a one-time annual fee, and it's only about $150 a year! Can't beat that.

SPEAK THE PART

Give your clients your complete, undivided attention. If you're meeting with them in person, maintain solid eye contact and turn off your phone. Remain calm, relaxed, and natural. If you feel nervous, crack a joke about yourself to show them you're human too. This usually loosens everyone up immediately and shoulders drop. Allow them to casually flip through your portfolio books while you take notes about their job. Let them know that you are genuinely interested in *their* specific job and that you assume you will be their chosen photographer. The more excited and engaged you are, the more they will be, too—and the faster you will book the job. Even if you shoot one thousand jobs a year, everyone still wants to feel they're special, so you want to let them know you genuinely care.

There is an art to this kind of conversation. Be a listener. I can't tell you how powerful this can be. People love to be heard and know that you are giving them your undivided attention. Let *them* ramble a bit, and then add your brief input. Keep it short, sweet, and to the point. Less is more. Elaborating too much can send the wrong message. It might say you have too much time to kill or that you're too anxious to sell them your services (because you have no other clients waiting). If you can maintain eye contact and eliminate the *ums* from your conversations you'll grow ten feet tall and have a much greater chance of booking the job. Not only will you sound more mature, but you'll also miraculously *become* more mature and confident. Try it. It works! Practice a conversation with your friends. Have them test you to see how many times you say *"um"* or lose direct eye contact while describing your work or your fees for shooting some-

thing. You'll see how this exercise can help you organize your thoughts and perfect your entire presentation.

While you want to be personable, time is money, so keep things moving along. Some clients will lose themselves in a conversation that has nothing to do with the photography shoot whatsoever. Politely glance at your watch or an easily seen clock, so they get the clue that you need to pick things up a bit. Steer the conversation back on track by asking if you have answered all their questions and if there is anything else they would like to ask. You may want to mention that you have another client arriving shortly at this point. End the meeting first.

When you've completed the shoot and are ready to either send out your clients' prints and digital files or have them pick them up, give them a polite but enthusiastic call: *"Hi Sharon, this is Elizabeth Etienne Photography. Your pictures turned out amazing! You look beauuuuutiful and I'm sure you will just LOVE them! They're ready for pickup, or we can send them out to you. Just let us know."* I had one assistant call a client and leave the most depressing message on her voicemail. He said in a very unexpressive, monotone voice, *"Hi Mary. Your photos are ready. Give us a call,"* then hung up. What? What kind of message does that send the client? Not only did he make it sound as though the images didn't turn out well, he didn't even leave his name or callback number! Remember, having your photo taken makes most people feel very vulnerable, and it can be a real ego-shedding experience. Even if it's not a portrait session, the client may still feel anxious because he or she just spent a chunk of cash and is now sitting on pins and needles waiting for the results. You need to be confident and excited about your work so that others can be as well. After all, if they think you like the photos, then they should, too!

INCREASE YOUR PROFITS BY OFFERING ADDITIONAL PRODUCTS OR SERVICES

From actors and models to corporate business portraits and online dating ads, it seems everyone needs a good "headshot" these days. Shooting standard headshots is a low-labor, low-cost, easy moneymaker that can lead to bigger jobs. Most small business owners, actors, and entrepreneurs aren't

art directors or savvy advertising gurus. They aren't thinking outside the box, expanding their presentation, and marketing ideas. They think all they need is a simple headshot to sell themselves to their customer. Well, thank God for headshot jobs, because they can be a great way to get your customer in the door. Once inside, you can introduce them to the array of other talents and services you offer—things they never even thought of—and turn your small headshot job into a major project.

Most artistic people forget about the numerous other hidden creative talents they have, which their customers might find very useful and which could also generate more income. These could include anything from custom retouching, digital slideshow presentations, and additional enlargements to graphic design layouts for invitations, album book designing, or maybe even website design. How about engraved framed prints for gifts? You might also offer hair, makeup, wardrobe, and props services as part of all-inclusive packages, or offer them à la carte. Create a team of stylists and then simply take a commission percentage of their fees for booking them. If you think hard enough, I'm sure that you could come up with some ideas of your own.

Years ago, I had a client who was a motivational speaker. She came to me for a basic headshot for her website, some business cards, and some brochures. She was thinking of a standard corporate head-and-shoulder image in a business suit. Instead of simply scheduling the time to shoot it, I took a few minutes to ask some questions about her business, her target audience, and what made her different from all the other motivational speakers out there. She lit up and was very eager to share the attributes that made her approach to her work so unique. As she spoke, I imme-diately had visuals of how she could present herself and her company through concept-oriented, metaphorical images that went far beyond the standard headshot. As I became more engaged in the conversation, I allowed myself to express my ideas with greater enthusiasm and confi-dence. She was ecstatic! Not only because she liked my ideas, but because of my sincere interest in her business. She could tell that I genuinely cared. She said my passion was making her feel as though *anything was possible!*

I outlined my ideas to include not only a headshot portrait, but also concept images: a silhouette of her on a mountain top, a close-up of her

hands, a split-face shot with eyes closed, etc. I explained how I thought all these images would directly relate to the motivational concepts she was trying to illustrate verbally. Within twenty minutes I sold her on the idea of doing a full photo session (at four times the cost!). I then suggested ideas for the brochure and offered my graphic design services (for an additional fee). Later, she decided that she wanted to create a press video and—you guessed it—I offered to direct and edit it, even though I had never done anything like this before in my life. I just knew I could figure it out in my off time. *Cha-ching*... more money again! In the end I became a one-stop shop for her. She loved the convenience of creating all of her marketing materials in one place with a consistent, branded, trademark style. I managed to turn a $200 headshot job into a few thousand dollars and a longtime repeat client. She loved working with me so much that she still hires me today for everything from pregnancy and infant/child portraits to family portraits and updated corporate portraits for her and her husband. She constantly referred me to all sorts of people, and my business just kept expanding and expanding as a result! This experience really taught me the art of selling my services and developing strong client relationships. It also gave me the opportunity to diversify, have fun, and earn more money!

Negotiating Your Fees

For years, I floundered anytime someone tried to negotiate my prices. I would immediately break into a sweat, my heart would race, and I would get all squirmy and shifty. I get really uncomfortable discussing the topic of money and my artwork in the same conversation. I just wished the world understood what I was worth and had the budget to pay me what I deserved, but unfortunately life doesn't always work this way. Sometimes we must negotiate our fees or risk losing a job.

When a nonadvertising client asks me for a job estimate, I usually offer them one of my all-inclusive packages. I already have several prede-signed packages for various portrait sessions, parties, events, engagement sessions, and weddings. I also shoot interiors, so I have two packages for those shoots as well. Any of these packages can be customized to meet a

client's particular needs. This means I can add or delete certain products or services and the client can then be credited this amount or pay an extra supplemental fee. This makes selling my services so much easier. Much of my client communication is done via email, so I simply send them my pricing sheet or a link to it on my website. If a client complains that their budget prohibits them from purchasing the package they want, I have two options I offer them in lieu of reducing my fees. I first suggest that they downgrade to a less expensive package. If they wrinkle their nose, or if I don't have a less expensive package, then I offer to remove some of the à la carte products and services included with the package they're interested in. For example, a couple contacted me recently for a wedding. The guy explained they had a budget that was about $1,000 less than the cost of my lowest wedding package, but that his fiancée was absolutely enamored with my photography, so they just had to have me shoot their wedding. I suggested eliminating one hour of time and removing the 4" x 6" prints (giving them a DVD of the final retouched files instead). He agreed. The objective is to maintain the same level of profit regardless. Reducing your time by an hour will not affect your overall profits, so I typically suggest eliminating a service over a product first. Give them a few moments to think about it. If they are still unsatisfied, you can then offer to include the one hour back in. Now they feel like they're getting a deal! And you haven't lost any money really. Even though I'm always preaching that time is money, you probably won't be shooting another job the same day anyhow. If they *still* are unsatisfied and ask you to reduce your fees for the exact same package, don't give in immediately. Sit back and think about it so that you don't seem overly anxious. If you do decide to reduce your fees, do it in small increments of no more than 10 percent. You can always go lower if needed, but you can never raise your rates back up if you have gone too low. The worst thing you can do is to close a deal and then feel angry about it afterwards. This is the art of negotiation.

When an advertising client asks me to negotiate my fees, things are a bit more defined. Because advertising jobs have so many cost variables, every job is different, and it is customary to give the ad agency an estimate that displays the photographer's fees (often referred to as "creative fees" or fixed "day rate") separately from all the expense costs involved. In

addition to creative day-rate fees and expenses there is something called "usage" or "license" fees. These fees are based on the usage of the images (where, when, how, and for how long the images will be used). Some photographers (or their agents negotiating the deals) will use the usage fees as a means for negotiation first rather than the photographer's fixed creative fee. Just like with nonadvertising jobs, this is another way to protect the photographer from losing the base of his profits. For more information about advertising estimates, refer to chapter 6: Invoices, Contracts, Estimates, and Releases.

As I have always said, the value of money is only equal to the happiness it brings you. Trust your intuition and know when to give in and when to walk away from a potential client. There is a fine line we walk between honoring a budget and giving in a bit and going so far that you feel like a used-car dealer. In moments like these you must ask yourself if you're at risk of sacrificing your artistic integrity. If so, it might be better simply to walk away and maintain your reputation and your sense of self-esteem rather than shoot a job for which you feel you are not getting paid what you deserve.

BE PREPARED TO SEAL THE DEAL

It's critical to have all of your price sheets, invoices, and contracts readily available to review with a client in person or email them directly when needed. You must be prepared and assume that they will book you. Not only is this a sign of confidence, it subconsciously prepares you to "receive." Confident people seem trustworthy and this usually makes people more likely to hire you.

The easiest way to get a commitment from your customer is to gently remind them that you work on a first-come, first-served basis, and that you require a deposit to hold the date. You can also remind them that you accept credit card payments (either through your e-commerce website or through PayPal). Make it easy for them to pay you. In the advertising world, this is known as an "advance" payment against the balance. It is not all that uncommon to ask for 50 percent both in the advertising and nonadvertising world; however, some clients may request a reduction of

this rate and ask if they may pay you 25 percent. You want to be flexible, but I encourage you to try to get 50 percent when and if you can. Let them know that while you are currently available for the specific date they requested, you cannot guarantee you will be next week should another client book you for the same date, so this is what the deposit is for. They may ask you if you could simply call them if someone else wants you for the same date. Politely decline this request. Explain that because you get so many different people calling with different dates, it just gets confusing and you would have to spend all of your time calling back and forth to see who wants you and who will book you first. They will understand, and this usually motivates them to book you on the spot. Ask if they have any more questions, and if they don't, they will either tell you they need time to think about it or that they want to move forward with booking you for the shoot.

In lieu of a formal contract for smaller, nonadvertising jobs, you may simply use your email correspondence and their payment as a means of legal proof of both parties' intent. If you opt for this route, make certain that all parameters of the job are detailed clearly in your professionally written email and that the client has agreed. It's imperative that you state that once the deposit has been paid, they will be given a receipt and your services will be officially reserved for them for the specific date indicated. If you're not certain as to the most professional way to phrase this, refer to your contract for the right verbiage. As suggested numerous times throughout this book, I highly advise you to accept credit as a means of payment in addition to checks and cash. Offering the option to pay with a credit card makes it easier and faster for my clients to book me. You can use PayPal or have a dedicated merchant account attached to your website, as I do (this is just a slightly more professional-looking system than PayPal, but it functions much in the same way). The system will generate an automated receipt of payment for both you and your customer. However, should your customer pay you with a check, you will need to create a receipt manually. As mentioned in my Ten Commandments in chapter 9, always give a receipt whenever money is exchanged. You can use an invoicing software and type in the details, or you can have preprinted carbon copies made at any print shop and then just fill in the

specifics for that job. Either way, it's imperative that both of you get a copy of the receipt for your records. Not only will you need it for your taxes, a receipt just makes everything more official—and it's standard practice for a serious professional in your field to provide one.

For larger, more expensive jobs such as weddings and ad campaigns, I prefer the formality of a signed contract. This is because there is usually a considerably larger amount of money being exchanged and the details involved in producing photo shoots at this level are far more extensive. You do not want to leave anything vague and thus open to interpretation later. It's also important to get the signatures of the persons responsible for payment and who could answer any questions concerning the job in the event of a lawsuit of any kind. Like everything else, your contracts should be copied so that each party has its own set of paperwork.

If a client is not prepared to book your services immediately, act relaxed and natural. You don't want them to feel pressured. You have already informed them of your policies and explained that you cannot hold the date without a deposit payment and contract for the job, so there is not much else to do. Just move on to your next client and hope that they call you back at some point and decide to book you.

DELIVERING THE GOODS

When you are ready to deliver your images to your clients you can simply email or call them. Tell them how great the images are and that they are now ready for pickup or delivery. I always encourage delivery (via messenger or insured FedEx/UPS). This eliminates the need to meet with them face to face, which would consume more of your precious time. However, some clients may prefer to pick up the package instead. That's fine, but do not invite the client into your home-office and sit and review the images with them (unless this is a huge project and you have cushioned the job enough to include additional reviewing time with them). If this is not the case, you can do one of two things: You can create a special pickup/drop-off box with a combination padlock on it so that they can come by at their leisure and no appointment is necessary (this will free up some time so that you can have a life instead of waiting around on a Saturday afternoon

when you could be out surfing). If you don't have the space for a drop box, then schedule a pickup time, greet them at the door with a big smile, hand them the envelope, and tell them enthusiastically, *"The photos look GREAT! I'm sure you're going to LOVE them! Call me if you need anything else."* They may be left with a blank look on their face, expecting you to sit with them, go through and discuss each and every image, revel in how gorgeous they look in their headshot, blah, blah, blah . . . but you won't. This might sound harsh, but for a $200 headshot you can't afford that time (remember your time logs? Time equals money). I knew one photographer who would always get stuck with an actor or model who would want to sit and discuss each shot and ask if the photographer could *"just do a quick retouch here or there"* (at no additional fee, of course). The photographer didn't have it in her to turn him or her away. In the end, she realized she was earning less than $10 an hour.

End Each Job On a Positive Note

In addition to following my Ten Commandments, I always make a point of trying to finish every business transaction in the most positive way possible. I stress the importance of giving each client a thank-you note and a gift. This might mean giving my client a little something extra that they didn't expect (an extra print enlargement, a frame, a discount coupon for the next photo shoot, etc.). You could spend millions on paid advertising and still never receive as many job leads as you would from your personal referrals. Keep in mind that while there may be dozens of other photographers just as good as you are, the photographer who usually gets the job is the one who is simply likeable, has the right price, acts professional at all times, and ends the job leaving the customer satisfied with his or her product and service. This can develop from the first meeting or conversation to the last good-bye after the photo shoot. When people ask me why they think I've been more successful than other equally creative photographers, my answer is this: I'm a people person. I genuinely love people and they love that I love them. The goal is to create a lasting impression on your clients so that they will think of you the next time they, or someone they know, needs a photographer.

NEVER FORGET PAST CLIENTS

I make a habit of trying to remember all of my clients' names no matter how long ago I worked for them. I know this sounds absurd, but when you've had hundreds of clients your mind can become full. It's like a computer hard drive (if only we could just purchase more storage or memory!). The best way for me to remember them is to latch on to something about them as individuals (she loves to travel to Paris or he is a big baseball fan), make notes on their contracts, and then periodically review my image library, organized in folders displaying their names. When I run into a former client at another event or even on the street, I always give him or her a warm hug, ask about her dog, Scoobie, or if he is still collecting vintage cars. My clients are always touched that I remember them; it makes them feel special. I hand them my business card and say, *"Hey, keep in touch!"* and they might reply, *"Yes, for sure. Actually we might want to do a family portrait this summer so we'll call you."* I say, *"Great. Hey, I give a 15 percent discount on all of my packages for repeat clients!"* This gives them an added bit of incentive to call me.

13

Preparing for Your Photo Shoot
Wardrobe, location, gear, assistants, and lighting

IF YOU'RE RELYING SOLELY ON A BUNCH OF EXPENSIVE GEAR TO MAKE you a better photographer, you'd better think again. Of course it helps to have great gear, but if you don't know how to use it, and you don't use it often enough, it's just a waste of money. I see too many photographers running out and spending $5,000 on a strobe system thinking they "should" have it to prove they are a good photographer. It ends up collecting dust and depreciating in value rapidly, when they could have rented it or borrowed it from a friend for a faction of the cost. If you're planning on investing in a piece of expensive equipment, my advice is to "try" it a few times first to see if you really must have it. Then, try to predict whether you will be able to profit from *owning* the equipment. This means not only will the equipment improve the quality level of your images substantially (enabling you to raise your rates), you will also be able to book enough paid jobs for it to pay for itself before it depreciates in value. You may realize that you only used your $5,000 strobe system a few times before it depreciated to only $3,000 when you could have rented it for only $200 a day. Yes, even *I* rent specific equipment when I need to. Of course, I own a majority of my own gear because I'm shooting paid jobs all the time, but when I need a unique item or an extra backup item when one of mine is out for repair, I simply rent it. It's easy. If you don't live near a camera rental shop, there are companies that will mail you the gear you need, such as www.borrowlenses.com.

The photography business requires a special combination of skills in order for the photographer to be successful and profitable. Learning to understand and perfect these skills can be the key to your success. Being a photographer requires one to be technically proficient with his or her gear while simultaneously creating unique images by making the right decisions about composition, exposure, lighting, timing, and direction. It's also important to be able to communicate ideas, concepts, and feelings with your clients to make certain that you understand exactly what they want and that you can deliver it. After all, photography is an art, and all art is a custom expression of the artist's ideas. Lastly, a good photographer needs to be able to create a plan of action, think ten steps ahead, improvise when things don't go as planned—and be able to do all of these things at once. Sound daunting? It's not, I promise you. In time you'll get the hang of it, simply by working on each one of these skills a little at a time.

There are obvious emotional and biological differences between one person and the next. It's a known fact that the way we communicate, react, and process information and emotions can vary widely. Some people are very right-brain dominant (creative, emotional, and spontaneous) while others are more left-brain dominant (logical, systematic, and practical). Right-brainers usually like to talk through their issues and handle things from an emotion-based place in their brains. Whereas left-brain people like to just take action; they are more "doers" than "sayers." This being said, some people might be more compassionate and communicative than others (useful traits for elaborating ideas to an art director or calming the nerves of a frantic bride during an emotion-charged wedding shoot). On the other hand, these kinds of people might become more emotional, more impatient, and more irrational than others. While some people can multitask really well (a useful task for directing your models and your crew at the same time so you can stay on a tight schedule and prepare for the next shot), other people are able to focus better on one thing at a time, giving it their undivided attention (a very useful skill when it comes to configuring an elaborate electronic strobe system, fixing a computer network, or adjusting a camera setting in a matter of seconds . . . without panicking and without any tears!). However, the multitasker can some-times overlook the small technical details others might absorb, while the

person who can only do one thing at a time can only do "one thing at a time." These people have a difficult time improvising when something doesn't go as planned, and they often neglect to have a backup plan in place.

I witnessed a photographer shooting a wedding I was attending once. He became totally flustered when the bride was crying because it started to rain. Instead of reassuring her that everything would be OK and switching to an alternate plan, he just stood there paralyzed and said nothing. Later, when it was clear that everything was behind schedule, he didn't know how to improvise; he didn't have a covered place to shoot arranged, or even explain to the bride that there would not be enough time to shoot all the different individual family pictures that they had planned, and that they would simply have to do a combined one. He simply shot what he could and left without saying a word. It was shocking to watch. The poor guy didn't know what to say or do, and he didn't have a plan B.

The best way for those who consider themselves to be more right-brain-oriented individuals (creative and nontechnical) to learn the technical operations of their photo equipment or computer software programs is to set aside a free day, sit someplace devoid of all distractions, take a deep breath, read the instructions, and be patient. If you still feel lost, call for tech support. Even if you have to pay, it's money well spent. You can also consult the numerous online tech forums (listed in the resource section of this book) and ask questions. I was *the* most *un*technical person when I started my photography business many years ago. I didn't understand everything that I knew I should (despite many years in photo school). The endless buttons on my cameras and flash systems seemed far too complicated, and I always ended up crying in frustration. Finally, I gathered the courage to ask for help. Calling tech support was great. I learned so much and the people seemed so patient with me. From then on, every time I stepped into a camera store, instead of feeling shy, embarrassed, and intimidated (because the people all seemed to speak a tech language I didn't understand) I just played it low-key, and if I didn't understand something, I would just keep asking until the person explained it in plain terms. It worked! Little by little, by asking questions, reading the instruction manuals, and constantly researching and testing everything, I began

to gather the knowledge I needed in order to operate my equipment the way I wanted to. This gave me the courage and confidence to create the images I am known for today. It took time but it worked—so hang in there and don't give up.

The best training for left-brainers (systematic, technical, rational people) to learn how to handle numerous things at once and develop better communication and multitasking skills is to wait tables in a busy restaurant. This task requires you to handle many customers' requests at the same time quickly (so the food is delivered hot in a prompt fashion). It also strengthens your social skills because one needs to be friendly and informative about menu selections and apologize, empathize, and respond productively when the service or the product is not to the customer's liking. Waiting tables can also teach you to sharpen your sales skills; you may suggest another bottle of wine, a dessert, or a cappuccino in order to increase their tab (and hopefully your percentage of the tip). These tasks will exercise and develop the same part of your brain that a circus juggler uses when he has several balls in the air. If you don't have the time to work in a restaurant, take a cooking class and then throw a dinner party. Cooking a 3- to 5-course meal is an excellent way to practice your multitasking skills, timing each dish just right so that all of the food comes out hot and perfectly cooked at the same time. Invite a few friends to dinner, test yourself, and see how you do. I suggest, at the very least, that you practice your communication skills by considering all the possible questions a client might ask and then being prepared with a concise reply (not a vague, one-sentence answer). Eventually, you will become a better communicator and a better multitasker.

• Preparing Your Location

No matter where you're shooting, be it an indoor studio in the middle of a snowy winter day or an outdoor racetrack in the dry, hot desert, previewing your shoot location is the first step in preparing for a shoot. Knowing the terrain logistics, natural or artificial lighting conditions, and photography shooting regulations are key factors to a successful shoot.

Before I scout a location (interior or exterior), I always consider and confirm the shoot regulations and logistics. I don't want to waste my time

finding the perfect location only to discover that I need a permit, the location is already reserved for another event or person, or that it is closed for renovations. I always bring my assistant with me, and if I'm shooting inside a studio with my flash strobes, we check the plug outlets. We confirm that they are functioning and that they can handle the amount of power I plan on running through them without blowing a fuse circuit. We also make certain that they are within the distance needed for my extension cords to reach them (we bring a tape measure for this purpose). To make things easier during my shoot, we have labeled all of my extension cords by length: 3 feet, 6 feet, 9 feet, 15 feet, and 20 feet. Because I often like to use obscure locations (an abandoned warehouse, a vintage theater, or an old barn), I also check to make sure the location is clean enough for my clients to sit, stand, or lean against something. Just in case it's not, we always bring some spray cleaner and trash bags. We also bring plenty of soft, clean rags to slide under the legs of the couches, chairs, and tables in order to protect floors from scratches if furniture needs to be moved. Before we leave, we look around for the closest bathroom and a place for the hair and makeup person to do their work. Everything is reviewed, cleaned, and prepped. In addition, I make sure that there is enough space for me to compose the kinds of images I envisioned by looking through my camera lens. Lastly, we determine the nearest parking places.

• Preparing Your Lighting

The next most important consideration is lighting. It's important to know in advance the type of lighting you need in order to create the kinds of images you're envisioning, be it something edgy and dramatic or soft and romantic. For example, early morning and late afternoon light can be much softer and flatter than harsh midafternoon light. It's also lower on the horizon line as opposed to directly overhead. Additionally, when I scout a location, I like to do it as close to the shoot date as possible because light gradually shifts positions each day. In other words, the light might fall in a totally different place at 3:00 PM in September than it does in December, only eight weeks later. Light is to the photographer what an instrument is to a musician. Sometimes it can be like a dazzling, heart-pounding orchestra, and other times it's just a sensuous whisper in

the darkness of the night. I am very passionate about lighting, so you will hear me speak about it often in my books, workshops, private consulting sessions, and guest-speaking events. The best way to truly understand light's power is by "experiencing" it. I suggest that you just spend some time looking around you. Notice the direction the light is coming from, where it lands, how strong or soft it is, and what patterns it makes. There are many different kinds of lighting, from strong, defined, and dramatic, to soft, diffused, and caressing. Whether you choose to shoot in a studio with artificial lighting or on location using natural light, it's critical that you know exactly what kind of lighting you will want in each shot. It's like a scriptwriter knowing what he wants the character to say in the next line. How you apply the light you choose and position a person or object in this light is what makes you an artist, and this is what will define your voice as a professional photographer. The thrill of creating or finding the right light is the same thrill I used to get as a child chasing lightning bugs on summer nights. It's just a magical thing.

TYPES OF LIGHTING

- **Diffused nondirectional light:** This is a very soft, flat kind of lighting with no patterns.
- **Side or split light:** This is a dramatic kind of lighting pattern. It's like the thunder of the drumroll and is often seen in classic black-and-white crime films. It usually comes from 90 degrees camera left or right of the subject.
- **Rembrandt light:** This is a formal, quiet kind of lighting pattern that was used in Rembrandt's classic portrait paintings. It's between side lighting and front lighting. It comes from 45 degrees camera left or right of the subject.
- **Dappled patterned light:** This is a dancing, tickling kind of light. It's like a ballerina twirling around. It's all about random shadows and specular highlights.
- **Backlight:** This can be either a dramatic, strong kind of lighting pattern (seen in many classic Hitchcock films of the '40s and '50s), or a soft, warm, and intimate whisper (depending on your subject,

composition, and expression and the luminosity level of the light's output).

- **Silhouette light:** This can be a dramatic or quiet kind of light pattern. The main source of light comes from behind the subject while the subject itself remains in shadow.
- **Shadow lighting:** This kind of lighting can also be dramatic or quiet. Many classic suspense films used it to create nervous anticipation. However, it can also be used to create a sense of anticipation in a romantic context.

For a more extensive look at lighting, see my book *The Art Of Engagement Photography.* It includes numerous image samples of lighting styles and patterns, explains how to find or create these lighting styles, and explores the emotions behind them.

Once I finish preparing the location logistics, I shift my mindset into creative mode. I truly enjoy wandering around and envisioning how I can transform this location into exactly what I need for my shoot. Using my assistant as a stand-in, I shoot as many test shots as possible. Sometimes I can find the perfect lighting patterns and scenic-backdrop spots in only a few minutes, while other times I have to search for hours. If I intend to use natural light and I don't find what I need the first time, I might return to the same location at a different time of day. Either way, I always have a plan B that allows for lighting, weather, or location changes. For example, if it's sunny and bright the day I'm scouting, but the day of the shoot it's overcast (or raining!) and the dramatic lighting I was counting on is nowhere to be found, then I need to consider shooting under a covered patio, using an umbrella, or creating a difference kind of image. Or, if someone is parked in front of the tree I planned on shooting, or the location is closed for renovations, I have to have another location nearby that I can access quickly. Rescheduling the shoot means losing a day's income, which is why having a backup plan that will allow you to capture equally beautiful images elsewhere is imperative to the success of your business. Yes, I have shot several portraits, engagement shoots, and even a few ad campaigns using my plan B. Ironically, the images came out even better than I had expected.

• Preparing Your Mind and Your Heart

On the day of a photo shoot, I will often take 10–20 minutes to clear my mind, focus, and meditate by writing positive affirmations. I imagine that I have an Olympic coach and am simply prepping for the next race according to my routine. It sounds corny, but it works! After 25 years in the business, I still do it today. This is a sample of the kind of mantra I meditate on.

I, Elizabeth Etienne, am an amazing photographer!

My work is outstanding!

People love me and love to be around me. I make them laugh and cry with my great images. My images will be fun, romantic, sexy, and beautiful. I can see people looking at them afterward, smiling because I captured just the right moment.

This form of subconscious programming really does work. We just need to trick our minds.

I use the same kind of meditative exercises when I'm prepping for a wedding shoot. I might add something like:

Today I am focused, totally present, creative, confident, and in control.

My crew and I will flow together, like a perfect team, each doing our part effortlessly and spontaneously. We will have fun and I will make the best images of my career! I am calm, focused, creative, and full of love, joy, and laughter. People adore me and love my presence.

As I write and read these words, I begin to feel better and better. I actually envision the images I am going to shoot, how I will feel shooting them, and my client's delighted response afterward. By the time my assistants and my clients arrive, I am pumped up and ready for action! I'm a firm believer that energy is contagious, so when I'm enthusiastic it

seems that everyone around me starts to feel more enthusiastic. It's really awesome.

• **Preparing Your Attire**

Comfortable but professional clothing is an important part of the success of your photo shoot. The type of attire you should wear depends on the type of shoot, location terrain, and climate. For example, if you're shooting a wedding, you don't necessarily need to wear a suit or dress anymore (as one might have in the past), but you do want to respect the tenor of this formal occasion by wearing professional dress slacks, a belt, and a fitted dress shirt. However, you should still be able to bend and move to get the right shot. I don't need to state the obvious, but I will: Do not wear low-waisted pants (even if you're shooting a rock band, a fashion shoot, or a casual headshot), because when you bend over your underwear (or butt crack) will show and this is *really* unprofessional. Moreover, do not wear an ill-fitting dress shirt that forces you to have to repeatedly tuck your shirt into your pants. Yes, people will judge you by your attire; it says a lot about how you feel about yourself and your work. It's always better to play it safe and be a bit overdressed than to be underdressed.

Because I was born with bad feet, spending more than a few hours standing up used to be agonizing. I had every kind of orthotic insert you could imagine. Most of them didn't fit into my shoes right and ended up causing me more pain than without them. For years I searched for a work-and-play shoe that would allow my feet to breathe, offer as much arch support as possible, and still look professional for my wedding and event shoots. When I accidentally stumbled into a Crocs shoe store and slipped into my first pair, I was ecstatic! Yes, this is the same company that makes those funny-colored, plastic-looking clogs with the holes in them, but what most people don't know is that they actually have hundreds of different styles of shoes and boots for both men and women, some of which you can only purchase online. Crocs are made out of a patented material that makes them soft, incredibly comfortable, lightweight, dry, and odor resistant (my feet never sweat in them, even during my twelve-hour-long wedding shoots!). They're also designed for maximum spine and foot arch support. This is really crucial for photographers because we

have so much heavy gear to carry. I now have over ten pairs in different styles that range from flip-flops (for my beach shoots) and sneakers (for my casual shoots) to dressy loafers and even high-heeled fashion shoes and boots. I use these shoes for everything from my formal weddings to my casual family portraits. The best part is that I'm comfy and fashionable at the same time. I even meet the dress code of upscale hotels.

• Preparing Your Gear and Your Assistants

Organizing your gear so you can find it quickly is probably one of the most important aspects of your preparation for your shoot production. There is nothing worse than having to make your clients hold a pose or missing a perfect shot because you're scrambling for the right lens. Regardless of how skilled an assistant is, I always do at least a 30–40-minute gear-review session before I work with them for the first shoot. Every photographer uses different equipment in different ways, and each has a different system for working with their assistants. You cannot get angry with an assistant if they don't know your mode of operation; it's your job to show him or her. Be a very good communicator when explaining how you like to work and how you want your gear handled. Never make assumptions.

On the day of the shoot, my assistants arrive usually an hour or two before we're scheduled to depart. Much will depend on the amount of production involved in the particular shoot we are doing. Occasionally, when given the opportunity, we will try to prep the location, props, gear, and anything else we might need a day or two before so that there is little preparation left for the day of the shoot, aside from packing the gear into the vehicle (or in our camera bags if we're walking to shoot locations near my home).

The first thing my assistants do is open my camera closet and pull out the gear. In keeping with the hierarchy, my first assistant directs the second and third assistants. The first assistant has the most experience working with me, so he is usually the most technically educated with my gear. Taped to the wall of the gear closet is my Gear Prep List. This is very important for all of my assistants to review, even if they have been doing the same routine with my gear for years. The assistants' job is to clean, prep, test, and pack all the gear. This means cleaning the lenses and

camera bodies with canned air and lens cloths, loading and formatting the memory cards into all camera bodies, loading the batteries into the bodies, flashes, pocket wizards, and walkie-talkies, and then testing all the devices to ensure that everything works OK. Before anything is packed into the camera bags, they confirm that we have twice as many perishables (film, digital cards, batteries) than we think we need for the shoot. Despite the fact that many of my assistants have been working with me for years, I don't want them to get too comfortable because I'm afraid they will accidentally forget something (yes, this has happened before, and no, I wasn't happy about it). I once had an assistant load the batteries into the flashes backwards, and then neglect to take the time to turn them on and fire them to make sure they were working. So of course, when I needed the flash in a rush during the shoot, it wouldn't fire. I didn't know what was wrong and we had to grab another flash. I missed a perfect shot and was really annoyed. I rarely even touch my gear before a shoot. This is what I am paying my assistants for, and I trust that they know what they are doing because they have been trained to do it.

The fact that most photography equipment is black—this includes everything from the camera bag to the bodies, lenses, pouches, and accessories—can sometimes make it difficult to differentiate between items (especially in low-lighting conditions). To help, my assistants put a small, sturdy, sticky white label on just about everything. Lenses are marked with their focal length, and duplicate devices such as camera bodies, lenses, and flashes will get a simple letter *A*, *B* or *C* on them. This enables us to find what we need fast and differentiate between duplicate devices should one break down and need to go in for repair. A small sticker label with my printed contact information is attached to any items that have the surface space for it, including everything from my stepladder, tripods, and light stands to my fanny packs, photo vests, and practically everything else I own. Should something get left behind, God forbid, perhaps someone will be kind enough to return it.

As I explain in chapter 3: Start-Up Expenses, I advise you to invest in a few different lenses, but this will ultimately depend on your budget and your personal shooting needs. There is much discussion over zoom lenses versus prime lenses. There are pros and cons to both. For example,

although a zoom lens allows you to work with various focal lengths (beneficial when you don't know which one you will need for a particular shot in a rush), zoom lenses tend to be less crisp and sharp in comparison to prime lenses. While having just one lens to carry can make things easier when it comes to packing and grabbing quick shots, a zoom lens can be considerably larger and heavier than a prime lens. However, all this being said, there are many variables that can determine the quality and the price of a lens. As zoom lenses are improving every day, not all zoom lenses will give you a noticeably different quality appearance. On top of this, not all prime lenses are cheap (the pro-level lenses can be incredibly expensive). Do your research before you buy. I have a combination of both lens types, so I'm always prepared for various shoot situations. I use all Nikon cameras, lenses, and flashes, primarily because I like how they feel in my hands and the different features they offer.

Here's What's in My Main Camera Bag

- 3 Nikon digital cameras (a Nikon D3, a Nikon D3S, and a Nikon D700)
- 1 Nikon F-100 film camera
- Elastic neck straps for each camera
- 2 digital rechargeable batteries for each digital camera and their battery chargers
- Batteries for film camera and flashes (and plenty of extras)
- Several prime and zoom Nikon lenses (20mm f/2.8, 50mm f/1.8, 85PC lens f/2.8, 105mm f/2.8, 28–105mm f/4.5, 24–120mm, and a 70–210mm f/2.8)
- 3 Nikon SB900 flashes (with various accessories such as snoots, diffusers, gels, etc.)
- 4 Pocket Wizard FlexTT5 flash controllers
- CF memory cards in various sizes (I typically prefer using smaller 4G and 8G cards in lieu of the 16G or 32G cards. They download faster during processing and make me more conscious of the number of images I am shooting. Moreover, should one of these malfunction, I don't lose all the images from the shoot.)

- Hoodman brand Hoodloupe screen viewer (for glare-free LCD screen viewing)
- Rubber retractable lens hoods and lens caps for each lens
- A small bubble level for my tripod (crucial for keeping horizon lines straight)
- A bunch of miscellaneous other stuff

While my assistants are prepping the gear, my production manager or I will give them some background information on what we will be shooting and the names of everyone participating so they may address them respectfully. In addition, we will review the shot list and timeline so that everyone knows the schedule and can be prepared to keep things moving along.

14

Directing and Shooting People, Places, and Things
Portraits, engagements, weddings, food, and interiors

I͏T'S IMPORTANT BEFORE YOU BEGIN SHOOTING ANYTHING THAT YOU determine your vision of the composition, depth of field, lighting style, direction, and grain quality. Knowing this will help you create images that most closely resemble what you and your client envisioned. After your shoot, I advise that you always back up your digital files on external hard drives. When I'm traveling abroad I like to use mini jump drives and just hide them in my purse or some other unexpected piece of my luggage just in case, God forbid, my laptop or photo equipment gets held up in customs at the airport (see the section on equipment carnets in chapter 7: Individual Job Expenses). Never take any chances with backing up your images. It's just not worth the risk should something get lost, damaged, or stolen.

It's also important to remind yourself that you must respect the time constraints of the scheduled shoot. Resist the temptation to get lost or carried away in your creative exploration with one shoot setting on someone else's time (be it your model's, your client's, or both). Part of being a great photographer is your ability to deliver an outstanding product *on time*. This means shooting the best images you can in the limited time you have.

Portraits: Just about everyone needs a portrait at some point in his or her life; this includes pregnant women, infants, families, couples, kids,

executives, actors, models, and just the average person. If you like photographing people, this can be the base of your income. When I shoot a portrait, I always try to get a feel for what the person wants by asking him or her how and where the images will be used. Having a portrait taken can be a very personal experience and can make some people feel very vulnerable. As a result, they can sometimes act apprehensive and unnatural in front of the camera. Many people fear they won't like the way they look in the photos and end up feeling depressed about having had their picture taken in the first place. With this in mind, it's imperative to ask them about the kinds of images they have liked of themselves in the past and why. They may have certain features they would prefer to camouflage (such as a large nose, thinning hair, or a crooked smile) and other features they would like to highlight, (such as their beautiful eyes, long legs, or great teeth). Listen carefully to what they like and don't like and do your best to address their needs. They may have specific ideas in mind, or they may have none at all and rely solely on you to be the art director. Either way, it's always good to have some reference images for hair, makeup, wardrobe, props, locations, or just subject matter and composition. The reference images are sort of a rough blueprint for the direction style of the shoot. Showing these to the client is an excellent way to communicate, and it allows you to feel more confident that you're both on the same page.

The expression of the person in your portrait images is usually determined by his or her reaction to the person directing him or her from behind the camera. It's a direct reflection of the symbiotic relationship between photographer and model. My personality is a *huge* part of the success of my image results. When I am directing people, I almost always have a vision of the desired expression I'm hoping to achieve from our ideas list before I begin coaching the people in front of my lens. This really helps. For example, if I'm taking pictures of kids, I always look for ways to make them laugh. It might be suggesting something funny like, "Let's play in Daddy's closet," or, "Why don't you try on Dad's shoes?" The kids immediately start giggling and I click shutter. If I'm doing an executive portrait I try to position the person in a powerful, commanding, but warm and approachable posture. For a man this might be leaning on his

desk, arms folded, smiling confidently. I always toss out a gentle, sarcastic remark, such as, "Boy, you look like the million dollar man!" He smiles authentically and I snap a few frames. The images look warm and real. However, there are situations in which I don't have the luxury of preparing the subjects (such as a party or event involving lots of candids). In these situations I must establish an immediate connection with the person I'm about to photograph in order to get a great image. I need them to instantly trust me so that I can direct them into the right pose. I might say, *"That's a great dress. Love it!"* or, *"How's the champagne? Looks good."* I look for some backlighting and add a bit of fill flash and that's it. This mixture of natural and artificial lighting is easy to achieve and always looks great.

When you're shooting portraits, it's not necessary to shoot more than 4–6 frames per pose before alternating and no more than 2–3 different alternations per set-up. When shooting party candids, snapping 1–2 shots (in case someone is blinking) is sufficient before moving on. Don't exhaust your subjects. It's important to distinguish between portrait sessions and party candids in reference to the number of images. A few months ago I was photo-coaching a young photographer who hired me to be on set with him during a shoot he was doing with a model. The model was hired for 2 hours, but the photographer shot for 3 ½ hours! He shot hundreds of frames in an effort to find the right light and angles. Instead of scouting the location in advance and preparing each shot with an assistant (as I had advised), he thought he would just wing it and see what he could get the day of the shoot. The model was clearly exhausted by the time they had found the best light and the best settings, and sadly we could see this in her face in the images. Unless you're shooting a major ad campaign or doing a catalog shoot, your everyday clients will rarely give you this much time anyway.

Being photographed should be a fun experience for your clients, not a laborious, time-consuming chore. If you can't get a good image in more than a few frame clicks then move on to a different scene or setting. A basic portrait shoot shouldn't take more than 60 minutes (max!). This includes headshots, family portraits, infant portraits, etc. I learned most of my prep skills years ago when I was hired to shoot celebrities and filmmakers for a film location magazine. I was only given 5–10 minutes

to shoot them in between their scene takes on set. Stressful? You bet! But boy, did it teach me the importance of prepping for my photo shoots. If you do most of your planning in advance, you won't be scratching your head for ideas or feel anxious while trying to decide what to shoot next. Your clients will be impressed by your organizational skills, creativity, and ability to produce what they need in less time. Because most people are scrambling to find the time for everything they need to do in their busy lives, the faster you can deliver a great product, the more motivated your customers will be to come back and hire you again soon.

Headshots: You don't need a studio to shoot a headshot. Just find some flat lighting in an open shade area, use a portrait lens, and use an f-stop that will give you a shallow depth of field (such as f/2.8–f/4.5). However, when you're shooting a close-up of a person's face, you must be more conscious of every flaw and detail. Since clients may not always tell you what they like and don't like about their appearance, it's your job to notice these things and to ask yourself, "If it were *me*, would I want to see this feature in my portrait?" There are ways to downplay certain aspects of a person's appearance. For example, if someone has bad skin, you can either use a soft-focus filter or reduce the amount of sharpening inside the camera's internal settings (if you have this option). The less retouching time you have to do after the shoot, the more profits you will make. Try your best to get the best images in camera as possible.

It's always advisable to follow the standard rules of posing. For example, if a person has thin hair or is bald, it's best to avoid placing any sunlight directly over his head. Instead, try to position the top of his head in shadow if possible. If the person has a full face, suggest that she turn her face slightly at an angle to the lens. You can also use shadows to thin the side and lower jaw area of the face or the entire body. This can be achieved by using a small black card next to or beneath the person's face or positioning them on the edge of a shadow area. It's subtle, but it helps. And as mentioned in the previous paragraph, you can always ask the model if he or she has a particular side of his or her face that he or she prefers over the other.

Pregnancy: Shooting a pregnant woman is a wonderful opportunity to capture a very special moment in a woman's life. If the father of her child-to-be is present, not only will you have a chance to create some romantic couple images (similar to those you might take during an engagement session), you might also get some poses showing his affection toward the fetus in the woman's womb. The woman should be far along enough in her pregnancy that it clearly shows that she is pregnant (not just bloated or overweight). Pregnant women can be very self-conscious about their weight gain, so choose poses that highlight her stomach (concealing her double chin, chubby arms, or swollen feet). Profile silhouettes can work really well for this. Explore your ideas with a variety of cute and funny but also sensuous, soft, and beautiful poses. To enhance softer poses, I like to use a soft-focus filter and sometimes a smoky white vignette around the lens. If the couple loves the pregnancy images, there's a good chance they will hire you to shoot the infant session, family portrait, and every other happy event that takes place as their family grows. It's an excellent opportunity to become their lifelong family photographer, so why not propose a prepaid, all-inclusive package that covers all of these things?

Families and Groups: It's imperative that you get the vibe of the group you're shooting before you construct your ideas list—whether it's a family, a sports team, or a corporate business. Directing and coaching these people in a way that appropriately expresses their connection to one another should be something you consider with great thought. It's best to speak to the person who is hiring you before the shoot date and try to get as much information as possible about the kinds of images he or she wants. Once again, you can ask questions as to how and where the images will be used (such as the company's corporate newsletter or professional website, or the family's Christmas card). If the words "fun and playful" are used, you're in luck, because you can have fun and make suggestions like having everyone either piled up on a pyramid on the grass in the backyard, packing into the hatch of an old truck, blowing bubbles, posed with beach cruiser bicycles, surfboards, or horses, or maybe just sitting on the front steps of an old house wearing matching cowboy hats. The ideas are endless

and giving a family or group an entertaining theme and/or interactive props always makes for better images. However, if the group is not that close to each other, you will have to compose a more conservative setting and then crack a joke or find something to say to capture authentic smiles or laughs. Be prepared either way to do something beyond the standard posed group of people lined up on a staircase. Stretch your imagination a bit and see what you can come up with.

Boudoir: The key to a successful boudoir session is to create images that always make the women look attractive and beautiful. This can be challenging when she is revealing so much of her body. Whether the poses are playful and coy or romantic and beautiful, it's absolutely imperative to use the most flattering poses and lighting to conceal her flaws and highlight her best attributes. Guys, this is not a porn shoot; it's a *beauty* shoot, so be discreet and tactful. You can certainly experiment with some "suggestive" poses but make sure they are tasteful. Whether she is a thin or full-figured woman, this is an amazing opportunity to shoot a woman in a sexy and beautiful way that makes her feel great about her body. I prefer either to use dark, moody, low-key lighting or overexpose the images using very high-key lighting to blow out any lines, wrinkles, blemishes, or skin imperfections.

Engagement Sessions: Shooting unique engagement sessions could enable you to increase your income, practice your shooting skills, get to know your clients better before the big wedding day, and even take your portfolio to the next level if you stylize them well. These sessions don't have to produce the typical, traditional, posed images of the couple sitting on a park bench or leaning against a tree. Envision a Hollywood film still, a *Vanity Fair* magazine celebrity spread, a vintage French postcard, or a quirky ad campaign. These sessions can be amazing opportunities to create some super-stylized, art-directed, theme-oriented images that will impress not only your clients, their families, and their friends, but maybe also ad agencies, stock libraries, or fine-art galleries. For more detailed information on shooting engagements, see my book *The Art Of Engagement Photography.* This book contains over 200 images and exclusive infor-

mation on how each image was made, so you too can learn how to shoot your own unique engagement images.

Weddings: Contrary to popular belief, shooting weddings is not for the weekend amateur or beginner photo enthusiast who lacks the proper training. This would be like surfing a 30-foot wave in Hawaii when you just started surfing last summer. To shoot a wedding successfully you need to be able to wear numerous hats at the same time. It involves knowing how to direct and capture large group shots, individual portraits, romantic couples, spontaneous candids, beautiful still lifes, and amazing location landscapes, all under the pressures of an emotionally charged day on a very tight timeline. It can be daunting and stressful if you aren't well prepared, but if you are, it can be one of the most exciting, invigorating shooting environments of your lifetime (especially for romantic, adrenaline-junkie photographers like myself). There's simply nothing better than traveling to gorgeous locations, eating amazing food, and shooting beautiful people in love. To learn everything you need to shoot weddings the right way and to create a profitable wedding photography business, read my book *Profitable Wedding Photography*, or enroll in one of my wedding photography workshops at www.destinationphotoworkshops.com.

Parties and Events: When I'm shooting a wedding or party, I'm often the one seen on the dance floor, smiling, with my camera in hand, shooting away. I usually use my wide-angle zoom so I can get close to people on the dance floor and zoom out for group shots. I'm a little goofy and crazy, but people absolutely *love* this and I become part of the entertainment. At the end of the night, I might even have a quick drink with the couple as my assistants are packing up the gear. I flirt and tease the guys a little and talk "chick chat" with the women. When I see the kids, I might sneak them a piece of candy and give them a secret wink. My clients always tell me afterward how many people loved hanging out with me and that I was the life of the party (all while grabbing those priceless party candids!). While these social gestures are an authentic part of my personality, they are also a big part of my self-promotion and advertising.

Food and Products: The goal of shooting food is to make it look like it tastes and smells amazing. This involves the right lighting, food styling, and lens. To stabilize the tight image and balance the horizon points within your frame, I suggest using a tripod with a level. To create an enticing, intimate feel, I suggest using a fixed, prime lens with a macro setting (such as a 105mm f/2.8) and varying your aperture f-stop between f/2.8 and f/6.7. While it's nice to throw the background out of focus by using a very shallow depth of field (such as f/2.8), you also want to make sure enough of the food is in focus. Bracket your depth of field and your focal distances so that you have a variety of options for the client to choose from.

To make the food look savory and moist (enhancing that dripping sauce or melted butter), you (or a professional food stylist) can use a simple spray bottle with oil and water. Chopsticks, tweezers, or other pinching, tongue-like utensils can be used to carefully position delicate items on the plate for the perfect food composition.

To give the food texture and dimension, place the brightest main light *behind* the food and fill the front of the food with a low-level flat light. If you want the food to look steaming hot, you will most likely need to backlight it with a powerful flash so you can shoot at a faster shutter speed to freeze the moving stream.

In addition to the close-up food plates and platters, you could double or triple your profits by up-selling your services (as mentioned in chapter 11: Pricing Your Services for Profits). Why not suggest some images of the raw ingredients (like fresh vegetables sitting on a chopping board or even on the vines in a farmer's garden), the chef's portrait, the restaurant interiors and exteriors, and the customers and the staff?

Property Interiors and Exteriors: If possible, it's ideal to schedule a location walk-through in advance with the interior designer, architect, builder, real estate developer, or property owner before creating the job estimate. This will help you to determine the number of shots you will be taking, how many hours or days you will need, the lighting conditions (both natural and artificial), and any necessary props required to enhance each image. While I think it's best to have the props provided by your client, you may also offer this service for an added fee if you wish. Pay attention

to any potential obstacles and address these with your client. These might include a broken bathroom tile, electrical wires, a stained carpet, or a patch of dead grass in the front yard. You might remind them to schedule the gardeners to come the day before to cut the grass or have someone dispose of the rusty patio furniture in the backyard. Your client should be the one responsible for prepping the location for the photographer (clearly define this in your contract). While you will certainly work around these issues and do the best you can to camouflage them, you cannot be held responsible for the quality of the images if the location is not properly prepped in advance. However, this being said, you can take this opportunity to up-sell your services once again by offering custom retouching to remove that ugly plug outlet, the reflection in the vanity window, or the crack on the cement walkway for an extra fee (or suggest a more expensive all-inclusive package that includes your retouching services). Never neglect to address this topic and, as mentioned previously, do not automatically include retouching unless this is part of your deluxe package shoot. Again, it's important to clarify every particular, so take notes before composing a detailed estimate for them to review.

The best interiors are always custom lit to "appear" as though the lighting came from the existing lighting at that particular location. Whether you prefer hot lights or flash strobes, you will almost always need some additional artificial lighting to highlight the key elements of a location. You want to have enough power to light the scene effectively so you can shoot at lower ISO settings (to minimize grain quality) and use broader f-stops (such as f/8 or f/11) for a greater depth of field. To keep your horizon lines as straight as possible, I suggest using a tripod with a leveler on top. The wider-angle the lens, the more vertical line distortion you will receive. In other words, while using a 20mm lens might enable you to capture more of the room (ideal for tighter spaces such as a narrow bathroom), this may make the walls or floor look crooked or tilted. There are perspective control lenses such as Nikon's 24mm, PC tilt shift lens that can help to straighten the horizontal and vertical lines, but be aware that this lens is manual focus only and not always that easy to use. While showing the entire room all in one shot is nice, wider angles have a tendency to render colder, less intimate-feeling images. For

this reason I suggest experimenting with a variety of compositions using different lenses with varying focal lengths. For wide-angle shots try a 20mm, 24mm, or 28mm prime lens (I favor prime lenses over zoom lenses because zoom lenses are not as sharp on the frame edges, and this is critical.) For closer shots try a 50mm, 60mm, or 70mm lens. For close-up detail images I suggest a 80mm, 105mm, or 120mm lens. It's always good to give your client wide-angle, mid-angle, and close-up images for a variety of perspective points.

Travel: As mentioned in the section on equipment carnets in chapter 7: Individual Job Expenses, when traveling abroad and going through customs, you want to look like a tourist, *not* a professional photographer. This can reduce the amount of hassle customs officials could give you about paying duties and tariffs on your equipment and potential images. I suggest traveling light and doing whatever you can to minimize attention drawn to you and your gear. The number of lenses and additional accessories you bring is up to you. If you have the room, you may want to bring a prime wide-angle lens, a prime portrait lens, and a flash if you intend on doing some light-assisted images. However, if have limited space and want the freedom of traveling lighter, I would recommend at the very least a good zoom lens like a 24–105mm that will enable you to store your camera in an unsuspecting backpack, like something a student might carry, and also give you the options of a variety of focal points. As mentioned in the discussion about prime lenses versus zoom lenses in chapter 13: Preparing for Your Photo Shoot, there are pros and cons to each, so you will have to determine which suits your needs best. If you don't want to drag along a flash, invest in a camera with low-light, low-grain capabilities, so you can shoot without the use of an attention-drawing flash. Nikon makes several amazing cameras with these features. As also mentioned previously, I advise you to always bring plenty of memory cards or hard drive storage. If you like the novelty of shooting film, you might want to bring some lead bags as an added precaution to protect them in case they are run through x-ray machines at the airport. Even if the operators tell you the machines are safe for most types of film, you never know, and I don't like to take chances.

Whether you like to shoot journalistic, editorial magazine-style images or high-end, travel-and-leisure advertising-style imagery, your objective when shooting travel images is to convey the feeling of actually being there to the viewer as best you can. If you're fortunate enough to work with a writer (for a magazine, for example), then it's best you get as much information behind the story of your images as possible. This might mean researching or interviewing the right people. The goal of photography is to tell the story with your images (not your words), and as a professional photographer this means capturing images that go beyond what the typical tourist might shoot. Tourist images are a dime a dozen, and they certainly won't impress magazine or stock-photo-agency editors.

As I teach in my destination-travel workshops (www.destinationphotoworkshops.com), when I shoot travel images, I remind myself that each country is known for something unique; this is what makes the world such an amazing place. I try my best to capture the sights, smells, tastes, and sounds of the culture of the country I am visiting. This means documenting the place's uniqueness with a variety of unique images from landscapes, architecture, and cuisine, to the local people living, working, and expressing themselves. For example, if you're going to Hawaii, you might want to research and shoot Hawaiian surfboard makers, the features of a traditional Hawaiian luau, or the farm workers at a Hawaiian coffee plantation. If you're aiming your images more toward the travel and leisure industry, then you might want to find out about the top tourist activities, historical scenic spots, or what the locals do on the weekends. If you're shooting in France, for example, you might want to schedule an editorial portrait with a French chef, a baker, or perhaps a perfume maker standing in his field of lavender.

Sports: While I have very little professional experience shooting sports, I do know that the key to shooting these things is to be passionate and knowledgeable about the sport before you start clicking your shutter. Knowing the key players in the game or the unique features of the vehicle will enable you to appease the magazine editor, ad-agency art director, athlete, child's parent, or anyone else who might buy your images. Positioning yourself in the right place for the best action shots is key to

capturing an emotion-charged image. I know of one photographer who has made an entire business out of shooting little league games and then selling the prints to the parents from the mini-printer set up in his van in the parking lot!

Whatever you're shooting, it's extremely important that you invest adequate time in preproduction prepping. The more preparation work you can do prior to your shoot, the more likely your shoot day will run smoothly and the less postproduction retouching work you'll have to do. Remember, less work means more profits. These are the keys to a successful photography business.

Notes

ETIENNE

PHOTOGRAPHY

15

Creating a Recognizable Brand
Images, logos, and packaging

Nikon, Kodak, Coca-Cola, and even McDonald's have a brand that people can easily recognize around the world. Their brands have a consistent look, taste, or feel that encompasses everything from their products and services to their logos, packaging, and advertising. Their branding is what distinguishes them from their competition and accounts for an enormous part of the success of their companies.

Technological photographic advancements have made it easier for photographers to make dynamic imagery. This is a wonderful thing for all of us, but it has increased the number of people offering their photography services in the marketplace. Now more than ever it's critical for you to define a brand style that will separate you from your competition. It is no longer enough to be just a good photographer with technical expertise, an eye for composition, and the ability to produce a photo shoot from start to finish; now it's also imperative that you have a specific, recognizable look and feel to everything from your images and service to your marketing and packaging materials.

From unique flash system and superb low-light digital cameras to postproduction manipulation and retouching techniques, we have far more options for controlling the final outcome of our images than ever before. Now we not only *take* pictures, we are also able to *make* pictures, thanks to photography editing programs like Photoshop and Lightroom. How you achieve the consistent look of your images doesn't matter to

your clients; they just want to know that you can re-create the same feeling again for *their* job.

Branding Your Style

While on your journey toward developing your image style, you should begin to think about not only that which makes your images unique, but also what makes you, your business, and your entire company stand out from the crowd. This could be anything from the types of things you shoot to your personality, hobbies, and interests. All these things combined will eventually become the backbone of your branding style.

Branding your company gives your entire business a recognizable, consistent, professional appearance. For example, I am of French descent with a very French last name. I also speak French and lived in France for many years. To add to this, I am a hopelessly romantic person, so shooting couples in love for their engagement sessions and weddings is a part of who I am. I am also known for being a very warm, down-to-earth Midwesterner with a no-nonsense personality. These two aspects of my character are apparent in both my timeless black-and-white images as well as my colorful contemporary-lifestyle images of real people, real places, and real things. As the daughter of an interior designer/antique dealer, I have an affinity for vintage artifacts and magnificent interiors. I incorporate all of these things into my photography, whether I'm shooting couples, still lifes, interiors, food and wine, or luxury lifestyles. All of these elements are a part of my life and in turn have become a part of my brand identity.

When you begin thinking about *your* brand identity, you might need to step back from yourself and your work a bit or ask others what they see, hear, and feel about you that makes you and your service unique. Step outside of your small community and look at yourself from a vaster perspective. Do you have a special connection to an ethnic, religious, or other unique market? Are you a surfer or a collector of antique lace or fine wines? Do you ride horses and live in a rural area, or are you a New York City girl with an eye for fashion trends? Use your contacts in these particular markets and you might even consider creating unique packages

exclusively for them. All of these things are a part of who you are and can be incorporated into your branding style. Your objective should be to target specific groups without eliminating the potential for a broader audience.

BRANDING YOUR IMAGES

The first step toward branding for any company is to develop a unique product. For photographers, this product is our images. As you begin to explore your photography, close you eyes, envision your camera attached to your heart, and see where it subconsciously leads you. Allow yourself to shoot a variety of things that inspire you without any particular objective in mind. The exploratory process should be effortless, easy, and fun. Most artists feel the need to communicate in a more profound way than the average person. This usually stems from events and feelings from our past. Our reaction to these experiences can penetrate the fabric of our images and create truly unique results. This is a part of who we are, and this is what makes good art *great* art. I urge you to explore yourself. As you do, you will start feeling happier and freer than you ever have before. In the same way that a writer finds his muse, you will find yours. You'll be creating images subconsciously when you're walking, talking, sleeping, and going about your day without even thinking about it. As you shoot more and more, others may notice a consistency to your work that you didn't even know was there. Eventually, your images will become as identifiable as your own voice.

BRANDING YOUR IMAGE PRESENTATION

The next step toward branding your photography company is to think about your product presentation. This includes your portfolio books and your website. Step back from your body of work and begin to organize your images into collections based on subject matter. However, as I've mentioned in chapter 16: Promoting Your Business, I stress quality over quantity. Less is more. Choose only your very best images. Once you have enough quality images to make a dedicated portfolio book, take note of elements such as color hue and temperature. You don't want to have a

random mix of warm-toned images following a few cooler, bluer-toned images. Consistency is key, so adjust them all to match. Also make a note of the framing and borders around your images. For example, if you're going to use sloppy borders around one image, then the entire collection should have this feature as well. If you have a 1-inch white border around one image, then all of your other images should have this too. Your page layouts should also be taken into consideration. If you want to mix up your page designs to keep the book interesting and refreshing, this design should be done very intentionally, like the rhythm in a song. For example, you might have a single, horizontal, two-page spread followed by two pages of montages, followed by two full-page vertical images. Like a song's chorus, this pattern could repeat itself several times in the book or gallery section of your website. A collection of images should flow; it should tell a story, like stills from a TV series. Even if the images are from different episodes with different actors wearing different clothes in different scenes, the overall feeling will be the same.

Once you have designed one book, you might decide you have enough quality images to create other portfolio books, each dedicated to different subject matter. However, just as the style of your images, the image collections themselves, and the page layouts are consistent, your portfolio book series should be consistent as well. While each book can certainly have its own unique look and feel, there should still be a thread that links all of your books together. You never know when a client may want to see your entire library of images for a very special project. While your work can certainly show diversity, you don't want it to look scattered. To do this, you might think about the book size, placement of the title, and the basic design format of the cover. Your client will feel reassured that not only are you talented enough to shoot a variety of things well, but you can do it just as consistently as you do when shooting just one subject matter. It will certainly be impressive.

Before you spend the time and money to print and bind your portfolio books, it might be best to print out a proof sheet of the images or the actual book page layouts you are considering and show them to others and ask for their honest reaction and constructive feedback. Do not ask them which images are their favorites; rather, ask if there are any images

they would consider removing, and then ask them if it feels like the images all flow together and if the collection looks like it could be a coffee-table book. If the answer is "yes," you're good to go.

BRANDING YOUR COMPANY NAME AND LOGO

Creating a company name should be something you consider with great thought. While you may want a name that's truly unique, you will also want something that others can easily remember and pronounce. I usually recommend using your own name (instead of some cute, cookie-cutter company name such as "ABC Photography") for numerous reasons. Having both a company name *and* your own name makes your buyers have to work twice as hard to remember whom you are and how to find you. People tend to remember a person's name first over a company name (unless your company is some chain of stores or something). Using your own name also personalizes your company more and makes others feel more trusting. A person can become famous, but most likely "ABC Photography" won't. However, if you have a name that's very common (such as John Smith), you might consider adding an initial or jazzing it up in some other way (John B. Smith or Johnny B. Smith). If you have a name that's difficult to pronounce, you might consider shortening it or adjusting it in some other way.

Once you've determined what name you will use for your business, you can think about your logo. Your logo might be something directly related to the kind of things you shoot, your family coat of arms, or just something that ties into your particular style of shooting. For example, my logo is derived from an elegant, ornate, iron-gate entrance I saw in a small village outside of Paris. Placing my French last name directly beneath the gates just seemed to work perfectly. A simplified logo might just be your initials wrapped around each other. However, while logos can have a certain prestige and commanding presence, they can also absorb a lot of space, especially if the logo is more vertical than horizontal (as mine is). This being said, you don't necessarily need to have a logo "design," per se. You might want to simply use your name with a unique script font that matches your style of photography. I have *both* a logo and a script signa-

ture. I usually use the script signature when I have limited space. Whether your logo is elegant and romantic, cool contemporary, or kitschy cute, it should match your entire brand identity.

Branding Your Services

As a part of your efforts to expand your brand, you might consider naming some of your all-inclusive packages or any other products and services with brand theme-oriented names. For example, my wedding photography packages have French names like "Paris Rendez-Vous," "Bistro Kiss," "Chateau Affair," and "La Grande Dame." Let's say you shoot little league games or other sporting events. You might offer packages such as "The Grand Slam," "Home Run," or "The Dugout." If you shoot family portraits and live in a rural area, you might link your package names to familiar locations in your town where you like to shoot such as "Harrelson Creek," "Grampa's Barn," or "Oakly's Coral." I'm sure you will think of a million unique names linking your products and services to your branding style.

Branding Your Packaging

The final touch to branding your company is your packaging. Classy packaging says a lot about how you feel about yourself, your business, and your work. Hold your shoulders back, stand tall, and smile proudly as you present your finished piece of art. The right packaging can often make up for a less-than-perfect product, whereas—sadly—lousy packaging can degrade and even destroy the value of dynamic images.

Your packaging can be something as simple as an envelope with your company's logo printed on it, or it can be something more sophisticated, like a deluxe, customized box with your company logo embossed on the lid. Get creative, have some fun, and impress the heck out of your clients. In my book *The Art of Engagement Photography*, I dedicate an entire chapter to crafty, theme-oriented packaging. Check it out.

Before you close the envelope or the box, don't forget to include a short note to your client on your company letterhead or maybe an embossed

note card. If you don't have legible, attractive handwriting, type it out and attach one of your matching business cards (I use a beautiful gold paperclip. I also like to include a beautifully designed gift certificate, with my branded logo on top, of course). This serves as the finishing touch on your package. From your branded images, branded logo, and branded company name to your branded letterhead, note cards, business cards, and boxes, your entire presentation will have a beautiful, polished, professional appearance, and you should feel very proud delivering your crown jewels!

16

Promoting Your Business

Create a buzzzzzzz about your bizzzz . . .

THE NUMBER ONE REASON MOST BUSINESSES FAIL IS FROM THE LACK of customers. You can be the most amazing photographer in the world, but if no one knows you exist, you'll never survive. Be prepared to dedicate approximately 25 percent of your time (and maybe income) to promoting yourself and your business. Whether you use free social networking groups or hire a marketing specialist to find the best paid advertising, you will still have to take the time to prepare your materials and determine how, where, and when your precious advertising dollars and your time will be spent.

Before you consider paid advertising, make sure you feel your work is at a level that warrants the expense (this is a question only you can answer). If not, your time and money should be put toward creating better images instead. However, if you need to generate some cash flow while you're continuing to update and improve your portfolios, there's no reason you can't promote yourself through your personal contacts, your social networking groups, and any other unpaid promotional outlet to get the word out to the masses that you're open for business.

WORD OF MOUTH

Nurturing your relationships (both personal and professional) is imperative to the success of your business. The most powerful and least expensive form of advertising is word of mouth. This means someone else referring

your services to someone else. This comes about as a result of good relationships with people. I have had numerous clients over the years that have continued to hire and refer me to all of their friends and family members, time and time again. This is a huge compliment to me because it not only means that they love the service I have provided, it also means that they love *me*.

Create an Advertising Target List

Your advertising target list can be divided into three sections: paid advertising, unpaid advertising, and self-promotion. You might create a spreadsheet for important tracking information such as advertising rates, advertising dates, the number of job leads, and the number of bookings. While most of your self-promotion items (like your portfolio books, website, and business cards) will be included in your start-up expense sheet (listed in chapter 3: Start-Up Expenses), these items will also need to be updated from time to time. This applies to your unpaid advertising as well. Therefore, these items should be included in your advertising list, advertising schedule, and advertising spreadsheet. Below is a sample list of some of the places you might consider for promoting your work.

Create an Advertising Budget

While word of mouth is a powerful form of advertising, one cannot rely on this method alone. If you've created a business plan (as advised in chapter 5: Funding and Managing Your Business) including a breakdown for your ongoing monthly expenses (as advised in chapter 4: Ongoing Monthly Expenses), then you will have a rough idea as to how much money you will have to dedicate to marketing and promotion. After a year or two of advertising, you will begin to see some trends and know where, how, and when to make your adjustments. As you become more established and begin receiving the majority of your job leads through word of mouth, you may get the false impression that you can abandon your advertising altogether. This is a common mistake many small business owners make. It puts you in a very vulnerable position because you

are now relying solely on one single source for your advertising. Should this source suddenly dry up for no apparent reason, you're left standing in the cold, wishing you hadn't given up that first-place spot in the advertising listings. Marketing experts always advise that when business is going great you need to keep advertising to keep it going great. There's plenty of evidence to back this up. Just look at large companies like Coca-Cola, Nike, and BMW. They continue to advertise despite the fact that they occupy the first position in the marketplace.

SELF-PROMOTION

- **Become your own agent:** You never know where your next job might come from, so don't be too shy to let others know that you're a photographer. The most unassuming person might be the son of a millionaire who wants to hire you to shoot his cousin's wedding. Even if you don't book the job, you might learn something interesting or make a new friend. You could be waiting at a bus stop, mingling at a party, or standing in line at the grocery store; these are all great opportunities to connect with people. I'm not suggesting you just start handing out your card and doing a hard sell on strangers—in fact, I advise against this because it looks desperate and pushy—but you might strike up a conversation by making a funny remark about the bus schedule, the party host, or the lack of cashiers at the store register. If the conversation organically leads to a natural opportunity for you to casually mention that you're a photographer, then do so. Photographers fascinate most people, so the person you're speaking with will inevitably ask you a lot of questions about what you shoot. Be prepared to answer with a confident, enthusiastic tone and always have a few business cards ready at hand. I usually keep a few in my wallet, my purse, my camera bag, the glove compartment of my car, and anyplace else I can think of. I just replenish the supply each week before I walk out the door.

Can you rely on an agent to sell you and your services? Maybe, but I find more often than not that clients prefer to meet the photographer face-to-face anyhow, not a liaison who acts as a go-between. While advancements in technology enable us to do things faster, our society is

now seriously lacking in human connection. Although the Internet is a fast and easy way to find a photographer, there is a lack of intimacy, which is something that only a real face or voice can provide. Use this to your advantage and let people see what an amazing person you are.

- **Blogs, websites, and Facebook:** There is much debate over whether a photographer should have a stand alone website or simply a blog. There are pros and cons to both. Some photographers, like myself, have both a website and a blog, for different purposes. In fact, I have two websites, but this is not atypical. Because of the fact that I divide my time between shooting and teaching and I have a massive abundance of images in different categories, I really needed to organize my products and services in the most effective manner. Therefore, my first website (www.eephoto.com) is dedicated exclusively for my nonadvertising work such as my portraits, weddings, and interiors. My second website (www.elizabethetienne.com) features only my advertising, stock images, and fine art. My blog (www.destinationphotoworkshops.com) is designed specifically as an educational platform for my workshops, books, and photo coaching. If your main intention is to display your images with no distracting text, then a dedicated website is most likely a better option for you.

Blogs: Blogs are more slick and professional than a Facebook page; they have a private website domain with a designated url address, and they have a menu bar with subpages much like a website does. While images are certainly a "part" of a blog, they tend to have limited design options, features, and image storage space in comparison to a stand alone website. The main purpose of a blog is to offer free educational or informative content while selling your products and services. Most people subscribe to a person's blog in order to receive regular updates, tips, or advice on one particular topic or another. Unlike a website, blogs and Facebook allow others to comment on images or text if you want (you can choose to disable this feature). The benefit of a blog is that you can also use this space to add hot links and keywords to your articles, linking them to other sites. Google will pick up the keywords in these articles, and this can draw more traffic back to *your* blog—more traffic than you might ordinarily get

from your stand alone website. More traffic means more exposure, and we all know what that means.

The differences between blog programs are much like the differences between Flash and html-based websites. Each blog application seems to have its pros and cons, so there is much debate over which ones are better. Some of the most popular blog applications are Wordpress, Blogger, and Blogspot. (When I talk about "Wordpress," I'm referring to self-hosted Wordpress blogs and not WordPress.org. This is something different.) It appears that the blog platforms that offer more options also seem to be more complicated to use. However, just as technology is forever changing, so too is the blogging world, so keep in touch with the industry.

- **Websites:** Your website is one of the most important marketing tools you will have. The purpose of a photographer's website should be to display his or her images in the most effective manner possible. The other purpose of a website is to reduce your workload by answering frequently asked questions. It is therefore imperative that the site's design and navigation be as user-intuitive as possible. This means links should be clear and easy to find and pages should load fast (especially the contact page). A small and select collection of your very best images should be separated into the appropriate categories. Size your images large enough for average viewing, but not so large that visitors to your website are forced to scroll up and down in their browsers' windows. A size range of 300 to 865 pixels in height by 600 to 1500 width should be sufficient. When you save your image, use the "Save for Web" setting in Photoshop to reduce and optimize the file size. This will help images load faster. There is nothing worse than having to sit and wait while an image loads on the page. This is a surefire way to irritate and even lose a potential customer. Remember, everyone's time is valuable, and most people's patience level is minimal. They want to see a large collection of images and a lot of information as fast as possible. As I emphasize in chapter 15: Creating Your Recognizable Brand, all images should have a consistent look and feel. This goes for your portfolios, promo pieces, and just about every other place you display your images.

Ready-made website templates: I'd be a millionaire if I got a dollar from each person who told me that he doesn't update his website because he has to send his requests to his or her webmaster, who then queues it up for weeks or months before actually making the changes. As mentioned in chapter 3: Start-Up Expenses, I recommend having a website that allows *you* full access and full control of the images and text content with no web design training whatsoever. You need to be able to update your site regularly (to show off your latest and best work) and quickly (when you need to update your press, pricing, or biography). This could make the difference between gaining or losing a new client and earning more income. I purchased my website template from Photobiz.com. If you end up using them as your website template company, be sure to let them know that I referred you when signing up.

Biography and press link: In addition to your images, it's important to have a biography with a *professional* image of yourself posted on your blog or site. People like to be able to put a face to a name. Subconsciously this makes buyers trust sellers more, and trust is imperative in our business. Don't use a silly "artsy" snapshot of yourself. This tells your clients that you really don't take your work seriously (so you don't need to get paid for it, either). Use a professional portrait.

Your biography should be short and sweet and feature only facts that are directly relevant to your work. It's not necessary to ramble on about how your dad gave you your first camera when you were 6 years old etc. . . . etc. . . . (that's every photographer's story). Instead, use this valuable space to speak briefly about what makes you and your service unique and the kind of images that motivate you. You might want to end the biography with any projects or career aspirations you have for the future. It's best to keep your biography to no more than a half-page long (unless you're a seasoned photographer with numerous featured career highlights).

If you have enough content to create a separate press link, do so. Magazine covers, awards, and gallery openings can really impress visitors to your site. Quotes about your work by recognizable industry leaders further legitimizes your work. However, if you don't have enough press to warrant a dedicated link on your website just yet, don't fret. For now you

might simply combine your biography and press sections by adding a few magazine covers to your biography page, next to your headshot.

Online payment system link: I think every photographer's website should have a shopping cart or at least some means of paying with a credit card. This makes it easy for your clients to pay you the job deposit and balance faster. It's a convenience and benefit for both you and your customer, so I highly recommend it. However, you will need to apply for a merchant account with your favorite credit card company or your bank (if they offer these services) and be prepared to pay transaction fees. Most credit card companies will offer you payment options. You can choose to pay either a flat monthly fee or pay each time you make a transaction. The rates will vary. While a link to PayPal is certainly an option, it doesn't look quite as professional as a secure payment option on your website.

Testimonials link: Research indicates that testimonials can be one of the biggest factors in swaying customers to purchase a particular product or service, so always save *any* compliments others have made about you. These include comments from clients, friends, admirers, publishers, industry professionals, or even other photographers. These are very powerful. I am fortunate to have hundreds of handwritten client letters from before the days of emailing, so those add a special touch to my website and authenticate my credentials. If you can't find anything, go through your old emails and see if you can track down some from clients where they mention how pleased they were with your images. If you don't have any, contact your clients directly and ask them if they wouldn't mind writing you a short testimonial—a few lines should suffice. You can certainly create a reference list as well if you choose (especially if you have some well-known clientele), but a written testimonial is far more powerful.

Search engine optimization (SEO): This term always wakes everyone up—it's one of the most important aspects of promoting your website. You want your website to appear at the top of the search engine's results when a potential customer uses specific keywords to find your services. However, because everyone is trying to find a secret way to beat out his or

her competition, encoding appropriate and unique keywords (metatags) into the individual pages of your website's control panel is a start. Be careful: Search engines are finicky things, and if they see a site that is using too many of the same keywords repetitively or inappropriately (known as stuffing or black SEO), the entire site is at risk of being knocked right off the search engines. The same goes for plagiarized phrases. Don't take someone else's text information and call it your own. Search engines may see this as identical phrasing and your site could be shut down altogether . . . permanently!

Here's how it works: Search engines look for activity, both incoming and outgoing, coming from a particular url address. The more clicks to a particular site (from different computers in different locations), the faster this site crawls to the top of the listings on its own. The goal is to get as many hits as possible. Yes, you can certainly pay for top-positioned listings (discussed below), but this can sometimes be very costly.

There is much discussion about the differences between Flash- and html-based websites in direct connection to SEO. While technology is improving every day, up until recently we were forced to choose between beauty and functionality. Traditionally, Flash-based websites look more slick and professional because they are more dynamic and have more design options in comparison to the somewhat bland, stagnant-seeming html-based websites. However, the trade off used to be that Flash-based sites performed less aggressively in the search engine rankings. This is because they weren't hard coded with as much text content as a standard, static html website. While an html site can certainly feature a slideshow of moving images and such, there will typically be less control options over things such as the type, speed, and duration of each dissolve. The same limitations apply to the font styles and font sizes used in the text. An html site is like a basic rental car with no power seats, windows, navigation system, or a surround-sound stereo system. A Flash site is like a loaded BMW with all the extra features. The good news is that Google has created a technology that enables search engines to crawl for Flash-based websites as well. As long as there are some static keywords implemented into pages of the control panel, there is a good chance search engines will catch the website. While there is much debate about their respec-

tive pros and cons, the general consensus is that Flash websites are still not at the same SEO level as a similar html site. However, Google claims it is advancing its Flash content technology more and more every day, enabling more and more people to find Flash-based sites when performing keyword searches. For the latest, most up-to-date data on SEO, go to www.googlewebmasterscentral.blogspot.com. The site features extensive information for website owners on SEO and how it interacts with Google. The site will also give you information on how to keyword your own site most effectively.

- **Portfolio books:** While many clients may hire you based on your website alone, other clients want to schedule a meeting to see your images and discuss a project face-to-face. As discussed in chapter 15: Creating Your Recognizable Brand, your portfolio images (as well as your website images) should represent only your very best work, and images should be displayed with a consistent design layout and color hue. If you have a large collection of dynamic images, you may want to take this opportunity to include some of the images in your portfolios that you didn't display on your website. This will give your viewers something refreshing to look at.

The number of different portfolio books you have will depend on your existing volume of high-quality images on a particular subject matter. While I caution against an all-inclusive portfolio book that combines random, unrelated subject matter such as food, sports, fashion, interiors, and photojournalism, you could to create a "portrait" book that includes couples, pregnancy, babies, kids, teens, families, seniors, and individual portraits. You could also dedicate a portfolio book exclusively to your engagement sessions and another one exclusively to weddings. If you don't have enough high-quality images for separate books on these topics, a combination "people" book is acceptable in the interim.

There are a number of reasonably-priced album bookmakers to choose from. It's always great to be able to touch, see, and feel something before you buy it. Ideally you should inspect the quality of the binding, the printing, and the cover. Make sure the book is durable enough to withstand being tossed about, but still lightweight and thin enough to handle and ship easily and inexpensively. Most importantly, the books should

have a powerful professional presence, not look like one of those flimsy, consumer drag-and-drop books the general public can buy. *Your* book should be something you feel very proud of and confident presenting in every way. I use Samy's Camera, a camera store in Santa Barbara, California, for my portfolio books. From the paper thickness and print quality to the book binding and pricing, their books are just perfect for my needs, and they're as high quality as one you would find at a retail bookstore. They're just great.

• **Business cards:** As seemingly insignificant as a tiny business card can be, don't let size fool you. In the age of instant information, a business card can be exchanged as quickly as you can shake someone's hand. In a two-second glance, a business card can tell someone who you are and what you're about. With this in mind, remember that you only have one chance at a first impression.

The design of your business card should be as much a concern as every other marketing piece you will create for your business. Create a card that's easy to read but elegant and sophisticated at the same time. Don't try to be trendy and cool by using super-small fonts. These cards drive me crazy, and I usually toss them out if they're too hard to read. Don't make someone work to read your name or phone number. On the other hand, it's tacky to make the text so large it screams, "I'm desperate. Call me! Call me!" Keep it simple, elegant, professional, and easy to read.

Don't try to save a buck by printing out your own from your home printer. The recipient of one of these will think that if you can't afford a good-quality business card, you're probably no good at what you do. It's sad but true. There are a number of inexpensive online printers out there, but I have had good and bad experiences with them. To keep costs down and profits high, some of these online printers print in a bulk "gang run." This means that hundreds of other business cards are lined up on the presses next to yours and everything is printed at the same time. Custom correction tests for bleeding, blocking, cutting, and color adjustments cannot be done. You get what you get. This being said, inquire about receiving print samples first. If this is not an option, make your first order a small one just in case.

After a few bad experiences with a big-name online printer, I almost gave up. Finally I found two print companies that did fantastic work. One of them is Tammy and Friends Printing (www.tammyandfriends.com) and another is Overnight Prints (www.overnightprints.com). They both processed and delivered my order quickly and I got optimal results.

- **Promotional discount specials:** As mentioned in chapter 12: The Art of Handling Your Clients, I typically finish each job by giving the client an elegantly designed gift certificate that includes a discount coupon applicable toward any of my products or services. Not only is my client touched, it also encourages them to hire me again for their next shoot (or to give the coupon to a friend or family member—another excellent way to drum up new customers).

In addition to gift certificates, I also send out a beautifully designed email promo about once a quarter to all of my former clients. In it I offer special rates for special shoots, like my Autumn Family Portrait Special (reserve a session before October 15th and get 15 percent off any family portrait package). Or I might target specific clients near their wedding anniversary and offer to do an updated couples shoot (or a sexy boudoir shoot of her for him!). Let them know this is a special offer you are giving exclusively to repeat customers only as a gesture of gratitude for their patronage. This gives the discount class and elegance without degrading the value of your work.

- **Guest gifts:** For my special big-budget clients instead of a gift certificate I might give them an actual gift. I had one repeat client who hired me numerous times to shoot for numerous family events. We became quite close over the years, so when they called me to shoot the husband's 50th birthday party, I decided that this time I wanted to say thank you and give something back to them. I came up with the idea to create a hardbound coffee-table book using selected images from all of the various events I had shot over the years. This included every event from the couple's engagement session, wedding, and pregnancy to infant portraits, anniversary parties, and a family portrait. The day of the party, I carefully placed the book, unwrapped, at the gift table. I left a bunch of extra pens and a note

asking the guests to sign the last few blank pages of the book. Not only were he and his family touched beyond belief, but I was also able to use this opportunity to tactfully place a few business cards in a small card-holder next to the book.

I surprised another client by making them a password-protected slide-show, which I posted on my website. I chose a collection of favorite images from their family portrait shoot, created some beautiful paired montages, and set the show to a touching song. They were so thrilled that they sent the link to all of their friends and family, and in no time I had several jobs and I nearly doubled my profits with reprint orders! To add to it, this drew a lot of traffic to my website, and search engines love traffic. Now I always ask my clients in advance if they would like their images posted online (in a password-protected area if they choose). My assistants simply hand out my business cards during the event that include the link to my website and a space where we write their password instructions for the slideshow. For more ideas and other à la carte services and products, see chapter 18: Recycling Your Images.

• **Books:** Once you've reached a point in your career where you feel you have important information to share, access to a large audience, and a knack for writing, a book like this one can be a powerful way to enhance your presence in the photography industry. It also might be an excellent launching pad for guest-speaking events, workshops, TV, radio interviews, and more.

I now have three books on the market. My first book, *Profitable Wedding Photography* (Allworth Press), is a paperback book containing approximately 20 black-and-white images and approximately 60,000 words of text. This book is a must-have book for every photographer who wants insider tips on shooting weddings. From pricing, marketing, and client relations to prepping, shooting, and packaging—my first book will teach you the step-by-step process in straightforward, informative, enter-taining writing. There's simply nothing better than wallowing in the glory of creating incredible images, traveling to beautiful, romantic locations, eating great food, meeting new people, and earning money with your camera! Could it get any better than that? Yes, it actually can: The final

bonus is the opportunity to create lifelong friendships with clients who love you and your images. In reality, the rewards are endless . . . *this* is the business of wedding photography!

My second book, *The Art Of Engagement Photography* (Amphoto Books), is a stunning how-to image book that contains over 200 of my color and black-and-white images. This book will walk you through the step-by-step process of selling, preparing, shooting, and reselling your one-of-a-kind engagement images. Offering super-stylized engagement sessions can enable you to increase your income, practice your shooting skills, and get to know your clients better before the big wedding day. Shooting engagement images will not only impress your clients, their families, and their friends, it's a great way to reach ad agencies, stock libraries, fine-art galleries, and more!

My third book is *this* book—an all-inclusive, must-have guidebook to a successful photography business. My objective in writing this book is to share with you all the inside tips and secrets most other pro photographers like to keep to themselves, so that you can create your own successful photography business—only a fantasy for most.

However, there is much to consider before plunging into the publishing world. Whether you decide to publish your own book or try to find a publisher, keep in mind that researching, writing, editing, producing, marketing, and selling a book takes time, money, and resources. It's also important to take into consideration that you need to have access to a large audience of buyers. Image books are more costly to produce in comparison to newspaper-print paperback books like this one. While every photographer dreams of having a coffee-table book of his or her images, four-color printing, binding, and shipping these books is very expensive. Additionally, to make books affordable for the buyer, they must be printed in mass quantities. I know of one photographer who teamed up with a writer and a marketing consultant and the three of them produced a book on their own. They agreed to share the costs and share the profits. Their book ended up costing them about $80,000 to produce. Sadly, five years later, they still have not broken even yet. While the book's design layout and image content are magnificent, they simply don't have the mass-marketing capabilities to sell the book properly. To

add to it, the book itself is so niche that there isn't a large enough audience for it. The one upside is that the book has been a useful tool for the photographer's self-promotion. It has helped him land several major ad campaigns, so for him it was not a total loss.

If you cannot find a publisher willing to take the risk and give you an advance on your book, you might research to see if you are eligible for a grant. Usually if the topic is newsworthy or of great interest to the general public, you will probably have a better chance at getting funding. You might also talk to a private investor and try to get them as excited about your project as you are. This is often how movies are made. Many investors are fascinated by artists and want nothing more than to be attached to something artistic. An added perk is that they may also be able to use the investment as a tax write-off if the project qualifies. Research your options.

- **Guest-speaking events:** While it's great to get paid to speak at events (as some of us educational and motivational speakers do), occasionally volunteering your time to speak for free can be essential to preparing yourself for the big leagues. Speaking to a classroom of students or a small photo club is excellent training for speaking at larger venues and a great way to connect with other photographers and photo enthusiasts in a much more intimate setting. Developing relationships with your fellow photographers is critical. Not only can they enlighten and educate *you* (because they are usually more exposed to the latest industry trends), they can become fans of your work and in turn help promote your books, workshops, and your photography services too! As a mentor, I can't stress enough how important it is to reach out to your photographic community in any way you can.

- **Television and radio interviews:** If you can get a television or radio station to feature you, you're in luck. Audio and visual markets are another great means of self-promotion. While many small radio or TV stations simply don't have the budget to pay you to be on their show, it's still a great opportunity for exposure to the masses. For example, if you specialize in infant and pregnancy photography, you might offer to speak

about this on a station dedicated to parenting. If you shoot weddings, maybe you can offer tips to couples or wedding coordinators on what to look for in a wedding photographer. And if you're an educator, you might be able to speak about your photo books and workshops to other photo enthusiasts. Do your research in your local community and keep in mind that these stations are always looking for quality content to fill their airtime.

FREE ADVERTISING

• **Online social networking groups**: Everyone knows about Facebook (if you don't you must have slept through the millennium). Facebook is an incredibly powerful marketing tool if you use it in the right way. However, it can also be just as damaging if someone posts something unflattering, or worse, defamatory about you. Be selective about the people you accept as your "friends" and immediately delete anyone suspicious (these people might use the opportunity to destroy you with a malicious, defamatory post or picture). Additionally, you should alert your close friends to be very careful not to post any incriminating images of or content about you (such as, "Here's Mark wasted again from another night out drinking," or, "There's Karen making out with some guy she picked up randomly in a dive bar"). As an added precaution, check Facebook regularly so you can remove the tag linking an unflattering image to your profile before too much damage has been done. You can also contact the person to request that they remove any written, potentially character-damaging content associated with your name. Be careful how you use your Facebook page because you never know who is seeing those posts. Just remember that your potential customers are everywhere (even your friend's sister's husband's grandmother might be your next client). Don't misuse or waste this valuable marketing arena with silly, pointless posts about mundane or depressing things. Be selective about what you post and keep it focused on positive, upbeat content *directly related to your photography business*. Because I have many photography-industry fans, sponsors, clients, publishers, agents, and such on my Facebook page, I use Facebook primarily for my photography business for selective marketing

purposes. While I do have both a personal page and a fan/business page, I update my fan page far more frequently. There I post updates on my workshops, books, gallery openings, and speaking events. I also include photo tech or business tips, display shots from my most recent shoots, and occasionally give away a free consulting session. It's an awesome way to keep your professional and personal life separate.

The best part about Facebook is the exposure it provides. Why not try posting a few images from a recent shoot with information on lighting, wardrobe, or how to prep for the big day? Giving advice to others is an excellent way to stay in touch with the world and keep your business fresh in their minds. However, I highly advise that you don't post too often. This dilutes the power of your images, your brand, and your reputation. I would also discourage posting anything of a personal nature if you're going to use Facebook to promote your business. Do not mix the two. It confuses things, and you could be giving the impression you have too much time on your hands (because no one is hiring you) and this is not a good sign. I know of a photographer who posts three times a day. His work is great, but I've seen it so much that I'm tired of it. The objective is to give people an appetizer now and then, leaving them hungry for more (not stuffing a platter of food in their face every two hours). I also know another photographer who is always posting about her struggles. "Each defeat makes us stronger," she writes. While there is something positive in these words, it's clear that she is always struggling, and people subconsciouslsy want to run away from struggling people. It's just not good business practice. Don't use Facebook as a replacement for a therapist; pay one instead. The same principles should apply to any other social networking platform, such as Twitter and LinkedIn. They function slightly differently. Twitter is a service for friends, family, and co-workers to communicate and stay connected through the exchange of quick, frequent messages. People write short updates called "tweets" of 140 characters or fewer. These messages are posted to their profiles and their blogs, sent to their followers, and are searchable on Twitter. Again, don't misuse this. Use it sparingly and use it wisely. Only tweet informative content. LinkedIn is a business network only. It is not used for personal posts and pictures like

Facebook. It's a good idea to update your work-related projects from time to time to keep others informed and interested.

- **Live social network groups**: There is nothing like face-to-face interactions with people. Your local chamber of commerce or other networking groups such as Meetup are great places to meet new people organically and make some genuine business connections. While the goal of many of these groups is to refer one another and gain new business, I have found that the best way to network is to create an authentic relationship with someone. I'm not speaking about a romantic relationship necessarily, but rather a human connection with another person that isn't just about gaining business from them. The best way to network is to refer *someone else's* business *first*. People are more likely to remember you when you offer to help *them* before they help you. It's kind, caring, and flattering and it just might encourage them to refer your business as well. Plus, it just feels really good to help others. I get high off of it!

The easiest way to get the ball rolling is simply to ask for *their* business card *first*, then wait for them to ask for yours. When you let someone know you're a photographer, say it with genuine enthusiasm and passion! Let them know the various things you like to shoot and the things you truly specialize in. Creating relationships the old-fashioned way is more powerful than spending $10,000 on advertising. When they do refer you, don't neglect to thank them. This lets them know how much you appreciate it, and it will probably motivate them to do it again!

- **Bulletin board postings**: Cafés, community centers, grocery stores, schools, stables, or even your community yoga center might have a place to pin up a business card, small promo postcard, or a discount flyer. This is how I launched my own business many years ago before the Internet was a popular tool for communication and advertising. It's an old-fashioned means of self-promotion, but it can work.

- **Community chat forums**: These don't necessarily need to be photography forums. You need to think like your buyer—think where *your* particular buyers go to socialize and get information about their

particular topic of interest. For example, if you love to shoot home inte-
riors, maybe you want to contribute a comment on an architecture forum
or an interior design group. You could causally mention that you happen
to be a photographer who specializes in interiors and comment that it's
always a good idea to remember to bring props when you're prepping
your project to be photographed. If you love to shoot horses and eques-
trian shows, how about a chat forum on caring for your horses, or a
website that actually sells horses? The owners might need a great photo of
their horse.

Paid Advertising

• **Internet listings:** If you're fortunate enough to have your site appear
at the top of the results when a popular keyword search is performed, this
is one of the most powerful promotional positions a business can get.
There are only two ways for your ad listing to appear near the top: either
you pay for it to be there, or it happens organically.

There are three main sections where ads appear on your browser's main
page. The premier positions are those that appear directly beneath the
search window with a crème-colored box around them. These are most
likely pay-per-click ad listings offered by Google. The next positions would
be those located directly beneath the paid listings with a white background.
These listings are organically generated (unpaid) listings. The next posi-
tions after these are the listings appearing in the far right column, also with
a white background. These are also paid ad listings offered by Google.

Everyone wants to know how to get to the top without paying for it.
The position of the organically generated (unpaid) listings is determined
by the amount of search engine activity or click-throughs from different
computers in different locations at different times. The position of the
pay-per-click ad listings is determined by who pays the highest amount
for a specific keyword, and the relevance of these keywords to his or her
ad listing.

There are a number of ways to generate activity on your website. One
of them is to pay for it (at first) through Google's pay-per-click system.
The system works like this: You create ads, choose keywords or phrases

related to your business, and then choose the amount of money you want to pay each time someone clicks through to your site. You can also set budgets so you do not go beyond a certain dollar amount each day, week, or month. Where your particular ad will appear depends on how much you are willing to pay for those keywords against what someone else is willing to pay. The more you pay, the closer to the top your listing will appear. The challenge is that Google will not tell you what amount these people are paying per click for specific keywords (it could be $.50 a click or $50 a click), so there is no way to know. It's simply a case of trial and error. It's a blind bidding system and the person who pays the highest gets positioned in the top spot on Google. It usually takes a few weeks (or even months) for the search engines to balance everything out and to see where your site is positioned in the rankings. Once you see this you can then make adjustments (or up your pay-per-click amount a little bit at a time so you don't go broke!). Obviously, the bigger keywords (such as "New York fashion photographer") will be in greater demand, so you would have to bid higher for those words if you want to be among the premier listings. However, you should keep in mind that while you may have to pay top dollar for those keywords at first, you will eventually get enough activity on your site that it will rise into the organic, unpaid listings position. Once this happens you can opt to stop paying for the pay-per-clicks, and this is the best position to be in. Yes, that means you no longer need to pay for those keywords! *This* is the key to advertising. If you're confused about this, a Google sales specialist can help answer your questions should you elect to go this route.

• **Print magazines, webzines, and resource outlets:** There are hundreds of print magazines, online magazines, and web resource-guide sites that will charge you top dollar to list your business. Do your research and get every detail in writing promised to you by a sales person. I have had some bad experiences with advertising salespeople. It seems they prefer to call you and then follow up with a generic, vague contract that leaves much to be interpreted later. While the top ad positions will be costly and in demand, they're worth it if enough people see it and your ad stays *fixed* on this page (make sure you're not paying for a listing that rotates). Placing

your business on the second or third page isn't worth your time or money because buyers rarely search beyond the first few listings, let alone the next pages.

- **Contests**: Winning a contest is an excellent way to show off your work. Even if you're the second-place winner instead of first place, you're still a "winner" and this is certainly something to brag about. Don't be shy; feature this achievement tactfully in the press section of your website or other promotional outlets. It will definitely impress and influence potential customers.

Keep in mind, contests are designed for the contest owners to make money; they are not offered for "fun." So just as with everything else, do your research. There are hundreds of photography contests. Some are legitimate and others are scams. Check the resource section of this book for a few reputable ones.

- **Promotional mailer cards:** These printed postcards are reasonably priced and easy to create. You can mail them to your clients, leave them at your local photo lab, or send them to anyone willing to help promote your business. You can also keep a few on hand for that chance encounter with someone who needs your services. It's better than a business card because it gives others a sample of your style of photography. You should always include a promotional discount with your postcard to encourage potential clients. These postcards serve dual purposes and generate more business.

CREATE AN ADVERTISING SCHEDULE

I recommend you dedicate a minimum of 8 hours a week to your advertising. This might sound like a lot of time, but it's imperative to the success of your business. I like to choose one day a week to pay my bills and work on my advertising (it's usually Monday if I haven't worked all weekend). On this day, I make a to-do list that can include: reviewing my current paid listings (to ensure that my advertisers haven't moved or rotated my listing), adjusting my listings (revising images, layouts, text, or pricing descriptions), and nurturing my unpaid advertising venues (Facebook,

Twitter, LinkedIn, or networking groups). I also make sure to review my Google Analytics service (a free web page analysis service) to see which pages of my website are getting the most hits and which ones aren't getting many at all. Then I make any necessary adjustments. Lastly, I create a schedule on my calendar for offering discounts during holidays or particularly slow times of year to give my business an extra boost.

EVALUATE YOUR MARKETING

Lastly, it's imperative that you track your advertising leads. By knowing how, when, and through which outlet your job leads reach you, you can determine which advertising platforms are working better than others. As an incentive for my buyers I will sometimes include a promotion— something like, "Mention you found me on this website and receive a 10 percent discount on your next package." If new customers contact me randomly, I always ask them how or where they found me. Sometimes they will simply say, "On the Internet someplace." As an incentive to get them to think harder, I will then say, "I offer discounts from specific websites on which I advertise, so I was just wondering if you could recall where you might have seen me." Sometimes this will jog their memory. While I lose a bit of revenue having to give a client a discount, I am at least able to track which ad sources are most effective and cut out those that aren't. In the end this saves me more money than the money I lose through the discounts I offer.

17

Diversify and Unify
The keys to survival

PEOPLE ARE ALWAYS ASKING ME WHAT I SHOOT. WEDDINGS?
Portraits? Food? Interiors? Fine art? Stock? Advertising? Boudoir? My
answer is *"Yes, yes, and yes . . . I shoot them all!"* There are no rules or reasons
you can't expand and apply your specific style to a variety of photographic
subject matter.

Most athletes know the importance of stretching and using different
muscles all the time to increase strength and flexibility. Artists need to
do the same with their work. I'm not saying you want to become a jack
of all trades, scattered and unfocused, but once you feel you've securely
developed your own unique style, I encourage you to then diversify what
and how you shoot. This might include testing new equipment, new
lighting techniques, or maybe a new composition style. It's imperative
that you push, stretch, experiment, and explore yourself through your
image-making process. Focusing your specialty too narrowly not only
limits your market and your earning potential, but many photographers
become bored from the lack of a challenge. Their work stops evolving, and
so do they; it's a form of artistic atrophy. Eventually others will pick up on
your lack of enthusiasm and this can really hurt your business. If you're
experiencing photographer's block and you're feeling unmotivated, give
yourself a self-assignment shoot and have some fun doing it! You should
just shoot and explore some ideas and emotions and not feel as though
you need to define how and where the images will be used. Just let go and

shoot for fun. This is a great way to recharge your batteries and get those creative juices flowing again—imperative to the health of your business.

As your career evolves and you become an established name in the industry, you might find that you enjoy sharing your knowledge with others, as I do. Teaching has always been a part of my life. I started teaching horseback-riding lessons when I was only 14 years old. By the time I was 26, I was a certified ski instructor, and when I lived in Paris I taught photography lessons in small groups out of the living room of my tiny apartment. Many years later, when I relocated back to California, the natural next step was to open my private photography-coaching business (offering services such as portfolio reviews, shoot assignments, photo gear instruction, and business-consulting advice). As my teaching evolved, I decided to write books, guest speak, and offer workshops to share my knowledge on a larger scale. Eventually this led to corporate sponsorships and many other opportunities. It's been an amazing journey and I've truly enjoyed the opportunity to diversify my photography talents, share my knowledge, and gain additional revenue.

Partnerships: Most photographers work alone. This can be a very isolating and lonely environment. Over the years I have noticed that some photographers guard their work as if they had found some secret recipe or the key to unlocking the universe, and they don't want to share it with anyone. It's an unnecessary fear that comes from excessive competition, and it gets us nowhere. No two photographers are alike. We all shoot in our own way and this is what makes us unique. It's imperative to step outside, get some fresh air, and expose yourself to new images, new ideas, new visions, and new people. People affect people. This is why God put us here on this planet together.

As your business grows, you might start to realize that not only is it impossible to do it all yourself, but that you don't want to. The idea of a partnership might come to mind. Creating a partnership with another photographer or industry vendor can be incredibly beneficial if you choose the right person. Ever heard of the expression "Two heads are better than one"?

THE ADVANTAGES OF A BUSINESS PARTNERSHIP

- **Shared expenses:** Imagine how much easier it would be if you could cut your overhead expenses in half, not only to make ends meet, but also to have money left over after a job to contribute to your retirement fund. You could share office space, utilities, telephone, and cable. You could also split the costs for advertising and just about everything else. If you're flexible, you might even share equipment, a car, and insurance!

- **Shared knowledge:** The photography industry is vast and constantly changing. It seems every day there is a new product, service, application, or technique popping up. This is what makes our world so fun and exciting, but it can be daunting and exhausting to keep up with it all. Everyone knows something that another person doesn't know. It might be the features of the latest camera, a new retouching filter, or the best location for finding wild horses! Having a partner to exchange this knowledge with is immensely valuable.

- **Shared skills and labor:** The best thing about a partnership is that you can combine your talents and share the labor. One partner might be better at creative tasks (such as shooting), while the other could be more naturally inclined toward business and money management. The combination can make for a perfect partnership. Also, you both might be equally talented photographers, so if one partner is unavailable for the shoot the other could be the ideal replacement—or maybe you could even shoot it together!

- **Shared joy:** You just got featured in a magazine! You experimented with a new lighting technique and the images are incredible! You finally landed a major ad campaign and you just want to scream with elation! Your business partner is there when it all happens, and she gives you a huge smile and a big hug. There is simply nothing better than having someone else to share the ups and downs with.

Choosing the Right Business Partner

A person's material possessions and cash contributions are certainly tempting attributes of a potential partner, but the most important qualities of a good business partner should be an ability to communicate, a good reputation, dedication, and strong photography skills.

When considering a partner, it's critical to ask yourself, "What kind of person is this, and can I work with them?" This can be difficult to do sometimes, especially if this person is a close friend, lover, or family member. There is a fine line between business and friendship. Taking that step back to make a rational and unbiased decision may be difficult, but it's absolutely necessary. The best way to do this is to privately ask yourself some questions like, "Would I consider this person to be flexible or set in his ways?" "Is he mature and open-minded enough to handle a conflict without it blowing up into something massive?" (There is nothing worse than a person who holds everything inside, walks on eggshells, and then explodes in a fit of rage over something seemingly insignificant.) A person who knows how to "fight fairly" is the best partner a person could wish for. It's not a question of *if* you will ever have a disagreement but *when* you will and *how* you will handle it. This could be the difference between an immensely successful business partnership and a disastrous tsunami.

Structuring a Partnership Emotionally, Physically, and Financially

Choosing the right partner for a business can be challenging. Before you commit to a legal business partnership, it's crucial that you both sit down informally and address not only your ideas and enthusiasm but also your fears and concerns. You might even want to document this discussion in writing or on a voice recording so that you could use the information from the meeting later to structure a more formal agreement. You should have this discussion as soon as you start considering a potential business partnership.

Consider every possible "what if" scenario you can think of. For example, you might ask: Who handles the accounting? What if one partner becomes ill or cannot cover his or her portion of shared expenses? Do we

shoot jobs together? How do we handle previous clients? Will we merge our client base or keep them separate? What if one photographer gets more press, awards, sponsorships, or even jobs than the other? How do we handle our emotions, our finances, and our physical property? Create a punch list of questions to address. It's good to agree that a discussion is just a discussion, and that you both will always honor and respect one another (regardless of whether you decide to establish a business relationship or not). Good communication is crucial to the well-being of any relationship. Without it, a disaster is just around the corner.

Handling disagreements: Most of us become more humble as we mature. We've had a few experiences with someone else that didn't work out, and hopefully we've gained some insight as a result. Love, compassion, humility, generosity, sharing, and caring can build bridges to the sky. Ego, narcissism, greed, jealousy, and criticism can destroy them like an atomic bomb in a single second.

When a situation arises that causes severe conflict between the two of you, what do you do? The best advice is to do nothing for the moment. Step back. Exhale. Give it time to cool down. Don't make a rash decision to suddenly end the partnership and the business. Women and men both have hormones that can make us more irritable and irrational than we would ordinarily be from one day to the next. "Please," "Thank you," and "I'm sorry" can go a long way, and "I accept your apology" can go even further. These words are so easy to say and yet so often underused. I've seen countless profitable partnerships go down the drain because one or both partners did not have good negotiation or communication skills. Regardless of who we think is right or wrong, oftentimes we just need to have the time to process it in our own way. A man might need to take a walk or shoot some hoops to blow off steam, while a woman might need to talk with a friend. Sometimes it takes one person (*you*) to take the first step forward by offering either an apology or a space to discuss what happened in a calm, rational manner. Resolution for most women means just being "heard" and venting our feelings, while for men it might mean finding a fix-it solution. Either way, it can be so helpful to simply gain

some perspective so that you can recall all the things you loved about this person that made you want to go into business together in the first place.

CONTRACTS

A handshake is not a contract. Bloodline is not a contract. Love is not a contract. Trust is not a contract. A *contract* is a contract. When most people consider partnerships it's often during a moment of mutually heightened excitement over a particular project, product, service, or business concept. Moments like these are powerful. They are like giving birth to a child of your own. There is simply nothing better than prospering with someone you like or love.

Partnerships can go awry for any number of reasons. We are all human, and we all make mistakes. Your friend, lover, or brother isn't necessarily a bad person, a thief, a liar, or incompetent. Unforeseen things just happen sometimes. Lovers don't get married without a contract, so why would you start a business partnership without one? I've heard so many stories about how a partnership went sour and the partners had no formal contract. Apparently, these partners thought they didn't need one because they "trusted" each other so deeply. This is the biggest mistake of all time.

It's always a good idea to have two contracts. One contract should be a formal legal contract (most likely constructed by a lawyer), and the other can be an informal agreement that covers personal issues (such as an agreement to always compliment each other in public and criticize in private). Your informal contract can list all your "what ifs" and resolution options. You might want to use your notes or audiotape from your initial business discussions as a blueprint to ensure that nothing is left out.

On the following page is a sample formal partnership contract. You may want to customize one exclusively for you and your partner, but this will give you a general idea of the topics that you might want to include.

Regardless of whether you decide to form a legal business partnership or not, it's always great for photographers to stick together, support one another, and refer each other's services. Instead of looking at one another as competitors, perhaps you can see each other as partners on a team. It's always more fun this way anyhow.

PARTNERSHIP AGREEMENT

This PARTNERSHIP AGREEMENT is made on _____, 20_____ between
_____ and _____.

1. **NAMES AND BUSINESS**. The parties hereby form a partnership under the name of
_____ to conduct a _____.
The principal office of the business shall be in _____.

2. **TERM**. The partnership shall begin on _____, 20____, and shall
continue until terminated as herein provided.

3. **CAPITAL**. The partners shall contribute the capital of the partnership in cash as
follows: A separate capital account shall be maintained for each partner. Neither partner
shall withdraw any part of his capital account. Upon the demand of either partner, the
capital accounts of the partners shall be maintained at all times in the proportions in
which the partners share in the profits and losses of the partnership.

4. **PROFIT AND LOSS**. The net profits of the partnership shall be divided equally
between the partners and the net losses shall be borne equally by them. A separate
income account shall be maintained for each partner. Partnership profits and losses shall
be charged or credited to the separate income account of each partner. If a partner has no
credit balance in his income account, losses shall be charged to his capital account.

5. **SALARIES AND DRAWINGS**. Neither partner shall receive any salary for services
rendered to the partnership. Each partner may, from time to time, withdraw the credit
balance in his income account.

6. **INTEREST**. No interest shall be paid on the initial contributions to the capital of the
partnership or on any subsequent contributions of capital.

7. **MANAGEMENT DUTIES AND RESTRICTIONS**. The partners shall have equal
rights in the management of the partnership business, and each partner shall devote his
entire time to the conduct of the business. Without the consent of the other partner neither
partner shall on behalf of the partnership borrow or lend money, or make, deliver, or
accept any commercial paper, or execute any mortgage, security agreement, bond, or
lease, or purchase or contract to purchase, or sell or contract to sell any property for or of
the partnership other than the type of property bought and sold in the regular course of its
business.

8. **BANKING**. All funds of the partnership shall be deposited in its name in such
checking account or the partners shall designate accounts as. All withdrawals are to be
made upon checks signed by either partner.

9. **ACCOUNTING BOOKS**. The partnership books shall be maintained at the principal
office of the partnership, and each partner shall at all times have access thereto. The
books shall be kept on a fiscal year basis, commencing _____ and
ending _____, and shall be closed and balanced at the end of each
fiscal year. An audit shall be made as of the closing date.

10. **VOLUNTARY TERMINATION**. The partnership may be dissolved at any time by agreement of the partners, in which event the partners shall proceed with reasonable promptness to liquidate the business of the partnership. The partnership name shall be sold with the other assets of the business. The assets of the partnership business shall be used and distributed in the following order: (a) to pay or provide for the payment of all partnership liabilities and liquidating expenses and obligations; (b) to equalize the income accounts of the partners; (c) to discharge the balance of the income accounts of the partners; (d) to equalize the capital accounts of the partners; and (e) to discharge the balance of the capital accounts of the partners.

11. **DEATH**. Upon the death of either partner, the surviving partner shall have the right either to purchase the interest of the decedent in the partnership or to terminate and liquidate the partnership business. If the surviving partner elects to purchase the decedent's interest, he shall serve notice in writing of such election, within three months after the death of the decedent, upon the executor or administrator of the decedent, or, if at the time of such election no legal representative has been appointed, upon any one of the known legal heirs of the decedent at the last-known address of such heir. (a) If the surviving partner elects to purchase the interest of the decedent in the partnership, the purchase price shall be equal to the decedent's capital account as at the date of his death plus the decedent's income account as at the end of the prior fiscal year, increased by his share of partnership profits or decreased by his share of partnership losses for the period from the beginning of the fiscal year in which his death occurred until the end of the calendar month in which his death occurred, and decreased by withdrawals charged to his income account during such period. No allowance shall be made for goodwill, trade name, patents, or other intangible assets, except as those assets have been reflected on the partnership books immediately prior to the decedent's death; but the survivor shall nevertheless be entitled to use the trade name of the partnership. (b) Except as herein otherwise stated, the procedure as to liquidation and distribution of the assets of the partnership business shall be the same as stated in paragraph 10 with reference to voluntary termination.

12. **ARBITRATION**. Any controversy or claim arising out of or relating to this Agreement, or the breach hereof, shall be settled by arbitration in accordance with the rules, then obtaining, of the American Arbitration Association, and judgment upon the award rendered may be entered in any court having jurisdiction thereof.

Executed this ____ day of _____ , 20_____ in _____ [city], _____[state].

Agreed, Name, Date

Agreed, Name, Date

Notes

18

Recycling Your Images
Giving your images a second life

AFTER ALL THE WORK YOU'VE INVESTED IN CREATING YOUR AMAZING images, wouldn't it be nice if they could keep generating income for you? Most photographers forget to consider the numerous ways in which their commissioned and noncommissioned images might earn additional revenue with little or no extra effort on their behalf.

PRINTS, FRAMED CANVASES, MUGS, CALENDARS, BOOKS, AND OTHER À LA CARTE ITEMS

Think outside the box. In addition to reprints and enlargements, your images could be applied to dozens of crafty products you can sell yourself, from calendars, coffee mugs, mouse pads, and key chains to fine-art prints, canvases, and more. There are a number of companies that can create these wholesale products for you, or you might think of creating some items yourself. You could either list your à la carte items on your website (processing the orders yourself) or use an online company such as Smugmug, Pictage, Zenfolio, or Miller's Imaging, and let them do all the work for you. These companies offer everything from standard prints, proofing books, and canvas frames to albums, books, postcards, and an array of small trinket gift items. They sell the items, process the order, collect the money, and then ship the items to your client. They then take a percentage of your sales and send you a paycheck. Time is money, so while it may "seem" as though you could take in less of the profits by using one

of these companies, it requires very little time or labor on your part. This would allow you to spend your time booking and shooting your next job instead of placing and shipping product orders. You're a photographer after all, so you must decide which is the most profitable option for you.

STOCK PHOTOGRAPHY

The term "stock image" refers to photographs that are not commissioned for a specific client or use but rather made available to anyone for a fee. In other words, instead of searching for and hiring a photographer to shoot a specific image, buyers can just "rent" (or "license") an existing image from a photographer directly or a stock image company that represents the photographer's work at a fraction of the cost. This can be beneficial to both the seller (the photographer/stock agency) and the buyer (a graphic designer, creative director, or anyone who needs an image for something). While the photographer earns a mere fraction of what he or she might earn from a commissioned job, at least *some* money is better than no money, and it requires little to no additional labor on his or her behalf.

Photographers may opt to license images to buyers themselves or have an agency do it for them for a percentage of the license fee when sales are made. Some photographers do a bit of both. While some agencies will require exclusive representation for any images their company represents, this doesn't mean that photographers can't license *other* images in their stock collections with other stock agencies or private clients. The benefit of licensing images yourself is that you cut out the middleman (the stock agency) who would be taking a cut of the profits, and you don't need to wait to get paid, hoping that the agency is honest about its sales amount. However, much like trying to sell something on your own, if you don't have the resources to promote your stock-image collection effectively, you'll have a difficult time generating much income from it.

The fees associated with licensing images to buyers will vary. Much depends on the current economic climate, how, where, and when the image will be used, and the demand for that particular image. Sadly, the fees for stock images have dropped substantially in the past decade as the supply has come to exceed the demand. But as I have said before, *some*

money is always better than no money, right? If you choose to use a stock-image agency, this agency will determine the fees for each image-license sale. However, should you decide to license some images yourself, there are software applications that you can use, such as fotoQuote Pro (a photo price guide that includes negotiation information for stock and assignment photography). These programs also give information about business practices, assignment pricing, creative fees, pricing strategies, and negotiation tips for simple editorial jobs to complex, half-million-dollar jobs.

As mentioned previously in chapter 6: Invoices, Contracts, Estimates, and Releases, it's important to have a release permission signed by or on behalf of any person, pet, property, or minor recognizable in your images. In our lawsuit-friendly society this is imperative, and most agencies won't even review a collection of images unless they are already fully released. For more information about the stock photography world, including how to make image submissions and licensing types, see my book *The Art Of Engagement Photography.* On pages 219–221 are some sample stock photo release forms.

DÉCOR ART AND FINE ART

Décor art is like a branch of stock photography, but the image subject matter tends to be more artistic in nature. Décor art essentially means mass-produced, fine-art reproductions. Unlike actual fine-art images, these images (and the hundreds of products they are applied to) are not signed and numbered original pieces of art, but copies of originals. You can find décor art everywhere, from ready-made frames you purchase at stores, computer mouse pads, and wallpaper to fabric, bedspreads, place-mats, and any number of household furnishings.

As with stock photography, you can try to sell these items yourself or find a reputable agency to sell them for you. I say "reputable" because I have not heard the best stories from the décor artists I interviewed, one of whom was represented by one of the largest décor art companies in the world (one I was considering joining myself). This woman had stunning work and appeared to be the most successful artist at the company, with thousands of products using images from her massive collection. When I asked this company if they provided monthly statements detailing where

the images were being used and how many units had been sold so that I could understand my commission check, they said, "No, we don't work that way. We just send you a check." I thought *Hmmmm . . . this seems odd* (red flag number 1). When I asked this company if they would mind my contacting this woman as a reference before I signed my images away to them, they were reluctant (red flag number 2). With a bit of investigative work on my behalf, I was able to find her number in the yellow pages and I gave her a call. She was a very sweet woman, but sadly she was living hand-to-mouth in a trailer in the desert and didn't even have enough money to buy a computer! She had no idea how many of her images were being used and for what (red flag number 3). Enough said. Based on the estimated commission information given to me by the company recruiter, this woman should have been very, very wealthy. Obviously, the agency had not been ethical about its accounting. Needless to say, I never joined this company. The bottom line is do your research, ask the right questions, and make sure that any agency you are considering gives you detailed monthly or quarterly sales statements. Beware; many agencies (both stock and décor art) may seduce you with flattery and shower you with compliments about your work to persuade you to sign a contract with them. This may be partly in the hopes that you won't question their business practices. Resist this temptation, be on guard, and ask the right questions.

FINE-ART GALLERIES

As with the other industries discussed above, you can opt to sell your fine-art prints yourself or have a "reputable" gallery do it for you. There's that word "reputable" again . . . darn. Yes, I was burned by one of the most established fine-art photography galleries in Los Angeles! This is in part because I neglected to research the gallery owner before surrendering a few prints to him. I was so incredibly flattered that he wanted to take one of my fine-art prints for a special auction (positioning them directly next to legendary photographers such as Helmut Newton, Cartier Bresson, and Robert Doisneau) that I just "assumed" he was ethical (wrong). I was naive and I never got anything in writing. He sold my prints and never paid me a dime. He just kept avoiding my phone calls and telling his staff

to tell me the check was in the mail. As fate would have it, the guy ended up in jail for tax evasion.

With this in mind, ensure that your agreement with a gallery states every detail of your arrangement before surrendering your images. Again, don't let a big gallery owner intimidate you or flatter you with compliments about your work so that you neglect to address the legal parameters of your agreement. Your contract should cover the print's price, the gallery's commission percentage, and when you will get paid. I prefer to work with galleries that pay artists immediately when *they* receive payment from the buyer. If this is what is promised to you, get it in writing. Additionally, you should make sure your contract has a copyright clause. This means that your limited-edition print is not to be reproduced for any reason whatsoever. If they insist that they need to make copies for promotional purposes, find out where and how the image will be used and provide them with a small digital file sized to scale for their specific use. Lastly, the contract should address advertising to promote your gallery show (who pays for the promo mailers, the email blasts, the valet parkers, and the drinks and appetizers served). If the gallery provides you with one of its "standard" contracts, let them know that you need some time to review and revise it. If they seem uneasy about this, you might want to pass on working with them. As exciting as it may seem to have a gallery show, the excitement will fade quickly if it ends up costing you money instead of making you money.

Recycling your travel images: I love to travel (who doesn't, right?). Wouldn't it be great if you could pay for your vacation by shooting some amazing travel images for stock agencies, travel bureaus, or magazines? This is why I decided to create my company Destination Photo Workshops. In addition to my wedding and portrait workshops, I wanted to also offer affordable, all-inclusive travel workshops in magnificent locations (such as Italy and France) that combined unique accommodations, incredible food and wine, and a backdrop for all of us to capture the best travel images of our lifetimes. Because I had already lived many years in France, had numerous contacts throughout the country, and speak the language fluently, I figured what better place to offer a travel workshop and

allow photographers to experience the country as a local would. When I discovered the most incredible 12th-century estate for my students to stay at in Italy's Tuscany region, only a few hours from where I was holding the France workshops, I thought, why not do a workshop in Italy as well? My all-inclusive travel workshops are open to photographers and photo enthusiasts of all levels but limited to no more than 15 participants. This enables me to give each student my undivided attention. The travel workshops are all about the total experience.

While standard "street photography" images of common destinations are less in demand because the market is already flooded with them, you can certainly make a point of capturing details of specific foods, a beautiful portrait of local professionals practicing their trade, and any other cultural, iconic, or symbolic images representing a particular location that might be of interest to your stock agency. It's always best to check your agency's "wants and needs" lists before you depart. They just might be seeking a specific image from a specific destination that could end up paying you a nice royalty check.

During a personal trip I made a few years ago to visit a friend in northern Norway, above the Arctic Circle, I captured a beautiful, spontaneous portrait of her niece. It's not a personal image but more of a graphic image of the close-up of her face split down the middle. This image has now been published in numerous magazines and has been licensed as a stock image dozens of times all around the world. This single image took less than a few minutes to shoot and paid for the entire trip twice over. Symbolic images and general images that could be used to promote a variety of products and services make the best stock images. Always remember to shoot both vertical and horizontal so you have the right format for your buyer.

When I'm traveling, especially to a new destination I've never been to before, I'm like a 5-year-old kid—eyes wide open with wonderment and my neck stretched out the car window like a Labrador on a hot summer day. I forewarn anyone who travels with me that I'll probably be totally consumed with my camera. Everyone in my life is used to it by now, and most of them even enjoy seeing how I compose my images and the

subjects I choose to shoot. For some it's part of the trip and part of the fun (especially when they get to see a slideshow of the images at the end).

What I like the most about traveling with my camera is that I am always looking around me, seeing people and things I might overlook otherwise—an antique, rusted key lying on a marble window ledge, or maybe a water bottle reflecting the afternoon light. The simplest things can make the most beautiful still-life images. As mentioned in chapter 14: Directing and Shooting People, Places, and Things, in order to capture the true essence of a place (so the viewer can experience it as well through your remarkable images), it's important to do some research and keep your eyes and ears open. While I'm shooting and enjoying the explorative scavenger hunt into the unknown, I'm always thinking about where and how I might recycle these images later in my portfolios, website galleries, fine-art prints, stock-image sales, or editorial-magazine articles. The goal is to give the art buyer or magazine editor a rich, extensive, and comprehensive view of a location in order to maximize the potential profits from my travel images.

On some trips I'll even bring my laptop and start editing images immediately after I shoot (especially if I'm shooting something timely and need to get it to my editor quickly). By the time I get home, I not only have a nice collection of images to submit to my stock agency for review, I also have images that give me (and my viewers) great memories of the trip and how magnificent our wonderful world really is.

Whether you're shooting for a commissioned client or just traveling and shooting for pure pleasure, as always, make sure to bring your model, pet, and property release forms with you. Your stock agencies can also provide you with release forms, so just ask them. If you're planning on shooting in a foreign country, make sure to have a translated version in the appropriate language. I always keep copies of release forms in common languages such as Spanish, French, German, Italian, Chinese, and Japanese on hand, just in case. You may not always be able to get a signed release for your street photography images (people and locations), but those images may still be useable for editorial (nonadvertising) purposes. While editorial images pay considerably less than images used for advertising, again, as I've said before, some money is better than no money.

The goal of any photographer is to make great images that can continue to make them money long after they've been created. Expand your horizons, get creative, think outside the box, and always remember to treat your customers as you would want to be treated—like royalty. This is *How to Create A Successful Photography Business!*

In closing, I hope that this book has really inspired you, and that it has given you the courage and the wings to do what you've always dreamed of doing—capturing great images and creating a prosperous business based on them. For there is simply nothing better in the world than getting paid for what you already love to do.

Wishing you all the very best!

—Elizabeth Etienne

For more information on Elizabeth Etienne's work, please go to: www.elizabethetienne.com or www.eephoto.com.

For more information on Elizabeth Etienne's workshops and private photo-coaching sessions, please go to: www.destinationphotoworkshops.com.

ELIZABETH ETIENNE PHOTOGRAPHY Date: _____Ref:_____
578 Washington blvd #372 Marina del Rey, CA 90292
www.etiennephoto.com/www.eephoto.com
tel: 310.578.6440 fax: 800-971-3042

MODEL RELEASE:

Model's Name:_____

Address:_____

Model's Phone:_____

Model's Email:_____Age_____Ethnicity_____

MODEL'S PERMISSION AND RIGHTS GRANTED:

For good and valuable Consideration of Elizabeth Etienne. herein acknowledged as received, and by signing this release I hereby give the Artist and Assigns my permission to license the Images and to use the Images in any media for any purpose (except pornographic or defamatory,) which may include, among others, advertising, promotion, marketing and packaging for any product or service. I agree that the images may be combined with other images, text and graphics, and cropped, altered or modified. I acknowledge and agree that I have consented to publication of my ethnicity(ies) as indicated below, but understand that other ethnicities may be associated with Images of me by the Artist and/or Assigns for descriptive purposes.

I agree that I have no legal copyright rights to the Images, and all the rights to the images belong to the artist and assigns. I acknowledge and agree that I have no further right to additional consideration or accounting, and that I will make no further additional claim for any reason to artist and/or assigns. I acknowledge and agree that this release is binding upon my heirs and assigns I agree that this release is irrevocable, worldwide and perpetual, and will be governed by the laws of the state excluding the law of conflicts.

Definitions:
"MODEL" means me and includes my appearance, likeness and form.
"MEDIA" means all media including digital, electronic, print, television, film and other media now known or to be invented.
"ARTIST" means photographer, illustrator, filmmaker, or cinematographer, or any other person or entity photographing or recording me.
"ASSIGNS" means a person or any company to whom Artist has assigned or licensed rights under this release as well as the licensees of any such person or company.
"IMAGES" means all photographs, film or recording taken of me as part of the Shoot.
"CONSIDERATION" means something of value I have received in exchange for rights granted by me in release.
"SHOOT" means the photographic or film session described on this form.

I represent & warrant that I am at least 18 yrs of age and have the full legal capacity to execute this release.

To be completed By Model:

Model's Signature: _____

ELIZABETH ETIENNE PHOTOGRAPHY

578 Washington Blvd. #372 Marina del Rey, CA 90292 tel:310.578.6440 fax: 800-971-3042
eephoto.com & etiennephoto.com

Shoot Date: _____ Shoot reference:_____

Shoot description:_____

MINOR MODEL RELEASE

Model's Name:_____

Model's address:_____

_____ZIP_____

Model's Phone:_____ Model's Age:_____

ADDITIONAL INFO TO BE COMPLETED BY PARENT/LEGAL GUARDIAN:

Model's ethnicity info is requested for descriptive purposes only and serves as a means of providing more accuracy in assigning search words. Please circle all that apply:

- Caucasian/White -Hispanic African -American/Black- Native American Mixed Race- Other:

- Asian: Chinese, Japanese, Korean, Thai, Vietnamese, Indian, Philipino, - Middle Eastern - Pacific Islander

PARENT/LEGAL PERMISSSION AND RIGHTS GRANTED:

By signing this release I hereby give the Artist & Assigns my permission to license images in any media for any purpose (except pornographic or defamatory), which may include among others, advertising, promotion, marketing, and packaging for any product or service. I agree that the images may be combined with other images, text and graphics, cropped altered or modified. I acknowledge and agree that I have consented to publication of my ethnicity(ies) as indicated below, but understand that other ethnicities may be associated with images of me by the artist and/or Assigns for descriptive purposes.

I agree that I have no rights to the images and all rights to the images belong to the artist and Assigns. I acknowledge and agree that I have no further right to additional consideration or accounting and that I will make no further claim for any reason to artist and Assigns. I acknowledge and agree that this release is binding upon my heirs and assigns. I agree that this release is irrevocable, worldwide and perpetual, and will be governed by the laws of the State of California excluding the law of conflicts.

Parent warrants and represents that Parent is legal guardian of model, and has full legal capacity to consent to the shoot and execute this release of ALL RIGHTS IN MODEL'S IMAGES.

PARENT/LEGAL GUARIDIAN PRINTED NAME:_____

PARENT/LEGAL GUARDIAN SIGNATURE: _____

MODEL'S DATE OF BIRTH: _____ DATE:_____

DEFINITIONS: "MODEL" means my minor child and includes his/her appearance, likeness, and form. "MEDIA" means all media including digital, electronic, print, television, film and other media now known or to be invented. "ARTIST" means photographer, illustrator, filmmaker, and cinematographer. "ASSIGNS," means a person or company to whom artist has assigned or licensed rights under this release as well as the licensee of any such person or company. "IMAGES" means all photographs, film or recording taken of model as part of the shoot. "SHOOT" means the photographic or film session described in this form.

ELIZABETH ETIENNE PHOTOGRAPHY
578 Washington blvd. #372 Marina del Rey, CA 90292
tel:310.578.6440 fax: 310.578.6788

PROPERTY & ANIMAL RELEASE

Name of Releasing Individual: _____

Description of Photograph:

Date of Photograph _____

For good and valuable consideration, I hereby irrevocably grant to Elizabeth Etienne,

("Photographer"), his/her affiliates, licensees, agents and assigns, the unrestricted right or

my animal named: _____

Or to depict my property located at:

_____, which is

contained in the above described photograph(s) taken by Photographer, and to distribute

such photograph(s) for editorial, trade, advertising or other purposes in any manner or

medium, whether now or hereafter devised, throughout the world in perpetuity.

I waive any right to inspect or approve any use of the photograph. I understand
Photographer may contract with a stock agency and that the above described
photograph(s) may be included in stock files. I expressly release Photographer, his/her
agents, employees, licensees and assigns from and against any and all claims which I
have or may have for invasion of privacy or any other cause of action arising out of the
uses herein granted, even if the use of the image is objectionable to me. In any event, I
agree that my monetary damages, if any, shall not, under any circumstances, exceed $US
500.00.
I warrant that I am over the age of eighteen and am competent to contract in my own name
in so far as the above is concerned.

Date: _____ Signature: _____

Print Name: _____

Address: _____

Phone No.: _____

Resources

PHOTO WORKSHOPS:
Elizabeth Etienne's Destination Photo Workshops:
www.destinationphotoworkshops.com
Tel: 310.578.6440 / 800.971.3042

EDUCATIONAL BOOKS BY ELIZABETH ETIENNE: *Profitable Wedding Photography* and *The Art of Engagement Photography*

PRIVATE PHOTOGRAPHY COACHING & CONSULTING:
Elizabeth Etienne Photography: 310.578.6440 / 800.971.3042
Sessions cover a range of topics including technical shooting guidance, portfolio reviews, and business coaching.

PHOTO BUSINESS SUPPORT GROUPS: SAA, ASMP, APA, WPPI

COMMUNITY FORUMS & PHOTO RESOURCES:
www.photobiz.com, www.skipsphotonetwork.com, www.photo.net, www.blogs.photopreneur.com, www.photocrew.com, www.wearephotographers.com

SOFTWARE PROGRAMS: BlinkBid (professional estimating program: billing and invoicing software for photographers and creative professionals. The easiest way to create estimates, usage licenses, and invoices), YouSendIt (electronic file-sharing software), Fotoquote (stock photo licensing program).

SOCIAL NETWORKING/ADVERTISING: Facebook, Twitter, LinkedIn, YouTube, eBay, craigslist, Myspace, Workbook

SELF-HELP MOTIVATIONAL BOOKS: *The Instant Millionaire, The Artist's Way, Wishcraft, The Four Agreements, The Secret, Feng Shui Dos & Taboos*

CONTESTS: WPPİ, Hallmark, www.photoawards.com, *National Geographic,* Vermont Photo Space, *Professional Photographer* magazine, *PDN* magazine

PHOTO ASSISTANTS: www.aphotoassistant.com, www.photocrew.com, www.assistantlist.com

PHOTOGRAPHY INSURANCE: Tom C. Pickard, Fireman's Fund

PRINTERS & COPY SHOPS:
www.overniteprints.com, www.tammyandfriendsprint.com

READY-MADE WEBSITE TEMPLATES: www.photobiz.com

PORTFOLIO BOOKMAKING COMPANIES: Samy's Camera (Santa Barbara, CA)

MODELS: www.modelmayhem.com

FUN & UNUSUAL PHOTO GIFTS & GEAR: www.photojojo.com

LEGAL DOCUMENT SERVICE: www.legalzoom.com

FILM: Kodak: www.kodak.com

PHOTO SUPPLIES: Samy's Camera, B&H Camera

ONLINE PHOTO EQUIPMENT RENTAL SERVICE:
www.borrowlenses.com

FILM SCANNERS: Nikon Coolscan 9000ED

CAMERAS: Nikon

PRINTERS: Epson

SOFTWARE APPLICATIONS: Photoshop, Lightroom, Stuffit expander, Dropstuff, Grab, Fetch

PACKAGING & PRESENTATION MATERIALS: DNL Photo Packaging: www.dnlphoto.com, Inmark: www.in-mark.com, Michael's Arts & Crafts

TELEPHONE SERVICE: www.ringcentral.com

Index

accommodations, 78
advertising, promoting your business
 through, 198–199
 budget, 37–38, 49–50, 180–181,
 196–197
 free, 193, 195
 referrals as, 140, 195
 Internet, 4, 22, 35, 59, 182,
 195–196, 199. *See also* Facebook
 paid, 28, 37–38, 49–50, 140, 163,
 179–181, 196–198, 203, 215
 resource list, 223
advertising photography
 clients, 55, 60–68, 120, 136–138
 jobs, 60–68, 76–79, 103, 120, 121,
 137–139, 217
all-inclusive packages, 57, 80, 100,
 125, 134–135, 176
Aperture (software program), 22
Art of Engagement Photography, The, 7,
 127, 149, 162, 176, 191, 213
art. *See* job types: fine art
Articles of Organization, 11, 15
assistants, 15, 21, 25, 27, 34, 37, 56,
 58–59, 63, 75–76, 78, 86–89,
 91–92, 95, 115, 119, 121, 127,
 131, 150, 152–153, 155, 163, 190
automobile, 38
bar/bat mitzvah. *See* job types: bar/bat
 mitzvah
branding, 122, 171–173, 175–176

Bridge (software program), 22
brochures, 6, 134
business attire, 28, 134
business cards, 29, 36–37, 98, 134,
 141, 177, 181, 188, 190, 195, 198
business entity, 13, 15
business plan, 43, 47–48, 180
camera bags, 20, 152–153
cameras, 2, 14, 18–19, 80, 86–87, 145,
 154, 166, 171
children, photographing, 157–158
client relations, 34, 87, 92, 190
computers, 21, 23, 34, 49, 186, 196
contracts
 advertising, 197
 agent, 90
 credit cards, 44, 52
 for jobs, 24–25, 36, 55–56, 57,
 60, 62, 65, 69, 72, 98, 101–102,
 137–139, 165
 for loans, 50
 insurance, 35
 partnership, 206–208
 with galleries, 215
craft services, 77–78
creative value mark-up, 118, 121
credit cards, 15, 42, 44–46, 50–53, 56,
 59–60, 123, 137–138, 185
data storage, 20. *See also* hard drives
deposit, 11, 24, 26, 55–58, 62, 98,
 103, 123, 130–131, 137–139, 185

documents, legal business, 11–12, 15
Doing Business As (DBA), 12
employees, 34, 59, 89. *See also* assistants; extra crewmembers; interns; interviewing
equipment
 backup, 19, 143
 carnet, 79–80, 157, 166, 201, 203
 rental, 63, 77, 143
 repairs and upgrades, 38, 82
 reviews, 18, 35
estimate
 contracts, 36, 55, 58, 60–62
 formula, 17, 33, 39, 81, 117–121, 126
 software, 62, 138
expenses
 budget, 17, 22
 job, 34, 75, 82, 120–121
 log, 77, 81
 ongoing, 29–30, 33–39, 49, 121
 sheet, 180
 start-up, 17, 23, 28–30, 41, 47, 49–50, 120, 121, 124, 180
extra crewmembers, 76, 78
Facebook, 29, 37, 49, 182, 193–195, 198
fashion. *See* job types: fashion
 images, 2
 photography, 2
 shoot, 151
flashes, 18–20, 80, 145, 153–154
gifts, 99, 189–190
hard drives, 22–23, 34, 157
headshots. *See* job types: headshots
hourly rate, 119
image idea, 3, 118
insurance, 13, 21, 28, 30, 34–35, 38, 63, 79–81, 119, 203
 locked equipment closet, 21
interns, 87–88, 95
interviewing
 agents, 89

 assistants, 86, 88
 interns, 88
 photo labs and bookmakers, 89
investors, 192
invoices, 36, 56–59, 61–63, 65, 76–77, 99, 137
job types
 advertising. *See* advertising: jobs.
 bar/bat mitzvah, 6
 boudoir, 57, 162, 189
 celebrity, 28, 111–112
 corporate, 133–135,
 décor. *See* job types: fine art
 engagement, 6, 7, 76, 135, 162–163, 191
 family, 6, 57, 75, 126, 159–160, 161–162, 189, 190
 fashion, 2, 151
 fine art, 6, 8, 213–214
 food, 5, 76–77, 122–124, 125, 164, 216
 group, 161–162
 headshots, 6, 19, 56, 57, 98–99, 133–135, 159, 160
 parties, 6, 159, 163, 189–190
 photojournalism, 4, 187
 portraits, 6, 57, 126, 133–135, 157–160. *See also* headshots.
 pregnancy, 6, 57, 161
 property interiors and exteriors, 6, 7, 8, 76–77, 122–124, 125–127, 164–166, 196
 sports, 167–168
 stock, 6, 167, 212–213, 215–217
 travel, 3–4, 166–167, 215–217
 weddings, 4, 5, 6–7, 28, 55–56, 57–59, 76, 103–104, 125, 135–136, 139, 145, 151–152, 163, 167–168, 190–191
lifestyle plan, 5
lighting
 preparing, 147

types of, 148–149
Lightroom (software program), 22, 171, 224
Limited Liability Company (LLC), 13
loans, 17, 44, 46, 104
 bank loans, 46
 personal business loans, 42
magazines, 2, 4, 111, 127, 197, 215–216
marketing, 28–30, 135
meals. See craft services
meetings, 25–26, 46, 97, 118, 130
negotiating, 90, 135, 137
newspapers, 4, 6
Nikon, x, 18–19, 154, 165–166, 171
office
 expenses, 11
 feng shui, 115
 framed image gallery, 29–30
 furniture, 25
 lighting, 27
 paint, 26
 security, 30
 signage, 27
 storage, 22
 supplies, 23
packages, all-inclusive, 57, 80, 100, 125, 134–135, 161, 176
packaging, 81, 104, 118, 171, 176, 190
paperwork, 12, 47, 55, 62, 91, 139
parties. See job types: parties.
partnerships, 13, 202, 205–206
PayPal, 15, 56, 59, 137–138, 185
pets, 6, 62, 67
photo perishables, 20
Photoshop, 22, 171, 183
portfolio books, 29, 37, 132, 173–174, 180, 187–188
portraits. See job types: portraits
positive energy and your business, 111–115

pregnancy portraits. See jobs types: pregnancy
pricing services, 117, 127
 trades, 97
printers, 23, 26, 36–38
professionalism, 28, 43, 55, 92, 98, 100–101, 129–133, 140, 151, 184, 188
Profitable Wedding Photography, 4, 7, 127, 163, 190
promotional emails, 189
properties, 6, 35, 62. See also job types: property interiors and exteriors
release form, 36, 62, 67–68, 213, 217
reshooting, 101
retouching, 61, 63, 99–100, 118, 134, 165
skill level, 1, 5, 7, 8, 63
social communication, 5
Sole Proprietorship, 13
sports. See job types: sports
stock photography. See job types: stock
subject matter, markets and areas of specialization, 2–8, 96–97, 174, 187, 201–202. See also job types; advertising: jobs
tax
 ID Number, 14–15
 permits, 14
 sales, 14, 58, 66–67
Ten Commandments of a Successful Photography Business, 95–104
time management, 4–5, 97–98, 114, 145–146, 157, 168, 179
transportation, 63, 78–79
website, 18, 28–29, 37, 56, 64, 67, 180, 182–187, 190, 196, 211
weddings. See job types: weddings

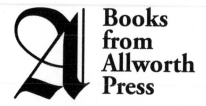

Books from Allworth Press

Allworth Press is an imprint of Skyhorse Publishing, Inc. Selected titles are listed below.